Detroit Resurgent

michigan state university press | michigan state university museum | east lansing

Detroit

photographs by **GILLES PERRIN** | interviews by **NICOLE EWENCZYK**

edited by **HOWARD BOSSEN** and **JOHN P. BECK**

Resurgent

♾ The paper used in this publication meets the minimum requirements of ANSI/NISO Z39.48-1992 (R 1997) (Permanence of Paper).

 Michigan State University Press
East Lansing, Michigan 48823-5245

 Michigan State University Museum
East Lansing, Michigan 48823

Printed and bound in the United States of America.

20  19  18  17  16  15  14        1  2  3  4  5  6  7  8  9  10

LIBRARY OF CONGRESS CATALOGING-IN-PUBLICATION DATA

Perrin, Gilles.

Detroit resurgent / photographs by Gilles Perrin; interviews by Nicole Ewenczyk; edited by Howard Bossen and John P. Beck.

pages cm

Includes bibliographical references.

ISBN 978-1-61186-130-3 (cloth : alk. paper) 1. Detroit (Mich.)—Biography. 2. Detroit (Mich.)—Biography—Pictorial works. 3. Detroit (Mich.)—Social conditions—21st century. 4. Interviews—Michigan—Detroit. I. Ewenczyk, Nicole. II. Bossen, Howard. III. Beck, John P. IV. Title.

F574.D453A266 2014

977.4'34—dc23

2013028632

Cover and text design by Charlie Sharp, Sharp Des!gns, Lansing, MI

Cover images are © Gilles Perrin

g green press INITIATIVE   Michigan State University Press is a member of the Green Press Initiative and is committed to developing and encouraging ecologically responsible publishing practices. For more information about the Green Press Initiative and the use of recycled paper in book publishing, please visit *www.greenpressinitiative.org*.

Visit Michigan State University Press at *www.msupress.org*

to Nicole
and to the resilient and creative people of Detroit

# contents

# foreword

LOU ANNA K. SIMON, PhD, PRESIDENT,
MICHIGAN STATE UNIVERSITY

Detroit was already a swaggering, 130-year-old commercial center when French political and social commentator Alexis de Tocqueville arrived there in 1831. Finding a "fine American village" with many legacies of its French origin, he sought out a fellow countryman, the community leader Father Gabriel Richard.

In his pocket notebook, de Tocqueville recorded the priest's observations of the American character as expressed on that pulsing frontier. Among them: "Nobody asks you of what religion you are, but if you can do the job."

Arriving as a missionary, Richard himself wore many hats and persisted in Detroit after the school he opened was destroyed in the disastrous 1805 fire that leveled the town. He stayed even after the city's 1812 surrender and his imprisonment by the occupying British for refusing to renounce his adopted country. Richard remained after his electoral bid to continue to represent the Michigan territory in Congress was unsuccessful in 1824. Aged but active, he was teaching school when de Tocqueville called.

In its long recorded life as an outpost of European empire, boomtown, industrial and technological hub, cradle of culture, and today, sadly, a metaphor for decay, Detroit has remained a place of stubborn resilience, personal industry, creativity, and

ix

even optimism. It remains home to many who, like Gabriel Richard, remain to work toward a brighter future in a place that still values a person's ability to do the job.

Thanks to my industrious colleagues Howard Bossen and John Beck, we meet sixty-four such contemporary Detroiters in the following pages. Far more than the artifacts and landmarks that come to be associated with a place, Detroit's story is chiefly that of its people. This book and the exhibit it accompanies are an effort to illustrate this truth—through the revealing photography of yet another set of perceptive French chroniclers—and through their subjects' own words.

Beyond the parallels of modern Detroiters with their pioneer forebears, we see similarities in their spirit with that of Michigan State University, which is proud to sponsor this book and the associated photographic exhibit. Since its founding a generation after de Tocqueville took his American tour, Michigan State also has built a reputation for hard-working excellence; for practical inquiry, discovery, and innovation; and for direct people-on-the-ground engagement throughout Michigan and, increasingly, around the world. Michigan State has been active in Detroit, in particular, for many years in educational and community-building endeavors, and certainly a good number of our students and alumni are from the region and share its spirit of resilience and enterprise.

It was Gabriel Richard who, after the great city fire, penned what remains Detroit's motto: *Speramus meliora; resurget cineribus*, or "We hope for better things; it will arise from the ashes."

When it does, once again it will be its people who will seize the modern equivalent of this old frontier town's bootstraps and pull Detroit up to new levels of achievement. ■

Detroit is frequently viewed as a city where hope has been lost, government is totally dysfunctional, and the city is beyond repair. To far too many people around the world, that is their image of the Motor City. *Detroit Resurgent*, while not ignoring the problems facing Detroit, explores the city in a different way. Through photographic portraits, interviews, essays, and poetry it demonstrates the vitality and humanity of its people, providing a powerful counternarrative to the vision of Detroit as a Rust Belt wasteland. *Detroit Resurgent* explores the city through the voices of those working in a multitude of ways to reshape it into a twenty-first-century urban space. To give voice to people with hopes for a brighter future, and aspirations to create a new city out of the old, required recording their own words and the skills of a portrait photographer, grounded in humanism, whose approach is based upon the traditions of social documentary photography.

Gary Morgan, the director of the MSU Museum from 2009 to 2013—who grew up in Australia and worked in museums in Africa and the Middle East before coming to MSU—embraced photography as a means of telling the stories of diverse cultures. Howard Bossen, the museum's adjunct curator of photography, worked with Morgan to bring exhibitions and programs to the museum exploring the intersection of photography and culture.

Bossen met Gilles Perrin and Nicole Ewenczyk a number of years earlier. He thought Perrin's portraits of workers from around the world fit well with the goals of a museum that had made worker culture—largely through the vision of John P. Beck, a curatorial colleague and fellow faculty member—central to its mission.

Because of the museum's strong commitment to worker culture, *An Extraordinary Document of Our World*, a retrospective exhibition of Perrin's worker portraits, was planned for the fall of 2013. While Perrin and Ewenczyk had traveled much of the world, they had not had an opportunity to make portraits in the United States. That changed in early 2012 when Perrin and Ewenczyk were invited to spend two months in residency at the prestigious Josef and Anni Albers Foundation in Connecticut.* This made it possible for the museum to bring them to Michigan to make a few portraits to include in *An Extraordinary Document of Our World*. As discussions took place regarding how the museum could help find subjects for Perrin and Ewenczyk, the idea for *Detroit Resurgent* began to form. Perrin was commissioned to make portraits, and Ewenczyk was asked to record short interviews with the subjects.

While some of the people highlighted in the book are well known, most are not. This was intentional because in the end, it will be the people of the city, especially those at the grassroots level committed to its revitalization, that drive the changes that will reshape it. The people featured in *Detroit Resurgent* are emblematic of the many, many thousands of people in Detroit who are committed to their city. The book could easily have featured other people, but time, chance and circumstance led us to the sixty-four people featured in this

book. Extraordinary content from two of the portrait subjects has added greatly to the book. Larry Gabriel wrote a heartfelt essay that weaves together his personal narrative with the history of the Motor City from the perspective of one who has lived almost his entire life there. jessica Care moore allowed us to use an excerpt of "A Poem Saved My Life," a long performance poem written in 2012. The story of how *Detroit Resurgent* was made unfolds in Beck's essay "Detroit Resurgent," and in Bossen's essay "Journey to Detroit: A Global Photographic Odyssey."

Ewenczyk conducted all the interviews except for the one with Monique Watson, who could not be interviewed at the time her portrait was made in June 2012. Beck interviewed her in May 2013. We separately selected portions of each interview and then compared our individual selections. The interview excerpts were sorted by theme and woven into a larger narrative about the resurgence of Detroit. Interviews were edited for clarity. The names and titles of the subjects were correct at the time the portraits and interviews were made. While changes may have occurred in the lives of some subjects, the information provided in the spring of 2012 is used in the book. This decision reflects the idea that a photograph and an audio recording capture a brief moment in time and freeze it forever.

Books and exhibitions don't just happen, and they are never truly the product of one person. There are many people who have played a role in the creation of *Detroit Resurgent*, especially the subjects who welcomed Perrin and Ewenczyk into their lives for a brief moment. Sarah Alvarez, Jena Baker-Calloway, Bob Baldori, Garry Bernath, Elise Bryant, Elizabeth Chilton, L. A. Dickerson, Larry Gabriel, John Gallagher, Elena Herrada, Hank Hubbard, Burton Leland, Deborah Groban Olson, Mark Strolle, Christopher Webb, and Pam Weinstein

---

*The Albers, "pioneers of twentieth-century modernism," created the foundation, in part, as a place where artists could "work in a concentrated way on one's art in idyllic conditions at a remove from the art world."

helped us create our lists, and introduced Perrin and Ewenczyk to folks in Detroit who became subjects. Others provided support, both financial and emotional, or lent various types of expertise.

For Perrin to work efficiently required finding a darkroom equipped with tanks for processing the sheet film he uses. In an age where pixels have largely replaced film, this task proved surprisingly difficult, as most colleges and working photographers now process their images on computers instead of in darkrooms. Rose DeSloover, Dean of Fine Arts (now retired), and Erin McDonald from Marygrove College made their school's darkroom available to Perrin, where he processed his film and made his contact sheets each evening after a long day making portraits. Photographer Kim Kauffman loaned the steel tanks and film holders Perrin needed to process his film. Vincent Risacher scanned Perrin's negatives.

To several people we extend an extra measure of gratitude and thanks. President Lou Anna K. Simon graciously wrote the foreword to *Detroit Resurgent*, and her office provided support to the project, as did Hiram Fitzgerald, the Associate Provost for University Outreach and Engagement, and his office. Mr. and Mrs. Richard A. Brodie's generous support made it possible to move forward in ways we could not have imagined when the project started. Gary Morgan provided leadership, guidance, and constant encouragement to all involved with the project.

Eric Freedman and Kim Kauffman read the essay "Journey to Detroit: A Global Photographic Odyssey," providing invaluable counsel and editorial advice, as did Dugald McMillan who reviewed the entire manuscript.

Kathy Bossen and Ann Austin-Beck have been there throughout the entire process proofreading and sharing the ups and downs, joys and frustrations of creating this book

Colleagues Lora Helou, Denice Blair, Mary Worrall, Stephanie Palagyi, Juan Alvarez, Sunny Wang, Annie James, Sue Schmidtman, and Jilda Keck, at the MSU Museum provided project support.

Marisa Hamel and Kathleen McLain, our student research assistants whose help was made possible through the Undergraduate Research and Creative Arts Funds from the Office of the Provost and the MSU Museum, transcribed and coded for subcategories almost thirty hours of interviews that ended up as more than 500 pages of transcripts, and worked tirelessly on many other assignments. *Detroit Resurgent* would never have been possible without their hard work. To them, a special thank-you; we know their future is bright.

To all of these folks we are indebted, and to many more that we aren't able to name, we also say thank you. We save our last and perhaps greatest Thank You to the subjects of these portraits and interviews, who helped all of us connected to the project to see the unfolding wonders of a Detroit resurgent. ■

# a poem saved my life:
## an homage to detroit

JESSICA CARE MOORE

They named me something French.
But I preferred Cadillac.
They didn't invite me to the naming ceremony
But they must have felt my steel body
longing for rubber against the ground.

I was re-born
The Motor City.
A beautiful city across the street from another country,
inside a thumb surrounded by
Great Lakes.

I was the music made from engines. Loud, tough.
Sometimes just a hum and hand clap sound.
When I grew up they called me

Motown.

He

is smoking a Kool/Mild
That was his way of slowing down

His 30-year-old nicotine habit. For me. His second to
Youngest daughter who thought he was God
And fought for position to ride in the front seat

Of his white, green,
or gold Cadillacs.
Detroit daddy cool. Outside on any summer
Night on the Westside with the radio loud
Enough for the entire block to listen.

& they did.

Mr. Copeland would carry his front porch
Chair to our driveway and they would
Simply listen to tigers baseball on the radio.

That sound, a whisper
surrounded by a fence and a prayer.

More than fathers who are worshipped
By their daughters.
Men who came home to families at night

After working 12 hour days.
Blue collar Michigan men with jazz in their
Feet and Motown 8 tracks in their rides.

Men who smelled like men and understood that
Women were delicate & brilliant
Revolutionary men who surrounded themselves
With artists and thinking people and protesting was cool.

Plum St.
Business men. George Agee. Who ran The Mystique
Room and would birth an artist who would paint the city
The way the bright way he saw it.
John Sinclair who incited riots and moved
People with poems and personal transformation.
Sometimes without a flash.
Leni. Armed. Documented the action/movement. Raw.
MC 5. rolling stones. Pappa was.

     ■  ■  ■

Men on the line of assembly. Coleman A. Young men.
Who fought to desegregate fire and police departments.
& curses were like poetry when they decided to fire
back. Politics were the people's conscience

Marvin Gaye was our battle crier.

We know work. It is our witchcraft/our bloodline gift.
Our deep south anxiety attack. Our dreams of something
Greater for the ones that come later.

     ■  ■  ■

Dobb Hats gangstas against a snake-skin shoe.

Sunday Best men.
Saturday all night. Men.
Straight back men with pride. Organizing frontline
Union workers. Men.
Who made women touch their hats and adjust their slips
as they passed.
Construction worker with steel toed boots
and a brown bag lunch. Men.

We miss
the corner we used to safely stand on.
To hear the good gossip.

He.
paints in the center of this universe.
Head leaning to the right. Shades off.
Working against the same sun.
This is what sons do. Standing literally in his father's shoes.
There are no such things as accidents.

■   ■   ■

What do these artists say in a time of war?
Nobody heard a bomb drop in Detroit?
Who's pushing the buttons and spiking the tea?
We need more Word Play and cane sugar
Spray paint and pulled canvas to make the
Skyline grow.

What do we have left if not poems?
How many times would I have died
If I couldn't articulate my own existence.
What else better to feed our babies than paint?
Coughing out the muffler smoke and
Running for safety from the aged meat in
What's left of the city grocery store.
We have a man-made farm all over this city.
No, this is not Charles Dickens. This is
Octavia Butler and we are the chosen.
Eastern Market shoppers and young
urban gardeners. For Hire.

Because the art is never in the artist. It is in the
People that inspire the artist's work.
So don't write Eulogies for Detroit.

No uninspired folk song of gloom.
Some of us are coming home.
To show the world
how we make
the planet move. ■

# detroit resurgent

JOHN P. BECK

For a space of three weeks in the spring of 2012, French photographer Gilles Perrin and his wife Nicole Ewenczyk brought cameras, an audio recorder, and a fresh set of eyes and ears to the city of Detroit and southeastern Michigan. Having made his reputation as the creator of stunning portraits of people in myriad work roles across the globe, Perrin was asked by the Michigan State University Museum to focus his attention on individuals in the city and region whose work was affecting and effecting the resurgence of Detroit. This focus was regarded as a consistent extension of Perrin's life work, and as a project niche that would allow the Museum to explore the past, present, and future of the city through its people. What does Detroit resurgence mean? According to the *Merriam-Webster* online dictionary, resurgence is defined as "rising again into life, activity, or prominence." The Princeton University online dictionary adds the word "revival" to the discussion as well. The portraits that Gilles Perrin took during his stay in Detroit are some of the faces of Detroit's rise, revival, and resurgence.

The Detroit Resurgent project was not meant to be exhaustive or even fully representative in its attempt to capture some of the faces and the words of people who may be described as playing a part in the revival of Detroit. A few decisions choosing the initial Detroit-based people to be contacted to serve as "guides" led to

1

some subjects, and these contacts led to others. Serendipity and total happenstance (chance meetings in coffee shops, for example) led to some of those who additionally were asked to be photographed. The group of sixty-two portraits taken together reflects and presents a number of themes, some of which were chosen by design, and others that emerged through the process of identifying and photographing the subjects. It was the intention to have Gilles and Nicole meet people connected to the arts, economic development, the auto industry, urban agriculture, and social entrepreneurship since the role of each of these has been linked in books and articles to the broader resurgence of Detroit. Many of the contacts in one thematic domain bled into one or more of the other thematic domains, either those planned for inclusion or those that emerged over the shooting period. Many of the portrait subjects were extremely complex people, personally reflective of multiple ways to understand the project themes and the broader resurgence of Detroit. In some ways the small-town nature of Detroit (as attested to by developer Joel Landy who stated that he "[knew] everyone" in the shrinking city of under one million people) became evident as people who were contacted independently cited one another as possible next contacts, or mentioned unexplored third parties known to both. The result of this portrait and interview project is a very diverse photographic and narrative composite of the experiences and work, the hopes and fears of a slice of southeastern Michigan people who range from the very old to the young, who represent all faiths and races, and who include recent arrivals to the city and some of its lifelong residents. The interviews conducted by Nicole Ewenczyk as her husband was preparing to photograph the portrait subjects were not meant to be long, meticulous oral histories.[1] Though not as detailed as more formal oral

histories, the interviews were rich and have yielded a wealth of thoughts and words that give even greater life to these vibrant photographs.

The word used most consistently in discussions of the city of Detroit and other older Rust Belt cities is not resurgence; instead the word is decline. Decline across the larger region of the Great Lakes states has been associated with the downsizing or disappearance of key industries—such as rubber, steel, auto, and paper, among others—that have given the region its economic definition. The story of Detroit has been coupled most dramatically in its ups and downs with the state of the American auto industry. Histories of both the industry and Detroit link the city's fate with the successful invention and launch of the automobile as one of the essentially iconic American business ventures, their dual heyday in the period between World War II and the aftermath of the oil shocks of the 1970s, and Detroit's current existence in a somewhat postindustrial era with a downsized, globalized, and dominantly non-Detroit-centric auto industry. This last shift and its consequences—loss of population, jobs, and wealth—has left the city suffering as a shadow, a hollow shell of its former self. The fortunes of the auto industry were the fortunes of Detroit, making it in the global mind "The Motor City." This was true whether you were one of its financial moguls or design wizards, a member of its unionized workforce or the neighbors living next to the plants, its myriad suppliers or its grateful nonprofit beneficiaries, or any of the range of political actors who were its allies or detractors at all levels of government. The fact that the collapse and bailout of the domestic auto industry has gone hand in hand with the collapse and financial disaster of the Motor City should not be a surprise. A revival of the city and region to parallel the recent revival of the post-bailout U.S. auto giants is still pending and elusive.[2]

The decline of Detroit has been recounted in a great number of social-science studies, journalistic features, and first-person narratives.[3] The decline has been captured most dramatically in a handful of photographic testaments to the city's descent from its pinnacle of glory, as reflected in the decay of stately public and private buildings, now unused and crumbling.[4] Many of the photos of Detroit in these books or exhibits show empty, broken buildings decaying into a post-urban art form that has been dubbed "ruin porn."[5] The images of ruin caught on film have a beauty, an allure that comes with and from their very sense of disarray and near-chaos, from these frozen-frame views of buildings and landscapes recently full of people and now devoid of them. The image that can be gleaned from many of these photos is that of a post-apocalyptic cityscape emptied of its citizens, perhaps the result of some deadly pandemic, or the planned result of a neutron bomb that killed the populace but left buildings intact and standing. The ultimate expression of this "art form" is reflected in the call by photographer and documentarian Camilo Jose Vergara to leave a twelve-square-block section of Detroit to perfect its state of wreckage and ruin for future generations, a modern acropolis or Roman coliseum to be understood in centuries to come as a relic of a distant urban architectural past, rather than as the heart of a present-day, living city.[6]

The subjects of these portraits do at times talk about Detroit with a sense of loss, and a recognition of some of its better-known negative trends and attributes. Community activist Thomas Wilson says that as a realist, he knows that "Detroit's not a well city." Developer George Stewart remembers a more vibrant Detroit social scene resident in its great ballrooms, clubs, and music venues, now gone but not totally forgotten. More than one of the subjects mentioned the recording giant Motown, which took its name, its sound, and many of its acts from the factory floors, streets, and neighborhoods of Detroit only to leave them behind for the sunnier climes of Los Angeles. DeAndre Windom, the mayor of Highland Park, has a desire to see a vanished feeling of community reestablished and renewed: "We want to get back to being that model city that we were in the past. . . . I know it used to be a community. I know the people next door used to care about everybody on the block. So we got away from that. And that's what happened to our community." Daniel Scarsella of the Motor City Brewing Works sees it almost as a form of social amnesia: "People forgot about what it takes to be involved with the community, to make a community successful." Grace Lee Boggs, a radical visionary who has been part of social movements in Detroit for over half a century, sees the potential for resurgence as a choice. "You know the Chinese characters for crisis, it's two characters—one is danger and the other is opportunity. You have to seize the opportunity."

Some of those who rooted their interviews with remarks on the city's history, like furniture designer Alan Kaniarz, mentioned Detroit as having been the "Paris of the Midwest," with a cultural and art scene once worthy of such comparison; yet he too balanced his hopes for the future against a pessimism lodged in his entire life lived in Detroit: "One of the things with Detroit is just when you think it can't get any worse, it does." In many cases, the loss is much more tangible—visible or invisible in real estate, the thousands of buildings now derelict or simply gone, the landscape returning to a more natural state complete with wild pheasants and coyotes. Larry Gabriel in his interview alluded to the replacement of local businesses with chains and box stores that owe no allegiance to the city or its residents, and have a cold calculus of success and continued existence based in profits destined to flow to far-off

headquarters. Any new revival or resurgence must be recognized as part of a longer historical ebb and flow; in the words of bookseller Janet Webster Jones, "So because we are having a revival now doesn't mean we haven't had other revivals. There is always great hope. Without hope, there's no life. And as you see, there's a lot of life in Detroit." It is the certainty of change, the need for change, the possibilities of change, and the pace of change that come up most in the words of these portrait subjects. Grace Lee Boggs captures the cusp of change at this time in Detroit's history. "I think the sense you have in Detroit is that it's the end of something and the beginning of something. It's very rare that someone lives at that time, at that place, where something's disappearing, vanishing into the past, and something new is emerging. That's very inspiring, to be at that particular time."

The subjects of these portraits are taking personal responsibility to ensure a rise in life, activity, and prominence—a revival—for Detroit. They are "not counting their city out," as one subject stated. This is not to say, however, that all of these people believe that the past glory years can be perfectly reclaimed and rekindled. Instead, they see a changed Detroit, a city whose rise again into any new life, activity, or prominence will not be the result of a simple wave of a magic wand, nor a march along a unitary path that is already preordained or the unified vision and plan for all. They are staking a personal claim on their future and the future of their city. In the words of Cassandra Thomas of Sweet Potato Sensations, "We want to be the change we want to see. We want to do good things and be positive and keep things moving forward. If that's what you want to see, you have to do that yourself and others will follow." The revival at its heart takes Detroit to a vast array of places, both old and new, all wrought with human hands. As urban farmer Noah Link explained, "It's a really exciting city to live in because so many people are just doing everything they can on their own, coming up with new ideas, creating new projects. There's room to do whatever you want to do in a lot of ways." The challenge of building the future extends to those who have left Detroit and are coming back, as recounted by hair salon owner Nefertiti Harris: "We're seeing a lot of people who are actually from Detroit, have left Detroit, and are coming back. That's great and I love it. And they're bringing fresh energy because they've been somewhere else. They're bringing a fresh perspective on how to make things better here."

The subjects in these portraits are not naively looking forward to an easy set of victories and turnarounds; they are working hard to see change, but many are dedicated to the work even though they are not totally sure of success. Blight buster John George was speaking for himself and many others when he stated the alternative to laboring away with all eyes on the prize: "Failure is not an option." Many of these workers for Detroit's revival will not see all of their dreams, plans, and labors come to fruition in their lifetimes, but they move forward knowing that they are leaving Detroit better off than when they started. We now turn to some of the themes reflected in the work and words of these portrait subjects, their special places in a Detroit resurgent.

## PRESERVING, BUILDING, AND SERVING COMMUNITY

The vision that many of the subjects have is rebuilding Detroit into a place where people can walk the streets safely day and night, get fresh food or retail items close by in their neighborhood markets and stores, make a living, and support one another as a true community. The placement of a key business, like Avalon International Breads, can catalyze

a neighborhood, as stated by Curtis Wooten: "When they put a bakery here . . . they changed this whole block. And now, from then to now, we not only have other businesses around, we have nice lofts. I see people walking the streets three or four o'clock in the morning and everything is safe around here." Some are doing this because they have a notion of the greatness of an earlier Detroit, a city of vibrant life night and day before highways cut through the heart of many of their lives and neighborhoods, creating daily paths in and out of the city for those who worked there but would not stay. John George is engaged in the work of revival for his neighborhood and is moving that work forward building by building, person by person. George has been consciously pruning away the dead and dangerous spaces in his neighborhood, busting the blight, and replacing them with gardens, public art, and new food and retail concerns. He is tapping into the dreams of his coworkers and neighbors, to help them create spaces and businesses (like Alicia Marion's Motor City Java House) that will make the city better—actions that build a stronger commitment to their area and to each other. George Stewart remembers the glory that was Detroit's nightlife, and knows that this is one piece in the puzzle of bringing people back to the city, even if it must be reclaimed and rebuilt "one block at a time." Stable businesses lead to people being able to take advantage of the neighborhoods, both as visitors and as residents. Urban farmer Patrick Crouch recognizes the task at hand within the reputation of the city and what he has found there. "A lot of people think of Detroit as a nasty, dirty city that's unwelcoming. I don't want to give the impression that it's not without its problems—but the people in Detroit are really warm and friendly and creative, and I just appreciated the ingenuity and the fact that folks weren't waiting for the government to come up with solutions." Hair-salon owner Nefertiti

Harris thinks that government lags behind strong action by individuals: "The politics have to change. The politics have to catch up with the people because the people are leading the way." To community activist Thomas Wilson, it is all about the focused group effort that includes the individual: "All in all, we are one, all the same; there is no 'I' in 'we.' There are a lot of 'I's in 'we,' but collectively we are all one." Solutions take people's creativity and the energy to see their solutions through. Metro Detroit Convention and Visitor's Bureau president and CEO Larry Alexander believes that this will happen: "There's no quit in the Detroit makeup."

One part of preserving the community is preserving its heritage—much of it lodged within many of the classic buildings in the city that have not met the fate of the wrecking ball, arson, or simple neglect as other buildings before them. It is a puzzle to Joel Landy. "I always wondered why you see a lot of abandoned buildings. Why we didn't fix 'em and the rest of the world did." Diane Van Buren of Zachary & Associates agrees. "Too often the cheapest system is the system of just throwing everything away and building new in a very cheap way. With historical preservation, it's not the cheapest way to do it, but it's the way you get the most character. We're deeply committed to the history of Detroit. So we wanted to preserve that history of Detroit . . . tell the story. Otherwise it's gone, it's just completely lost." As the deputy director of the Arab American National Museum, Devon Akmon knows the special place that cultural institutions play in preserving heritage and building bridges. "We're bringing people together, we're convening, we're talking, we're sharing our stories, our histories, learning a little bit about each other." Bob Bury, the executive director and CEO of the Detroit Historical Society, also wants to preserve Detroit's history, but in large part because of the role that he sees it playing in the

definition of Detroit's future. "One of the things that I think we can do better is utilize Detroit's history to help inform and educate the future. . . . Detroit has its share of challenges, education and poverty, and the gap between the people who have achieved and have not achieved is big and is growing, and you know those are all issues that you can't ignore . . . but if you look at Detroit's history, there's precedent for solving all of those."

Many of these portrait subjects talk of family as one important part of community and the ties that bind. Frank Germack is a third-generation owner of his family's pistachio business, proud of the reputation and the quality that the name represents. David Bullock was "born to be a pastor" in a family of pastors. Construction work created a pathway for Kyle Smart, who wanted to "follow [his] father's footsteps" into the electrical trades, and he was able to do this through his involvement in the electrical industry and union's apprenticeship program. Having an "in" into the family business was also true for factory workers Jett Kulaga and Monique Watson. Both women joined the auto industry and followed their mothers into their workplaces at Wico Metal Products and General Motors, respectively. Ms. Watson actually works across from her mother in the same station on the Chevy Volt auto assembly line. Businessman Andy Linn sees his dedication to the future of Detroit coming out of his parents' teaching: "I think that our parents always instilled in us pride in the city and a desire to make it better and to share it with others."

**AUTO PRESENT / AUTO FUTURE**

"Detroit is the car city" according to author and *Free Press* reporter John Gallagher. "It's hard . . . to understand how dominant the car industry was. Not just economically, but culturally. If you go to the art museum, and you look at the donor wall, people that gave money—Ford, Dodge, Chrysler—it's the auto companies. They did everything in this town. And so that's why when they started to collapse in the late nineties, that's why it was so devastating here." Many of the portrait subjects recognized the past importance of the industry and the effect of its reduced role in the economy and life in the city and region. A reduced role, however, is not an empty or absent role. General Motors, Ford, and Chrysler all still have significant presence in the city—within factories, suppliers, dealerships, advertising offices, and headquarters buildings. The United Autoworkers Union, though quite smaller in membership than at its height of power in the 1970s, still sits between the river and Jefferson Avenue as an iconic house of labor.

Bob King, the current president of the United Autoworkers, knows that the city and region are changing, but that there will still be an important role for the auto industry and its workers. "I think Detroit's coming back. I think obviously the auto industry coming back is really helpful to Detroit. . . . I think Detroit will rebound; it'll be a very vibrant city in five or ten years. It's changing—less manufacturing, more different service industries—but there still will be a strong manufacturing component to the success of Detroit." The turnaround in the auto industry happened because "workers really pitched in, made a lot of sacrifices to save the companies." The key to the future is, in part, listening to the workers, who are the glue holding the auto workplaces together as managers come and go. "The workplace and the manager succeed more when the workers really have a voice." Shop-floor worker Monique Watson sees what was at stake for everyone when the industry was in crisis: "I think a lot of people don't understand the importance the auto industry has for this region. When we were going through all the bankruptcy and all

the bailout talk, I feel like people didn't see the bigger picture. It's not just all our jobs. We work in this factory, build our cars, we work hard. We're also business to so many people. If we're going strong, it brings the economy up around us. I think as long as we're thriving, it's going to build the whole region up."

Bouncing back from the massive effect of the automotive industry downturn on its role as a supplier to General Motors and Chrysler—"We almost called it quits"—Wico Metal Products is, according to CEO Richard Brodie, now "twice as big as it was before the downturn, and you can tell by the smile on my face that business is pretty good." Joseph Keys of Correct Car Care sees people still using his business to repair their older vehicles, but he sees fundamental changes in the industry as well. "The more they design and build cars, the better they get. Let's face it: they have been building cars for a hundred years. They are going to get better and better and better the more they build." Design is important to Ed Welburn of General Motors, and he knows that the car companies' parity on issues of safety and reliability leads customers to have aesthetics as one of the most important defining parts of their decision as to which automobile to purchase. "If everyone has got autonomous driving, fuel cells and all that, the good-looking car will do better than the other one." As the auto companies move out of crisis toward the future, Welburn is convinced that consumers will want the industry simply to deliver. "The customers don't want to hear about our challenges; they just want a great car."

## NEW BUSINESSES / ENDURING ECONOMIES

When it comes to issues of commerce and development in the revival of Detroit, it is certain that new enterprises will be developed alongside more traditional economic actors. It is also certain that the auto industry and others will not be engaged in business as usual if they want to survive. As Monique Watson stated about working the Chevy Volt electric-hybrid automobile assembly line in the General Motors Hamtramck plant, "We have people coming here from all over the world to see what we're doing [with the Chevy Volt]. It makes me have real pride in my job and everything we're doing here at General Motors. It's just amazing to see the expressions on their faces, how impressed they are . . . it's a good feeling." Though Kyle Smart followed his father into the electrical trades, the son is making his way in a part of the industry that is quite unlike the one that welcomed his father decades ago: "I had the opportunity to get in on the low voltage side, and I think that's just the wave of the future, getting in with all the fiber optics and telecommunications cable and all that." The emphasis within traditional businesses is on innovation—as Ed Welburn mentioned with autonomous driving and fuel cells—and skill. These two attributes are necessary elements in business old and new. Lydia Gutierrez, the president and CEO of Hacienda Mexican Foods, sees it as a business leader's responsibility to create and nurture skill where it may not have been present before: "I was asked [after an entrepreneurial workshop by one of the participants] . . . 'I have this problem: I've got these two girls and they're helping me, but they really don't have the skills that I need in order to help my business grow.' . . . And I said, 'then your job is to develop them.'" Mentoring the next generation of workers either formally, as in the case of the apprenticeship program, or more informally is one of the responsibilities that many of the portrait subjects take very seriously.

Developing new businesses may be easier in Detroit because the energy and resources required are less than in other locales. "One of my favorite things about the city is that it is

very accessible for people to do things. It's a city where there are lower barriers to entry in many ways. It costs a person less to live day-to-day, and it costs a person less to do something. So if you don't have quite as much money, you can open a store that you couldn't open, say, in Chicago or New York," according to retail business owner Andy Linn. This sentiment is echoed by Bob Bury, who sees the fit between those coming to Detroit and the environment that awaits them: "There's a very significant influx of young, educated, creative people that are interested in having an urban experience, living in an urban setting—and Detroit is very welcoming. You can be very creative, you can be inventive, you can be an artist, you can be any number of things and get an access to space or a facility and start your business relatively inexpensively compared to somewhere like New York." One of the strongest sectors of entrepreneurial development practiced by the portrait subjects is in the area of food.

### FOOD AND THE CITY

To Jess Daniel, the founder of FoodLab Detroit, food is at the heart of social justice and is a strong place to start the conversation on the revival of the community. "Food is a very tangible, beautiful, sexy way to talk about things that are difficult to talk about in other ways, . . . race, racism, . . . the way workers are treated, . . . what we're putting into our bodies and our health. All of these things we can talk about through food in a joyous way and not in a painful way." To food-truck owner Anthony Curis, the conversation about food is about the perennial problem of supply and demand. "The problem with Detroit is there's a lot of people here; there's so much demand for restaurants and good food, and there's just not enough options." Many of the portrait subjects are caught up in trying to create more options when it comes to food in Detroit, and to create greater community as a linked outcome to that process. Pam Weinstein of the Northwest Detroit Farmers' Market lays out this link between food and community. "[The market] is meeting an important need in our community for access to fresh, healthy food, and people need a place to be with each other. So you'll see lots of shoppers already have a relationship with the vendors, they're on a first-name basis, people are meeting their neighbors here; people are showing each other pictures of their grandchildren. Detroit is a food desert, but it's also a place desert. There aren't places for people to be with each other in a social way. So in a very small, micro way we meet that social need." The options for greater access to, and a greater variety of, food, along with the parallel commitment to building and sustaining community, are being met by a number of the portrait subjects through the creation of new commercial food-production ventures and retail outlets (like Avalon International Breads), farmers' markets, and through the use of vacant land and empty buildings for urban agriculture.

To Burton Leland, a Wayne County commissioner, the problem is evident if one looks at Detroit from above. "If you look at Detroit from up in the sky from a satellite, there are parts of Detroit that look like a farm, it looks rural, so overgrown. A third of the city is occupied with people, and we have tremendous abandonment, tremendous." Others see opportunity in the open land. Urban farmer Noah Link saw the possibilities. "I had worked on a number of organic farms, and so had my partner Alex. We decided it would be a good idea to jump into this movement in Detroit and build the best farm we could with this vacant land that is so readily available." To Cornell Kofi Royal, the vision of urban agriculture involves more than simply raising vegetables

in the city. "Personally I think for me, it's to try to create a model of how cities ought to be, how urban places ought to be. To me, the ideal urban community would have a lot of vest-pocket farms, gardens . . . where vegetables and produce were being grown not so much for a mass-market thing, but just to cool people out, bring about some sense of neighborhood, as a meeting place, as well as offsetting some of the cost of food. When you look at the fact that most of the food has to travel great distances, and a lot of the time it's been stored for a long time, so it's not fresh. So essentially I could see Detroit as having these little vest-pocket farms or gardens all over; it would make an interesting contrast to what cities have traditionally become." Patrick Crouch sees the link is not only to community, but to notions of self-determination. "I'm really interested in how can communities come up with solutions, how can we have more community control over access to resources; urban agriculture is just one example of that."

### THE SPARK AND ENERGY OF THE ARTS

Lydia Gutierrez, the president and CEO of Hacienda Mexican Foods, stated the linkage between two of the broad themes in the resurgence of Detroit. "For Hispanics, it's all about art and food. There's a marriage between art and food! It crosses every nationality, because if you have art and you have food, you don't need to have language. You could be from a whole other part of the world and we could communicate by just art and food." Like food, the arts serve a number of ends in the revival of the city of Detroit. The link between creativity and resurgence for the city was made by a number of the portrait subjects. Rick Sperling of the Mosaic Youth Theater of Detroit stated an idea closely linked to the importance of a "creative class" in the vibrancy of a city or of an economy:

"There's a lot of talk right now in the education world about the twenty-first-century skills that our kids need to learn. They're innovation skills; there's the four C's: creativity, communication, collaboration, and critical thinking. If you take those four things together, nothing does all four of them better than the arts."

Lower costs for housing and property spurred an influx of young artists into the city. As stated simply by mime and actor Michael Lee, "That usually happens first: the artists move in." There is already a very diverse arts community based in not only theater and performance, but in music (including techno, hip-hop and jazz), in the visual arts (including gallery and museum spaces like the N'Namdi Contemporary Art Gallery and the spectacular Detroit Institute of Arts, with its heritage of auto-magnate support for the arts, most notably the Diego Rivera Industrial Murals), and writing and publishing. Gilda Snowden, an artist and teacher, sees a tradition of artists working together in organizations and groups. She thinks the young are part of a longer tradition of "everybody [doing] their job and [getting] their work out." The young are "doing pop-up galleries, and they're starting arts organizations where they find a building, they get together, and then they craft a space out of it." Sperling believes that the environment for the arts is really replete with opportunity and with lower barriers to actually getting something done, as Andy Linn had seen with business development. "I think a lot of people say this about Detroit—you can accomplish more, you can have a greater impact in Detroit than in a lot of other places. In New York or Chicago or L.A. it takes years to just make a dent to be there. In Detroit the opportunities are so strong." A program of state grants to commercial movie producers made Detroit the location for a number of Hollywood movies, a program that was substantially reduced by state-government budget cuts. Often

cuts to arts funding have been an easy decision for leaders in dire times, but jazz singer Shahida Nurullah sees the arts not as a taker, but as an essential giver to the city and its people, "Culture and music are necessary for our souls and our existence." Poet and multimedia artist jessica Care moore echoes this sentiment and sees herself as a personal example. "I think that we can make better people, so I do that work because it made a difference in me growing up in Detroit, that poems helped save my life."

### SOCIAL ENTREPRENEURSHIP / SOCIAL JUSTICE

Detroit has a history of moments of social upheaval, like the race riots of the 1940s and 1960s, and a parallel timeline of organization building and social movements designed to bring positive change to the city.[7] Among the sixty-four portrait subjects are a number of well-known individuals, like Grace Lee Boggs and Bob King, who have dedicated their lives to personal and organizational efforts to "bring to birth a new world in the ashes of the old," as sung in the labor anthem "Solidarity Forever."[8] There are many more among the group whose work may not be as well-known, but they, as well, are continuing forward on a path to greater social justice. Assistant U.S. Attorney Judith Levy sees the link between civil rights and a revival for Detroit and southeastern Michigan: "The sooner we have people's civil rights being honored and respected, we will be a community where people want to live and educate their children." It is the young who dominate the vision of community activist Ron Scott of the Detroit Coalition against Police Brutality: "I have a real feeling about wanting to save this generation of young people. . . . I find this generation, specifically those born in the '90s and the 2000s, are probably some of the most creative, some of the most astounding

human beings on the planet, because they have found a way to survive and live and maintain their humanity when the whole world is going crazy, when they don't have the jobs that they need, when they're paying too much if they go to school, when they've had to challenge and change and move beyond race and gender and all the other things to really try to become whole human beings."

To many of these portrait subjects, the environment must be respected and is a necessary aspect of any resurgence for Detroit. Guy Williams of Detroiters Working for Environmental Justice got involved in the late 1980s and found that the environment that we all share is not shared equally: "I was new to working on environmental issues, and I learned about the disparity of suffering of people of color and poor people around pollution. It came to be my life's work . . . to create change— positive change—and relieve the suffering." Among many of the entrepreneurs already mentioned, the triple bottom line including the environment is essential, a given as they take their businesses forward. As explained by Gary Wozniak, "Triple bottom-lined is social justice, so taking care of people in the community . . . ; environmental stewardship, so doing something different with the land so we can leave it to our kids and our grandkids . . . in better shape than we found it; and then the third one is the one that most nonprofits don't do well, and that's fiscal sustainability." Ann Perrault of Avalon International Breads spoke of her business working to meet the triple bottom line, but in her own words: "focusing on business, but also focusing on the community, and feeding yourself and eating local, and being small within big."[9]

Some business leaders, like Hank Hubbard of the Communicating Arts Credit Union, began to think of fiscal responsibility too, in new ways. "Our mind and our mission shifted.

We said, you people of means, you don't really need us, it's these people at the lower end of the spectrum that need us, and we changed our focus. Everything that we do . . . goes through a low-income filter, and if it helps those people then we try it." According to Grace Lee Boggs, who is an icon and inspiration to many generations of social-change activists both within and beyond Detroit, it is all about visionary organizing. "We encourage people to embrace the conviction that they can create the world anew, that this is actually what the soul is: the soul is not a thing, it's a capacity." Working on social change and a positive revival for Detroit are a long-haul mission and prospect. As Mike Prochaska of Detroit Geothermal explained of his work on energy alternatives, "It's a slow, hard process. I had dark hair when I started and now it's very gray."

## RECOVERING CITY / RECOVERING INDIVIDUALS

The mayor of Highland Park captured what it will take to create a Detroit resurgent, to bring the area back to life, activity, and prominence: "If we don't take a stand, who will? Nobody is going to come from the outside and come in and clean it up. It has to start from right within. Once we start doing it, then people from the outside will start coming back." Some of these subjects are using the revival of Detroit as their own canvas of personal change and redemption. Either because the "thrill" of the job was gone or it was their "time to give back," portrait subjects like Cornell Kofi Royal and Gary Wozniak have come to personal crossroads where their new lives in urban farming and social entrepreneurship, respectively, are radical departures from their previous lives as successful account executives or business managers. Throughout the interviews, a great number of the portrait subjects, such as Ghada Aziz, cited their work as mission-driven:

"My mission is to help my community." Activist Yusef Bunchy Shakur linked the mutual outcome for himself and Detroit in his efforts. "Detroit is part of my story of redemption. To complete my story of redemption is to see Detroit's redemption. She never forsake me; I can't see myself forsaking her." All of these missions do not come at the expense of joy or personal advancement; these activists and entrepreneurs see that you can do well by doing good (having that balanced bottom line is a good thing). Many of the portrait subjects embody a wider definition of work as captured in the refrain of a song written by Charlie King—"my work is more than my job and my life is more than my work."[10]

At the center of the revival of Detroit are the people. People are both a means to the end and the end itself. "What we need in Detroit more than anything is people," according to James Cadariu. "People on the street, because people see other people and they want to get involved, and that's really activating the street front. . . . Down here, you're rubbing up against people that aren't like you . . . that may be somebody that you didn't think you'd ever talk to and you're learning from [them]—people sharpen people and that's a good thing for everyone." As Janet Webster Jones stated about Detroit, "What it will be, how it will look is all going to depend on the people, because it's always the people and not the place."

## CONCLUSION

The resurgence of Detroit will not be accomplished with smoke and mirrors as in a magic act; instead it is a human act, a set of human acts by the subjects of these portraits and the countless other Detroit residents and activists who also could have been photographed and interviewed. Yul Allen

sees his commitment to the city and its youth metaphorically linked to first responders meeting both duty and risk. "On 9/11, people were running out of the World Trade Centers, and the firemen and the policemen ran into the buildings to save others. So many people are running out of the city of Detroit, and I want to be one of those individuals that run into the city of Detroit to try and save or inspire as many kids as possible, to get them into careers that our country and the world can legitimately use." For Alicia Marion, her coffee shop is her right place to be: "I am blessed, and I know I am supposed to be here. This is my calling." For Yul Allen, the calling is youth and education. For Pam Weinstein, it is access to food and community. For Bob Bury, it is using the city's history to help its residents make choices about the future. For Damany Head, it is all about greening the city through recycling. For Ghada Aziz, it is helping the women of her community gain better health care. For others, it is seeking and gaining social justice, creating urban food production or small businesses, bringing manufacturing up as a vibrant sector of employment, reusing the city's architectural jewels, allowing the arts to illuminate the world—or all the other committed and complex ways in which these sixty-four individuals are tied to the resurgence of Detroit. ■

## NOTES

1. These sixty-four interviews were edited and form the text that accompanies the portraits in this volume. All three essays draw on these interviews, sometimes utilizing quotes that come from the raw interviews rather than the edited versions.

2. For a recent history of the city of Detroit, see Scott Martelle, *Detroit: A Biography* (Chicago: Chicago Review Press, 2012). The literature on the history of the auto industry is voluminous. For a good single-volume history exploring the industry's rise through the story of Henry Ford and the Ford Motor Company, see Douglas Brinkley, *Wheels for the World: Henry Ford, His Company, and a Century of Progress* (New York: Penguin Books, 2004). An exciting recounting of the bailout and a 2012 Michigan Notable Book Award winner, Bill Vlasic, *Once Upon a Car: The Fall and Resurrection of America's Big Three Automakers—GM, Ford, and Chrysler* (New York: HarperCollins, 2011).

3. Mark Binelli, *Detroit City Is the Place to Be: The Afterlife of an American Metropolis* (New York: Metropolitan Books, 2012); Paul Clemens, *Made in Detroit* (New York: Doubleday, 2005); Paul Clemens, *Punching Out: One Year in a Closing Auto Plant* (New York: Doubleday, 2011); Joe T. Darden and Richard W. Thomas, *Detroit: Race Riots, Racial Conflicts, and Efforts to Bridge the Racial Divide* (East Lansing: Michigan State University Press, 2013); John Gallagher, *Reimagining Detroit: Opportunities for Redefining an American City* (Detroit: Wayne State University Press, 2010); John Gallagher, *Revolution Detroit: Strategies for Urban Reinvention* (Detroit: Wayne State University Press, 2013); Charlie LeDuff, *Detroit: An American Autopsy* (New York: Penguin Press, 2013); Edward McClelland, *Nothin' But Blue Skies: The Heyday, Hard Times, and Hopes of America's Industrial Heartland* (New York: Bloomsbury Press, 2013); and June Manning Thomas, *Redevelopment and Race: Planning a Finer City in Postwar Detroit* (Detroit: Wayne State University Press, 2013), among others.

4. These photographic works include Dan Austin, *Lost Detroit: Stories behind the Motor City's Majestic Ruins* (Charleston, SC: The History Press, 2010); Yves Marchand and Romain Meffre, *The Ruins of Detroit* (Göttingen, Germany: Steidl, 2011); and Andrew Moore, *Detroit Disassembled* (Bologna, Italy: Damiani, 2010), among others.

5. See Richey Piiparinen, "Ruin Porn: As Dirty as You Need It to Be," *Huffington Post*, 22 August 2012; and John Patrick Leary, "Detroitism," *Guernica*, 15 January 2011.

6. James Bennet, "A Tribute to Ruin Irks Detroit," *New York Times*, 10 December 1995.

7. Sidney Fine, *Violence in the Model City: The Cavanagh Administration, Race Relations, and the Detroit Riot of 1967* (East Lansing: Michigan State University Press, 2007); Nelson Lichtenstein, *The Most Dangerous Man in Detroit: Walter Reuther and the Fate of American Labor* (New York: Basic Books, 1995); Thomas J. Sugrue, *The Origins of the Urban Crisis: Race and Inequality in Postwar Detroit* (Princeton, NJ: Princeton University Press, 2005); Marvin Surkin and Daniel Georgakas, *Detroit: I Do Mind Dying: A Study in Urban Revolution* (Chicago: Haymarket Books, 2012); and Heather Ann Thompson, *Whose Detroit?: Politics, Labor, and Race in a Modern American City* (Ithaca, NY: Cornell University Press, 2004), among others.

8. Ralph Chaplin, "Solidarity Forever," 1915. See *Little Red Songbook* (Spokane, WA, 1915). The song has become a staple in the American labor songbook and also has been adopted by other unions and labor movements across the globe. Song lyrics are available at www.unionsong.com/u025.html.

9. The term was first used by British writer John Elkington in the mid-1990s and has been the basis of a number of books reflecting on business and sustainability. John Elkington, *Cannibals with Forks: The Triple Bottom Line of 21st Century Business* (Mankato, MN: Capstone Publishing, 1999).

10. Charlie King, "Our Life Is More Than Our Work," *Vaguely Reminiscent/Somebody's Story*, www.charlieking.org.

Gilles said, "Look, we are two oxen harnessed together, day after day we must pull the plow to sow. One day the seeds will grow. You'll see. I always have that image in my mind."

—*Nicole Ewenczyk*

# journey to detroit: a global photographic odyssey

HOWARD BOSSEN

*Detroit Resurgent* is the latest chapter for Parisians Gilles Perrin and Nicole Ewenczyk in their nearly twenty-five-year-long global photographic odyssey to document the people and cultures of the world. Their odyssey and *Detroit Resurgent* both started by chance. First came a chance meeting of Perrin and Ewenczyk in 1988 in France at Rencontres d'Arles, an international photography festival.[1] Then came a chance meeting with me in 2008 at FotoFest, an international photography review in Houston, Texas, attended by several hundred photographers and reviewers from around the world.[2] Serendipity put Perrin on my "dance card" as one of about sixty photographers whose work I was reviewing.

In Arles—a magical place during festival time—photography takes over the city. Exhibitions, lectures, and parties are everywhere, in churches and galleries, in museums and converted old industrial spaces. It is a place, for a few months each year, where photography and photographers demonstrate the power of the medium to communicate simple truths as well as complex realities, where straightforward depictions vie for attention with introverted conceptual constructions.

Ewenczyk had gone to the Rencontres d'Arles because she thought it would be fun to spend a few days in the lovely old Roman city of Arles, also famous as the place where Vincent

Van Gogh made paintings in 1888 and 1889, including *Vincent's Bedroom in Arles* and *Self-Portrait with Pipe and Straw Hat*. Here she immersed herself in photographic exhibitions and the excitement of a community of people who appreciated the power of photography to document the world physically, as well as to explore it through metaphor, allegory, and spirituality.

Perrin went to Arles to appreciate the work of other photographers and to join in the community of photographers. An invitation to Ewenczyk, by a photographer-acquaintance, brought her to a party to which Perrin had also been invited. This serendipitous meeting one night profoundly changed both of their lives. It started a collaboration that has produced a body of photographs spanning a large portion of the globe: photographs of indigenous cultures and ceremonies, industry, and agriculture, and—most importantly—portraits of the thousands of people they've encountered in their travels.

Chance also brought them to my table at FotoFest to look at a portfolio of twenty photographs by Perrin. It was immediately clear that I was looking at an exceptionally powerful set of portraits that were straightforward and simply composed, but also emotionally and psychologically complex. These were a tiny sample of images he'd made in Africa, Asia, Europe, and South America. They made me want to know more, a lot more, about the images and this couple sitting across the review table. How did they work? Why did Perrin feel compelled to start this odyssey? Was I looking at a thin slice of an encyclopedic study of humanity from the last portion of the twentieth century and the beginning of the twenty-first?

Their odyssey began in China in 1989. The country was in a period of rapid transition as the China of Mao Tse-tung and hardline communism was giving way to a more consumer-oriented and liberalized society. It

was a perfect place and time for Perrin to begin his study of people and culture. This field trip was only one of two without Ewenczyk.[3] They began traveling together in 1991 with the first of three field trips to Egypt. At the beginning, she was his assistant, but over time became his collaborator, his partner, a key to the success of his documentary and artistic quest.

Make no mistake: The portraits are Perrin's but the projects were made possible through the work of Ewenczyk, who knew from the beginning that photography would define their lives together. As she wrote, "When we decided to live and work together, Gilles said to me, 'I must tell you something. There will always be something between us—photography is my mistress.' I answered, 'I could manage.' For years I hid behind him and he always wanted me to be by his side, not behind. Now I am." Working together not only makes the work less arduous but also enriches them emotionally. Ewenczyk describes her feelings about their collaborative process:

> During the reportage while Gilles rinsed the film in the bucket that contained a solution of water and sodium sulfite, permanently fixing the negative image, I have always been the one who gave the positive print to the people he photographed. I loved that moment. I received so much from each one, everywhere. That was my part, my way to exchange with people. I need that exchange. I need to observe people, to learn from them by approaching their way of life, their habits. I feed myself this way.

Projects begin when Perrin selects a destination to document people before their way of life is drastically altered or even disappears. He frequently selects a location where the pressures of social, political, economic, technological, and/or environmental

change brought about by globalization are profoundly reshaping that place. His earliest work in China in the late 1980s, his studies of agricultural workers in Africa and Asia beginning in the 1990s, and those in Latin America in the early 2000s are obvious examples of people living in societies undergoing profound transformation. Similarly, many of his Detroit portraits, especially those of grassroots activists, imaginative entrepreneurs, and artists, reveal the powerful changes in that city. A key difference is that in many locations Perrin has photographed, the subjects primarily represent the end of an old order, while in Detroit his work was focused on those bringing forth a new vision of what may become possible in an enlightened twenty-first-century Rust Belt urban space.

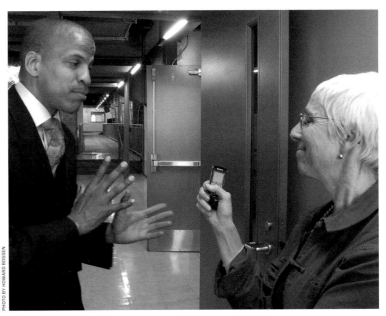

PHOTO BY HOWARD BOSSEN

Figure 1. Nicole Ewenczyk interviewing Yul Allen, June 18, 2012.

Ewenczyk, who is self-effacing about her role in setting up the conditions in which Perrin makes his portraits, describes what she does for trips that typically last for one to three months.

> When Gilles wants to start a new reportage, anywhere in the world, he asks me to organize everything. I look for information on the people he wants to approach and for people who can give me more information and contacts in the country. I decide how many days we'll stay here and there. I look for places to sleep and sort out transportation. I take care of all details like buying food in Ethiopia before leaving for the Omo Valley, calculating how many bottles of water we will need, kilos of onions, rice, etc. . . . to take with us in an area where there is absolutely nothing. I like that. I like to organize, contact people, and always learn from them.

For each project, Ewenczyk makes careful field notes that include names, locations, what each subject did, and occasionally information about the person or place that adds to an understanding about the portrait Perrin makes. Ewenczyk explains how they work in the field, saying, "We really work as a team. We know each other quite well and can exchange with our eyes during the shootings. Each one has a role, a place."

The plans for *Detroit Resurgent* were less complicated in the logistics of travel and lodging, but more complicated and quite different in regard to finding and arranging subjects to be photographed.

*Detroit Resurgent* differed from previous projects because each subject would also have a recorded interview (figure 1). Ewenczyk asked a few open-ended questions about the subjects' biographies, what they did, what they thought about Detroit today, and where they thought Detroit would be in five to ten years. These interviews, which run from about ten minutes to more than an hour, allowed Ewenczyk to capture a verbal portrait of each subject as Perrin was making a visual one. Each interview was transcribed, edited, and paired with that person's image, becoming "Portraits of the Motor City," the centerpiece of this book.

errin's approach to portraiture is informed by an understanding of history, especially of the problems created by the centuries-long colonization of large parts of the world by European nations, as well as those created by contemporary forces of globalization. His approach to reportage has clear and strong underpinnings in his worldview. A statement Perrin wrote about his work in Ethiopia—but which is equally applicable to the rest of his projects—reveals his motivation as a photographer:

> Since the beginning of time, human beings have had an effect on their environment. Instead of drawing up a geographical report of our actions, it seemed preferable to create a human report, to keep a visual trace of those who work with and transform the earth; those who are the bearers of the knowledge and know-how passed down through generations.[4]

He has created a body of work that not only shows the faces and feelings of people from many countries, but also makes an important ethnographic contribution to the study of a constantly changing world. "We soothe our consciences," he says, "by way of educational programs and economic aid, but these represent so little compared to the pillaging of the natural resources that only the Northern countries benefit from. Most so-called 'primitive' cultures have disappeared, whether physically destroyed by colonial occupation, or culturally destroyed by the evangelism of Western missionaries. . . . We have no respect for these people, and not much more for ourselves. It is perhaps a premonition of what might happen to all mankind."[5]

Respect for people and the work they do is central to Perrin. His reportage seeks to show how complex and nuanced social structures are. This is especially evident in his multiyear study of women made in Egypt in the 1990s, a period when Hosni Mubarak was president. While Egypt under Mubarak was not a free society, it was one where women were able to move beyond the roles available to them in a largely traditional Muslim society. Ewenczyk describes what they wanted to accomplish with this reportage:

> Gilles wanted to give homage to women in an Islamic country because he struggles for feminism, so we started to photograph Egyptian women. I saw and heard the women struggle, intellectuals and women in the country. In the country they were looking for me, looking for my eyes watching them, they were more confident when they could see me.

Ewenczyk's presence allowed Perrin to gain entry to situations that would have been more difficult, if not impossible, without a female partner. Malak Rouchdy's essay "The Women of Egypt: A Photographic Study," in Perrin's book *La moitié du monde*, provides insight into Egyptian

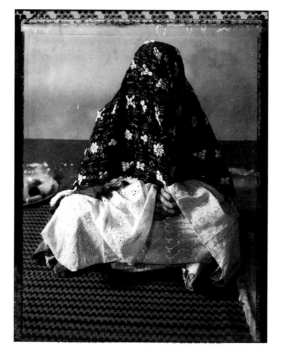

Figure 2. Mabrouka, trousseaux embroiderer, Siwa Oasis, Egypt, 1998.

society in the 1990s, as well as into Perrin's respectful manner of approaching his subjects.

Teenagers, women young and old, rich, middle-class, and poor, Gilles Perrin introduces us to women who have chosen to be photographed, to pose and choose how they want to be seen. His work provides one of those rare occasions when the photograph submits to the desires of the subject and not the other way around. Each individual is an accomplice in the event: they take their time, tidying themselves up and choosing the best pose in which to enter into a dialogue with the photographer.[6]

Rouchdy goes on to explain that "Perrin's photographic language is largely inspired by photographic techniques from Europe at the end of the nineteenth century" and does not have "the orientalist viewpoint that dominated" anthropological and ethnographic studies of the time.[7] Perrin rejects the stereotypical colonialist attitude so prevalent among photographers during the nineteenth and a good portion of the twentieth century. He views his subjects as individuals with unique identity and value, not as the "other," not as objects to be studied by a "superior" race.

Perrin's observations about the complexities and contradictions of Egyptian society become clear when two of his portraits are viewed side by side. His 1999 portrait of Mabrouka (figure 2), a traditional trousseaux embroiderer, was made with her completely covered. All that is visible of her body are her fingers and a few toes. She looks out at Perrin and Ewenczyk through her veiled face. We see her sitting on a traditional mat, with hands folded together, covered in the finely embroidered material she made and in which she has wrapped herself. This faceless portrait communicates a great deal through the subtlety

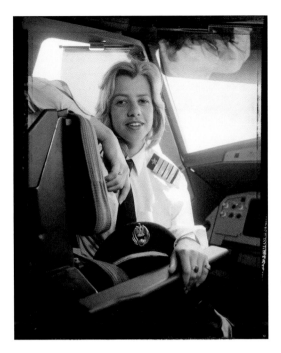

Figure 3. Dina el Sayed, called Charlie, first female pilot at Egyptair, Cairo, Egypt, 1998.

of body language and represents an image of a traditional Muslim society.

Dina el Sayed—known as Charlie (figure 3) —was the first female pilot at Egyptair, according to Perrin, who photographed her in 1998. In her portrait, el Sayed is seen in her pilot's uniform, officer's hat in her lap, arm draped over the top of her seat. She turns toward the viewer, her expression and body language exuding confidence and pride. She is young and blond, with the facial features of an Egyptian of Western heritage. Although from the same country as Mabrouka, el Sayed lives in a different, more modern, and secularized world.

Perrin's study of Egyptian women presents an interesting mix of young and old, traditional and modern, teachers, singers, circus performers, writers, potters, tour guides, surgeons, and human rights lawyers. Their collective portraits tell the story of a country in transition. Perrin's portraits reflect his written observations about the Egyptian society of the period:

In Egypt I have been struck by contradictions that are as much cultural as social,

17

Figure 4. Lakshmi, fish seller, Chennai, Tamil Nadu, India, 2007.

contradictions that have doubtless been intensified by the historical, political and religious circumstances of this nation. It seems to me that this situation is even more acute in the case of women. Women are at once victims of and actors in the injustice and oppression that overwhelms them. The paradoxes of Egyptian society are almost caricatures; society remains paralyzed between its ancient traditionalism and its longing for western liberalism. One need only look at the freedom enjoyed by the upper-class women as contrasted with the condition of the women in the lower classes.

In Egypt I get the impression that profound changes can come about unexpectedly, even if such upheavals do not occur overnight or in a few months, an inexorable will for change exists and will perhaps manage to organize itself.[8]

Perrin's observations made in 2000 were, indeed, prescient, even though the Arab Awakening that swept Mubarak from power

was more than a decade in the future. And while the Arab Awakening at first held the promise of a more open society, the rise of the Muslim Brotherhood government of the now deposed President Mohamed Morsi increased tensions between traditional Islamist perspectives on the role of women and more liberal views.[9]

The dignity of each individual is revealed in Perrin's portraits, no matter his or her station in life, no matter whether the subject is the 1988 Egyptian Nobel laureate Naquib Mafouz, or Lakshmi, a poor fishmonger in India (figure 4), or General Huang Zheng, a companion of Mao Tse-tung during the 1934–1935 Long March, the first envoy of his government to France, and the man who helped prepare the way for President Richard Nixon's famous 1972 visit to China.[10] Or Amentag Brahima, a coal miner known as "Peanuts" from the north of France (figure 5). Or the Karlberg family, traditional Finnish farmers (figure 6). Or Patrick Crouch (page 137), an urban farmer in Detroit. Or Aminata, a traditional potter from Mali. Or Lydia Gutierrez (page 117), president of Detroit's Hacienda Mexican Foods. Perrin's portraits show what ties humanity together across time and geographical space.

Robert Coles, who won a Pulitzer Prize for his *Children of Crisis* series and wrote *Doing Documentary Work*, describes in this book the goal of the documentarian, regardless of the medium used. Coles explores the interconnections between writing, photography, and film. He uses the metaphor of a journey to succinctly explain the working impulse for documentary photographers like Perrin:

Doing documentary work is a journey, and is a little more, too, a passage across boundaries (disciplines, occupational constraints, definitions, conventions all too influentially closed for traffic), a passage that can become

a quest, even a pilgrimage, a movement toward the sacred truth enshrined not only on tablets of stone, but in the living hearts of those others whom we can hear, see, and get to understand.[11]

Perrin is a social documentarian who uses the portrait as a vehicle to report about the world. He is on a metaphorical journey, as Coles describes, as well as an actual journey. His travels over the years have become a form of pilgrimage where one project leads to the next, where one set of issues explored is reexplored in another place, another context, another sociopolitical reality.

Perrin is soft-spoken but steel-willed. From the beginning, he's seen his job as an artist and social documentarian, in part, to document people and places before they disappear, to seek out and photograph what may become lost to time. Part of the importance of his continually growing body of work is that it offers a rich and varied historical record of the world that reveals

Figure 5. Amentag Brahim, called "Peanuts," coal miner, mineshaft number 9, at 2,887 feet below ground, Oignies, North of France, at the closing of the mines in 1991.

the strength, dignity, and spirit of his subjects. We can look back to his early work and see what has disappeared, how customs and ways of working have died out, been altered, made

Figure 6. Tuula and Hans Karlberg and their daughters Jenni and Anni, sheep breeders, Sumiainen, Finland, 2009, from the series "Traditional Farmers."

Figure 7. Nakumo and Maganto Hailou, Omo Mursi village, Mago Park, Ethiopia, 2005.

the sea, the people who till it, those that husband livestock and fish its seas. This interest in the people who create the sustenance that feeds all peoples in all cultures is a theme expressed often in his portraits. And it is a theme that allows him to explore preindustrial and ancient methods of working in Africa, Asia, and South America and place them alongside methods of the modern, Western world. Perrin's body of work allows us to compare similar endeavors across cultures. For example, one sees his interest in how food is produced in a preindustrialized society in his portrait of Nakumo Hailou, who is kneading bread dough on a grinding slab while carrying her baby, Maganto, on her back in Ethiopia (figure 7). Although this image might have been made one hundred years ago, it was made in 2005. This same theme of food production is also present in Perrin's portrait of Ann Perrault standing in front of Avalon International Breads (page 131), an entrepreneurial, postindustrial food enterprise she cofounded in the Midtown area of Detroit.

He also has great concern for the way in which responsible—and irresponsible—modernity affects people and the planet. He set off to travel "the planet" almost twenty-five years ago "to meet others, like me, in their diverse cultures." This, he says, allowed him "to see and show that which is not seen, that which is forgotten or ignored; to place a light on what makes us different to others."[14]

He describes himself as "a photographer close to humanity, in search of images that tell a story." "My thirst," he continues, "cannot be quenched by a glance or a superficial once-over. What drives me above all is the thirst to scrutinise people, to draw out the fine detail, to tease out of my subjects their social reality, their inner self, the-way-they-are and not the-way-they-seem-to-be . . . and through my work to record their vitality forever."[15]

Perrin travels to make portraits but is not a

concessions to global change, or made obsolete by technological change. We can look at the recent work and realize that nothing remains still—all is in flux.

A keen observer of people and customs, Perrin is on a mission. He describes himself as "a photographer of the human heritage in all its forms," who places his work into the time-honored humanistic photographic tradition of bearing witness. An introduction to his work in the Omo Valley in Ethiopia explains, "My work is to make photographs, and I want to be a witness to the condition of the world. I try to show a reality that matches my vision and my emotions; the work is a conscious construction intended to be far from ordinary photography."[12] And the introduction to his *People of the Sea* project further expands on his goals. "My desire," he writes, "is to show the contradictions and paradoxes; the counterbalance of a world in progress which is impossible to deny. I am interested in the reality we don't see."[13]

Perrin, the grandson of a farmer, an avid hunter, a gourmet cook, has, as a photographer, an extraordinary appreciation of the land and

travel photographer. Although place plays a role in his work—and indeed the geopolitical reality of a place at a specific moment may provide an important piece of his narrative—his work is fundamentally about people.

> My photographic work springs from my feelings and my intellect. I like to follow my feelings when I take photographs, but I want above all to document, and for my pictures to be the product of an intellectual view of the world, and thus, to make a record of the people around me, to document their lives, their problems and their pleasures. . . . While I have no illusions about my ability to fight the injustices that I observe about me, it is nevertheless my duty as a human being and as a photographer to document them.[16]

Perrin describes himself as "a researcher and humanist photographer," whose focus is "on people at work and in their environment."[17] He works within a rich photographic tradition that goes back to the end of the nineteenth and beginning of the twentieth century. Perrin's monumental study of peoples and cultures evokes the work of photographers who preceded him by many decades, including Eugène Atget of France and August Sander of Germany, as well as Americans Lewis Hine and Edward Curtis.

Perrin found in Atget—who used a large-format camera mounted on a tripod, and began to photograph in 1888 until his death in 1927—a kindred spirit who had created an in-depth portrait of Paris and its extended environs over almost forty years. Atget concentrated on recording every aspect of the old city that was rapidly giving way to a new one—its architecture, parks, monuments, and residents. He was especially interested in "Parisians who reflected an image of the old city (craftsmen, passers-by, tramps, rag-and-bone men, prostitutes) as well as the activities in this area

of the city (the small shops, brothels, market stalls, cabarets and shop windows)."[18] Perrin's 2002 book, *Guide des artisans d'art de Paris*, with text by Ewenczyk, can be viewed as an early twenty-first-century reinterpretation of Atget's photographs of craftsmen.[19] His portrait of the shoemaker Norayr Djoulfayan is a particularly good example of an image and a place that hearkens back to the Paris of Atget's time (figure 8). Atget's work served as a model for how to organize his own geographically larger projects, and as a means to think about categories of human activity that would help his quest to photograph life before it is irretrievably altered.

Perrin admired the organizational methods of Edward Curtis, who began his monumental study of the North American Indian at the end of the nineteenth century, and between 1907 and 1930 published a twenty-volume series with more than 2,200 photographs.[20] Curtis's field trips required extensive planning and research as he chose a specific location to photograph during each extended trip. In each location, he focused on the customs of individual tribes to

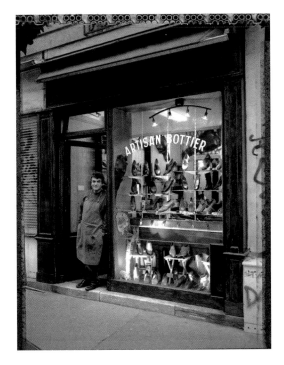

Figure 8. Norayr Djoulfayan, shoemaker, Paris, France, 2000, from the series "Craftsmen in Paris."

record the rich diversity of indigenous culture before it vanished. While Curtis is sometimes criticized today for his outsider's perspective on what he and others referred to as "the Vanishing Race," he did a great deal to preserve the language, music, and history of North American Indians, and created—with all of its flaws—the visual catalog of how contemporary society thinks of life for the indigenous people of the United States at the beginning of the twentieth century. That Curtis's vision was romantic and Western-centric does not diminish its historical importance.[21] For Perrin, it gave both a model of how extended fieldwork could be organized, and a warning about potential problems of voyeuristic exploitation of his subjects.

Lewis Hine, who had a degree in sociology and began to photograph in 1904, also inspired Perrin. Hine was a product of the Progressive Era, and a social activist who believed in the power of photography as a tool for social reform. From 1908 to 1918, he worked as an investigator of the National Child Labor Committee and made now-iconic photographs of children working in textile mills, coal mines, glass factories, food processing plants, and on farms. It was a bleak picture that Hine revealed through both his photographs and his meticulously researched investigative reports. He used many of them as the basis for articles in Progressive Era magazines such as *The Survey*. Hine turned away from the negative aspects of child labor in the 1920s and focused instead on celebrating working men and women, and on the making of the modern city through his landmark study of the construction of the Empire State Building. In Hine, Perrin found a man who believed passionately in the dignity of working people, and the power of photography to move people. Hine said, "I wanted to show the things that had to be corrected; I wanted to show the things that had to be appreciated."[22] Hine's words describe, in part, Perrin's photographic mission.

Perrin also found inspiration in the work of August Sander, best known for his "sweeping cultural work *People of the 20th Century*." It was conceived in the mid-1920s, but eventually reached back to 1892 and forward to 1954 for its full set of images. Perrin saw in Sander's photographs the importance of using a subject's environment as content and compositional elements. He also saw how Sander used shallow depth of field to soften the background and help provide visual emphasis to the subject in the foreground. And he saw how Sander often used diffused light on his subjects, a technique Perrin incorporates a great deal in his own work.

Susanne Langer's introduction to Sander's seven-volume set of portraits said, "The people he portrays appear as types representative in their time and station in life. Working within a geographically limited framework, Sander adopted an encyclopedic approach to his typologically oriented opus, which he imbued with a universal character."[23] While Perrin finds much to appreciate about Sander's portraits, he also differs philosophically with Sander, who by never using his subjects' names, stripped them of their individual identity and replaced it with a catalog of professions, stations, and roles in life. Where Perrin always includes the names of his subjects, allowing the viewer to see each person as an individual, Sander referred to them generically with titles such as "Young Farmer," "Country Girls," "Home Help," or "Farmer Working the Fields."[24]

Perrin's philosophical approach also shares affinities with the French photographer Henri Cartier-Bresson, who coined the term "the decisive moment" in the early 1950s. Cartier-Bresson discussed what it means to take photographs in his book *The Mind's Eye: Writings on Photography and Photographers*. He broke the act of photographing into two pieces, the first an action and the second recognition. "To take photographs," he wrote, "is to hold

one's breath when all faculties converge in the face of fleeing reality. It is at that moment that mastering an image becomes a great physical and intellectual joy." This statement speaks to the photographer's need to not act in haste, but to have senses attuned to anticipating the exact moment to make the exposure. It expresses what the photographer experiences visually as well as psychologically. Cartier-Bresson continued, "To take photographs means to recognize—simultaneously and within a fraction of a second—both the fact itself and the rigorous organization of visually perceived forms that give it meaning. It is putting one's head, one's eye, and one's heart on the same axis."[25]

While the genre of social documentation applies to Perrin and Cartier-Bresson, their concerns and working methods differed greatly. Cartier-Bresson pioneered the use of the 35mm hand-held camera in the 1930s. For Cartier-Bresson, the decisive moment is often compositional, defined by geometry, light, and the relationship of the pictorial elements. Perrin is not concerned with a rapidly changing scene. His large-format approach requires him to work slowly and methodically. For Perrin, composition and light are critical, but his decisive moment first and foremost is emotional and psychological, a moment found in body language and facial expressions—a window into the subject's soul.

Perrin has learned a great deal from Americans Irving Penn and Richard Avedon. Both are well known for their pioneering fashion photography, although that's not what attracts Perrin to their work. He is attracted to Penn's project *Worlds in a Small Room*, begun in 1948 and finished in the early 1970s. For this project, Penn traveled the world to make portraits of regular people engaged in work, and whose customs he thought would soon be transformed. Penn, however, brought his own portable studio with him. His cloth backdrop

eliminated any environmental context. He also approached his subjects like the consummate fashion photographer, adjusting dress and positioning subjects as if they were fashion models. This approach produced extremely powerful portraits, but they were more about the photographer's vision than the subject's life.

Avedon's attraction is different; Perrin appreciates the overt social comment in many of Avedon's portraits, his use of large-format cameras, and use of the full negative including the black border outline. Perrin presents his own photographs, whether made with Polaroid film or conventional sheet film, in this manner. The edges of the photographs in *Detroit Resurgent* reveal an aesthetic choice fundamental to Perrin's vision. He wants the viewer to see that he never crops an image: the full negative is the frame for the final image. Many photographers crop the image inside the border area so the image has rectangular edges. By using the full negative, Perrin creates a cleanly defined frame that surrounds an irregularly shaped image—a way of asserting the importance of the photographic materials he works with.

In addition to single images, diptychs and triptychs are part of Perrin's oeuvre. While the majority of his portraits are of individuals, he switches to the diptych or triptych format when he photographs groups or ceremonial life, or when he feels the need to include a larger environmental context. He intends for the viewer to perceive these as a holistic entity rather than as separate images, even though each of the two or three images placed together has a different vanishing point. Thus Perrin must visualize not one, but two or three discrete images simultaneously. He must figure out the perspective as well as determine how much and in what direction to move his camera so each photograph flows one to another, creating a panoramic image.

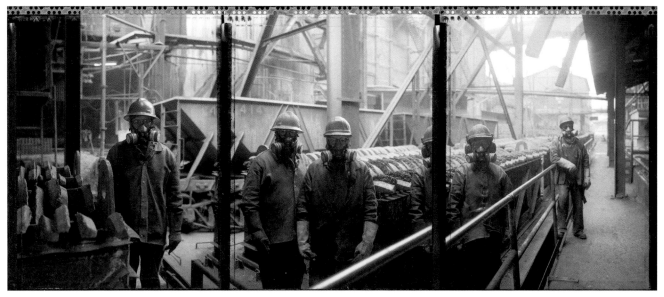

Figure 9. Zosimo Garcia Huayamates, Dionino Vergarey Macario, Leon Erasmo Hernandez, Hernan Churampi Solano, Licodadio Grinio Huatta, foundry workers, La Oroya, Altiplano, Peru, 2003.

Avedon also occasionally explored diptychs and triptychs in his group portraits. One of Avedon's best known triptychs is *The Chicago Seven: Lee Weiner, John Froines, Abbie Hoffman, Rennie Davis, Jerry Rubin, Tom Hayden, Dave Dellinger, Chicago, 9/25/1969*, a portrait made the day after their trial began in the courtroom of Judge Julius Hoffman. They had been charged with incitement to riot for demonstrating at the 1968 Democratic National Convention in Chicago—a convention that Mayor Richard J. Daley determined would not be taken over by antiwar protesters, but that ended with many confrontations between police and demonstrators.[26] Avedon, like Perrin, relied upon the large-format camera, but their styles differ greatly. Where Perrin uses each subject's environment as the setting for the portrait, Avedon used a completely white backdrop. Avedon's portrait has no environmental details, just stark images of proud and defiant people with a profound impact upon their time.

Perrin's diptychs and triptychs explore his subjects with rich environmental details that show the viewer the relationship of each person to his or her place. Tuula and Hans Karlberg and their daughters Jenni and Anni operate a small family farm in Sumiainen, Finland, where they breed sheep (figure 6). Perrin packed a lot of information into this diptych. Jenni and Anni are shown in print dresses, sun hats perched on their heads. Mom and dad are on the left side, in the mid-ground with their sheep in front and their 1990s Zetor Czech tractor behind them. In the back of the field stands a row of trees. Compressed into this space is a story about family farming and familial relationships, typified by how older sister Jenni has her arm around the shoulder of her little sister. It is from Perrin's 2009 study of fifty-three farm families in three provinces, a project made possible by a residency at the Center for Creative Photography in Jyväskylä, Finland. Kimmo Lehtonen, the director of the center, thought the relations Perrin forged with the local community over a short period of time were unique, and says that the "connection the material is creating to global issues on rural culture [within] Finland is something never done before."[27]

Perrin's 2003 triptych of foundry workers in Peru is one of only a few portraits where his subjects' faces are masked.[28] While masked, the eyes that look out can be seen through the workers' protective goggles, connecting the subjects to the photographer and giving the workers a sense of individuality. By posing the foundry workers in their protective clothing, complete with hardhat, goggles, and respirators, Perrin comments not just on the men but also on the dangerous environment in which they labor. And keeping with his commitment to show people, not types, the title of this portrait includes the names of all five workers (figure 9).

Perrin's diptychs and triptychs extend the tradition of panorama photography first used by landscape and industrial photographers in the mid-nineteenth century. With these early panoramas, the photographers often were concerned with how industrialization was altering the landscape. This was especially evident in the large panoramas made by Hugo van Werden of the Kruppsche Gußstahlfabrik (Krupp cast steel factory) in Essen, Germany, from 1861 through the mid-1870s. Van Werden's images reveal the growth of the Krupp works over time, and like Perrin, he had to previsualize panoramas that ranged from three exposures to as many as eleven separate panels, resulting in an image nearly 13 feet long. While the conceptual framework of what photographers like van Werden did, and Perrin does, has similarities, their concerns couldn't be further apart: Van Werden was making images that were used to present industrialization in a positive light, where buildings and industrial machinery were part of the transformation of the world, and where the worker was a piece of the process. Perrin's concern is with the people photographed, with their essential humanity, and where landscape becomes the setting to describe human relationships.

Figure 10. Gilles Perrin throwing the black cloth over his head as he gets ready to look through the ground glass of his camera to make Cassandra Thomas's portrait, June 6, 2012.

Slow, deliberate, intellectual—it happens in his mind and with his eyes. Perrin works in a style that hearkens back to the beginning of photography. He makes his portraits using a 4×5-inch field camera mounted on a tripod. Perrin throws a black cloth over his head that blocks out light, and looks through the ground-glass viewing area on the back of the camera (figure 10). The image appears upside down and backwards. Once Perrin is satisfied with his composition, he places a film holder with a single sheet of film in the back of the camera, thus ending his ability to see what the camera now sees. He goes to the front of the camera, cocks the shutter, and returns to his position behind the camera. He pulls out the dark slide so that once he depresses the shutter, light exposes the film. He is patient, sometimes communicating with his subject through body gestures, sometimes by talking, sometimes simply by looking at the subject. He waits for the right moment to depress the shutter and expose his film. He reloads his camera with a second sheet of film and makes the next exposure. Most of the time, one to two exposures—that's all—and he has a powerful portrait. As he is composing each photograph,

he carefully considers the frame and makes sure there isn't extraneous detail. He then places his subject within the frame so the viewer's eye will go exactly where he wants. If the image is cropped, the visual balance Perrin has achieved is damaged.

Perrin's use of light is intentionally subtle. While he figures out where he wants to pose his subject and sorts out technical issues of lighting and exposure, Ewenczyk makes sure the subject is comfortable with the process of being photographed. She assists with the lighting by holding a strobe unit for fill light—a soft but sculptural, shadow-free light that illuminates the subject while allowing ambient light to be used for exposure of the background. The mix of strobe and ambient light looks natural to the viewer's eye but is part of a consciously constructed image.

Perrin spent years as a successful advertising photographer, where products often required sophisticated and complex lighting setups, and he also worked in theater and film as a lighting technician. He adopted a simplified approach for his portraits that is easy to use in the field—one strobe tethered to a long cable that allows him to direct Ewenczyk to aim the strobe where he wants the light directed. The simple lighting setup frees him to concentrate on emotionally and psychologically connecting with his subject, a condition essential to creating multilayered environmental portraits. These images are meant to comment not just on the individual, but also on the space the person occupies. They anchor the subjects to a small piece of their world, filled with details that enable Perrin to create a narrative about each individual (figure 11).

Working this way requires great intellectual discipline as well as technical skill. It is a manner of working far removed from how most photographers approach image making today. Over the last quarter century, he has made portraits of approximately 5,000 people with

fewer than 7,500 exposures. It is a predigital, large-format method, harking back to a time when each exposure carried a cost for film and chemistry—a time when photographers worked as economically as possible. Much of that kind of discipline is now lost. The norm is to shoot hundreds, if not thousands, of images and then edit them on a computer screen. If Perrin worked in the manner of the typical digital-image maker, he would have made hundreds of thousands of exposures. In the digital realm, the first edit is to cull the large number of images down to a manageable number. The second is to put the images through a postproduction cycle to crop and make other adjustments. For many of today's photographers, the idea is shoot first, edit later. Perrin is decidedly old school. He preplans, editing in his mind before making his exposure. He knows what he wants and achieves it with an economy of grace and style largely lost in today's small-format, handheld, digital-image-making world.

Perrin works as he does because he chooses to engage his subjects in the image-making process. This enables him to turn the act of taking a photograph into an act of sharing between photographer and subject. From the beginning of Perrin's photographic odyssey until recently, he used Polaroid Type 55P/N film, introduced to the marketplace in 1961. It is a two-part black and white package that peels apart, producing a positive print and a negative at the same time. It is also a slow panchromatic film with an ISO rating of 50, requiring relatively long exposures even in well-lit situations. The decision to work in this manner was not simply driven by a convenient technology, but also by a clearly articulated philosophical approach to portraiture:

> I work with a photographic process adapted for large format photography. I use a 4 × 5 inch folding camera on a tripod and have my

subjects pose for me. I choose to use black and white instant film in order to capture only the intrinsic qualities of the individuals I am working with. Using negative/positive film allows me to immediately give a print to my subjects while I retain the negative. As I take a photograph and give back the image, my subject and I are engaged in an important ceremony. The splitting and exchange of the negative and the positive renders our unspoken bond into a material presence, symbolic of what we have shared. This ritual linking human interaction to the photographic act is essential to me as a photographer.[29]

The idea of ritual and ceremony are central to Perrin's humanistic approach. Perrin often describes the purpose of his working methods. Each description, while customized for the specific subject matter of the exhibition or publication, carries a constant theme exemplified in the introduction to his study of Irish fishing men and their families, *People of the Sea*: "All shots are taken at a slow shutter speed (one second to ⅛ of a second), a more 'human' speed with which one can capture a breath or a heartbeat."

His portraits are never taken furtively and are never, as he says, "stolen." He and Ewenczyk explain how he works and what he wants to do so there "is always a dialogue with [his] subjects." And this communication, sometimes verbal and sometimes gestural depending on the country, allows "each person to participate in this social exchange, thus creating collaboration between myself, and the subject as a human being."[30] This philosophically based approach to portraiture honed over many years is how he approached subjects for *Detroit Resurgent*, a project that differed from his others in terms of how some subjects were selected, while relying on the same humanistic foundation.

Figure 11. Gilles Perrin and Nicole Ewenczyk setting up to take Gary Wozniak's portrait in front of the site near Detroit's Eastern Market where Wozniak was developing a commercial urban fish farm, June 14, 2012.

To think of portrait making as a shared exchange between photographer and subject was eloquently expressed by the French essayist and playwright Jean-Louis Sagot-Duvaurou in an essay on Perrin's portraits made in Mali. Sagot-Duvaurou wrote about a specific subset of Perrin's work, yet his comments apply to Perrin's entire body of portraiture. Sagot-Duvaurou titled his piece "Photos Taken, Photos Given" and said,

Now, observe very carefully the look, especially those in the single portraits. In one minute the person who has been photographed will receive in her hands her "pose." Gilles Perrin can do this with his technique, an instant print. Not a photo taken, but a photo given. Observe these looks and remember this: in this very specific moment, the photo you are admiring under the lights of an exhibiting space leaves its photographic life in a family. It can be seen in the everyday life on a wall in a bedroom in Mali or in a photographic book one looks at and turns the pages and passes it to the friend who came to visit. Okay? You've made the

27

journey? So go back to the photo you were looking at and pretend you are a parent or a friend of that person.[31]

Changes in technology and the photographic market forced Perrin to find a way to continue this idea of exchange after Polaroid Corporation went bankrupt, Type 55 film ceased to be made, and the supply of film he managed to accumulate was all used by 2011. Today he accomplishes the exchange between photographer and subject by placing a small digital camera on top of his 4×5 field camera and making a few exposures after exposing his film. The subject receives a digital image of the portrait session soon afterwards in an e-mail with thanks for allowing his or her portrait to be made. This mixed analog and digital method was used to create *Detroit Resurgent*. While Perrin's philosophy about the importance of interaction and exchange between subject and photographer remains the same, the change in technology removes the intimacy of the exchange, altering its ceremonial quality as well as eliminating its materiality. This shift to making a digital image as a substitute for the small black-and-white print worked in Detroit, where all his subjects have e-mail addresses. This method will present challenges, however, when Perrin does photographic odysseys in remote places. Perrin is already planning a photographic reportage in Papua New Guinea about the difficulties of retaining one's traditional culture and identity as the economic development of land puts pressure on the people to abandon their traditions. His interest in places in the developed as well as the developing world, to make reportages that record what is left of old customs and the beginning of new ones, remains constant.

The loss of the use of instant Polaroid film also changed his relationship to the process. No longer does he have immediate feedback as the two-part film was separated, feedback that let him know whether his exposure was perfect and the composition strong. He needed a different working methodology with the shift to sheet film. Thus he processes his film and makes contact sheets each night after the day's portrait sessions, similar to nineteenth-century photographers who traveled with portable darkrooms, and twentieth-century photojournalists who processed film in makeshift darkrooms—often a hotel bathroom. He expresses concern about the need to evaluate his work as he goes along. "Without Polaroid film, the relationship with the people, the subtle confidence between us, was difficult to establish as I could not show and give them their image immediately. We organized ourselves so that I could develop the pictures as we went along, so that I could visualize what I had done and see whether the magic had functioned between my subject and myself."[32] The new method, while more awkward and time-consuming than the Polaroid process, worked well, according to Perrin, who says of *Detroit Resurgent*, "I think I found the form that matched the commission. I am delighted. It is the first step to my next reportage; each one evolves to the next one."[33]

The project started with questions that led to the beginning of an idea that became *Detroit Resurgent*. What could a skilled observer from another place, another culture, reveal about the people of Detroit? Whom would he photograph in a short three weeks, and how would he find them? What would be added by Ewenczyk's recorded interviews? These intriguing questions had a clear starting point, but there was no way at the outset to understand how they would be answered.

To Perrin and Ewenczyk, as with so many people the world over, today's Detroit is known as a city in ruins. The city fascinated them as

it does others who know it only as a place that once was great but is now down on its luck, tattered with a crumbled infrastructure, a place of poverty, crime, and corruption. Yet Detroit is a Rust Belt community struggling to redefine and remake itself for the twenty-first century—not to forget its past, but to find its future in a postindustrial world. To tell this story required Perrin and Ewenczyk to explore a Detroit whose physicality has not yet been transformed, whose new physical look is slowly taking shape. The challenge of *Detroit Resurgent* for Perrin and Ewenczyk was to find a representative number of subjects, and through portraits and words demonstrate that people with vision, energy, commitment, and belief in the city are reshaping it.

As Detroit in the 1920s was becoming a powerhouse in the industrialization of America, photographers found it a fascinating place to document. Many were especially attracted to the Ford River Rouge plant, a symbol of the new vertically integrated manufacturing ideas of industrialist Henry Ford. His vision changed not just Detroit, but also played a significant role in defining an industrialized, consumer-oriented America with an emerging middle class. Ford's ideas, as well as those of the labor unions he often opposed, did more than build cars—they helped shape the modern American city.

Detroit and the Rouge attracted German-born British photographer E. O. Hoppé, who embarked on a large project to explore America of the 1920s. Hoppé made photographs in the Rouge in 1926, the year before the American painter and photographer Charles Sheeler accepted a commission by Ford Motor Company to photograph the Rouge, where he made his iconic modernist photograph *Criss-Crossed Conveyers*. It also attracted Margaret Bourke-White, the pioneering industrial photographer and photojournalist who explored industrial architecture as an expression of modernism

and the Machine Age. These photographers celebrated a Detroit on the rise. They were fascinated much more with the graphic power of industrial architecture than with the people who worked in the mills, factories, and auto plants and who lived in the communities that grew up around such massive facilities.

In recent years, as Detroit shifted from a symbol of growth, prosperity, and pride to one of decay and despair, photographers have focused on the ruins of the once-proud city, on what remains of the Packard Plant and Michigan Central Station, and on the vast, sprawling landscape of abandoned buildings and overgrown lots. These are images of ruins, not of a living, breathing, evolving space or dynamic people. While they wield great graphic power, like the iconic images of the Machine Age, they don't speak to the visions, aspirations, frustrations, and undaunted human spirit of the people. To tell the story of contemporary Detroit, the story of its residents, requires the skills of a photographer and an interviewer who focus on people, not structures, and who situate their subjects in the rapidly evolving urban space that is the Detroit of today and tomorrow.

Finding subjects was a challenge. The starting point was reaching out to people who live and work in Detroit, who are engaged actively in forging its future, for suggestions on portrait and interview subjects. Slowly a list of potential subjects formed. It was a list with obvious names, such as longtime social activist Grace Lee Boggs (page 41) and United Autoworkers president Bob King (page 67). It was a list that included grassroots activists like Gary Wozniak, president of Recovery Park (page 77), and writer, journalist, and musician Larry Gabriel (page 35), author of this book's essay "Detroit Dreams: No Rust Belt Scene."

Diversity was key, and we sought a wide variety of people to respect Detroit's ethnic diversity and to ensure representation of a

range of ages, occupations, and perspectives. We shared this evolving list with Perrin and Ewenczyk, who with me, made initial contacts to explain the project and develop a schedule. It was not easy within a restricted time frame, an ambitious goal of at least sixty portraits, and a geographic area as immense as Detroit.

It also was initially an uncomfortable way for Perrin and Ewenczyk to work. They were accustomed to finding all their subjects by themselves and to photograph without having to take into account another participant's agenda. In past projects, even the residency in Finland, they had total freedom to choose subjects and to photograph as they wanted. The Detroit project imposed no restrictions on how they could photograph, but we had a number of people we definitely wanted to include. At the outset, the project didn't feel quite right to Perrin, who commented, "These portraits from Detroit, it is a strange story. I am asked to make portraits of people I know nothing about. I meet people without knowing precisely who they are, how important they are."[34]

The first stop in Detroit was to meet Gabriel. He not only introduced the couple to local people and provided a walking tour of Midtown and a driving tour of greater Detroit, but also had recommended potential subjects. Some—like Yusef Bunchy Shakur, the author of *My Soul Looks Back: Life after Incarceration*, who "grew up hard on the lower Northwest side of Detroit" (page 157)—worked out. Others didn't. It was on Gabriel's neighborhood walk that they met George N'Namdi (page 49), the founder of the N'Namdi Center for Contemporary Art, one of Detroit's most influential art organizations, and Diane Van Buren and Ernest Zachary, both involved in Midtown development, historic preservation and restoration, and the green building movement (page 91).

It was on that walk that they were exposed to Avalon International Breads, where they would later photograph cofounder Ann Perrault (page 131), and Curtis Wooten, Avalon's head baker (page 133). Avalon International Breads became their home away from home, a place to relax and meet people. It was here they had a chance meeting with Judith Levy, an assistant U.S. attorney who also became a subject (page 59). And while exploring the shops on and near Willis Street—all part of the Midtown revival sparked in part by Avalon's opening more than fifteen years earlier—they met Nefertiti Harris (page 47), owner of Textures by Nefertiti, who told them, "You know Detroit is a city of activism. It always has been. The people have always risen to the top in our Detroit."

And in the northwest corner of Detroit, near where Grand River Ave. and Lahser Road intersect, they met John George (page 155), director and cofounder of Motor City Blight Busters, who was referred by Wayne County commissioner Burton Leland (page 37) and several others. George said that for twenty-four years his organization has "been bringing folks together from both the city and the suburbs in an effort to re-create Detroit—to stabilize it, to revitalize it, and to beautify it." He, in turn, introduced them to Cornell Kofi Royal (page 139), a former copywriter and account executive for a New York advertising agency and current master gardener for Artist Village. And so it went.

Days were long. Some days as many as six portraits were made in several parts of the city. Perrin spent nights processing film to make sure, as he likes to say, "the magic was happening" between his subjects and himself. Ewenczyk spent her nights working on the next day's schedule, making calls, planning the route, logging the interviews, and handling the many, many logistical details of the project.

The interviews were as rich as the photographs strong. As Perrin reflected on the project, he said:

Little by little, meeting and interviewing people we were asked to meet and interview, plus others we found by ourselves, I discovered the interest of the project. I understood it and I got enthusiastic. I was afraid I would have to photograph giving just aesthetic pictures without being able to reveal the real personality of each one. I try to make real pictures, just like the old family pictures. The people we found ourselves completed and reinforced those we were told to photograph.[35]

Out of this hectic and at times seemingly crazy quest, Perrin and Ewenczyk's Detroit story emerged—"Portraits of the Motor City." ■

## NOTES

This essay is largely based on many discussions, interviews, and studio visits, as well as e-mail correspondence with Perrin and Ewenczyk beginning in 2008. It also draws from published and unpublished exhibition statements by Perrin.

1. The photography festival Rencontres d'Arles was founded in 1970 by photographer Lucien Clergue, writer Michel Tournier, and historian Jean-Maurice Rouquette. It has become a festival of international importance.
2. Frederick Baldwin and Wendy Watriss, documentary photographers and journalists, and European gallery director Petra Benteler founded FotoFest in 1983. The first biennial, citywide Month of Photography was held in 1986 in Houston, Texas.
3. The other one was when Perrin made a reportage in the north of France at the closing of the coal mines in 1991. For this project, he had to photograph 2,887 feet below ground.
4. Gilles Perrin, "The Earth" (Houston, Texas, MOCAH, Fotofest, 2006, exhibition statement).
5. Gilles Perrin, "The Omo Valley, Ethiopia, 2005" (Paris, France, May 2006, exhibition statement).
6. Malak Rouchdy, "The Women of Egypt: A Photographic Study," La moitié du monde [Half the world] (Toulouse, France: Les imaginayres, 2000), 9.
7. Ibid.
8. Gilles Perrin, "Women of Egypt," La moitié du monde [Half the world] (Toulouse, France: Les imaginayres, 2000), 6–7.
9. David D. Kirkpatrick and Mayy El Sheikh, "Muslim Brotherhood's Statement on Women Stirs Liberals' Fears," New York Times, 14 March 2013.
10. "Huang Zhen, 80, Beijing Envoy Who Helped Plan Nixon's Visit," New York Times, 11 December 1989; Jeffery A. Engle, The China Diary of George H. W. Bush: The Making of a Global President (Princeton, NJ: Princeton University Press, 2008).
11. Robert Coles, Doing Documentary Work (Oxford: Oxford University Press, 1997), 145.
12. Perrin, "The Omo Valley, Ethiopia, 2005."
13. Gilles Perrin, "People of the Sea," exhibition statement (Sirius Arts Center, Cobh, Ireland, 2010; West Cork Arts Center, Skibbereen, Ireland, 2010; Alliance Française, Dublin, Ireland, 2011).
14. Gilles Perrin, "Portrait from a Village in the Hautes-Pyrénées," exhibition statement (Vielle-Aure, France, 2000).
15. Gilles Perrin, "People of Mali" exhibition statement (National Black Arts Festival, 2003).
16. Perrin, "Women of Egypt," 6–7.

17. Gilles Perrin, "The Omo Valley, Ethiopia, 2005"; "Labor and Emotional Realities," lecture (Paris, September 2007).
18. Gillaume le Gall, "The Eye of the Archeologist: Eugene Atget and the Forms of the Old City," Eugene Atget (Madrid: TF Artes Gráficas, 2011), 18.
19. Gilles Perrin with text by Nicole Ewenczyk, Guide des artisans d'art de Paris (Paris: Éditions Alternatives, 2002).
20. Edward Curtis, The North American Indian, 20 vols. (Cambridge, MA: University Press, 1907–1930).
21. Timothy Egan, Short Nights of the Shadow Catcher: The Epic Life and Immortal Photographs of Edward Curtis (New York: Houghton Mifflin Harcourt , 2012). This is a fascinating reevaluation of Curtis's place in photographic and American history. It was honored with the National Book Award.
22. Robert W. Marks, "Portrait of Lewis Hine," Coronet (February 1939): 147–57.
23. August Sander, Hommes du XXe siècle [People of the 20th century], vol. 1 (Paris: Éditions de La Martinière, 2002), 30.
24. All titles taken from photographs in vol. 1 of the seven-volume set.
25. Henri Cartier-Bresson, The Mind's Eye: Writings on Photography and Photographers (New York: Aperture, 1999), 16.
26. Richard Avedon and Doon Arbus, The Sixties (New York: Random House, 1999), 219.
27. Kimmo Lehtonen, Director, Center for Creative Photography, letter, Jyväskylä, Finland, 12 November 2011.
28. Perrin has done extensive work in Africa depicting a variety of masked ceremonies. These photographs are not portraits of individuals, rather they are reportages on specific cultural ceremonies and hence are a separate body of his work that requires a different analysis than his portrait work discussed in this essay.
29. Perrin, "People of the Sea."
30. Ibid.
31. Jean-Louis Sagot-Duvaurou, "Photos Taken, Photos Given," essay (La Courneuve, France, 2007).
32. Gilles Perrin, e-mail to the author, 3 June 2013. All the film was processed in a darkroom borrowed from Marygrove College, and with a set of steel tanks borrowed from photographer Kim Kauffman. The search for a darkroom for Perrin to use turned out to be considerably more difficult than anticipated. Few schools still have darkrooms, having replaced almost all of them with computer labs.
33. Gilles Perrin, e-mail to the author, 3 June 2013.
34. Gilles Perrin, e-mail to the author, 31 May 2013.
35. Gilles Perrin, e-mail to the author, 31 May 2013.

Sixty-two portraits, sixty-four people in photographs and their own words. People from all walks of life, ages, and ethnicities; these are the people whose stories of vision, hope, frustration, joy, courage, and renewal represent the greatness of Detroit past, present, and future. These people, and many thousands like them in Detroit, are the ones who breathe life into an often-maligned and frequently misunderstood city. From factory workers and autoworkers to business executives, artists, entrepreneurs, developers, community activists, union organizers, community bankers, social-justice advocates, urban farmers, cultural and political leaders, doctors and community health workers, lawyers, journalists, poets, musicians, educators, religious leaders, and steelworkers, these are the people of Detroit whose expansive humanity is poignantly captured through Gilles Perrin's sensitive portraits and Nicole Ewenczyk's insightful interviews. These are the people moving Detroit forward, remaking Detroit for the twenty-first century. These are the people of today's Motor City. ■

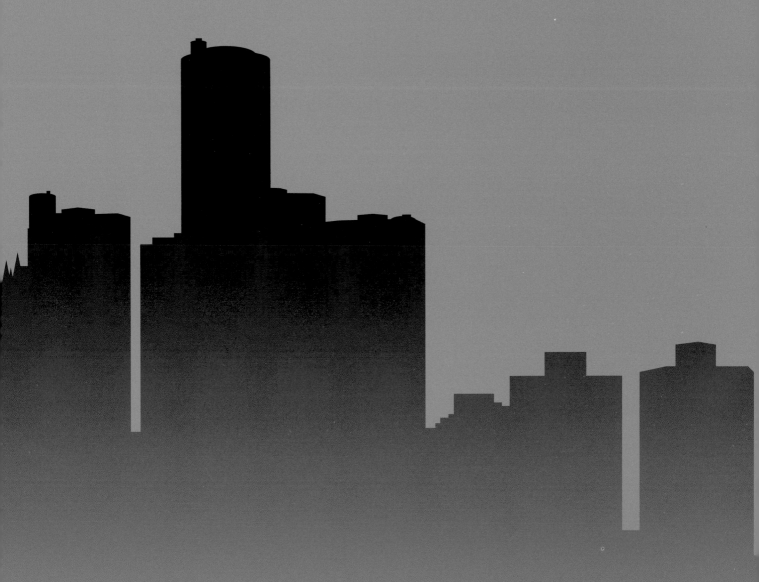

# portraits of the motor city

photographs by GILLES PERRIN and interviews by NICOLE EWENCZYK

I've always felt that this is where I belonged. I've thought about going other places, but it was always this is where I belong.

Detroit is definitely at a crossroads. There are forces that are working to create a different kind of Detroit, and some people don't believe in it. I'm very excited about the urban agriculture that's going on here and people who are creating farms and community gardens. I expect in ten years that we're going to see a lot of the open land in Detroit turn into gardens. The world population is getting ready to explode, is exploding, and all these people have to be fed.

So some people think the city should just give away buildings. I think they should at least give away houses. They're empty houses everywhere and nobody's paying taxes on them.

It's almost like in Paris where everything is around the neighborhoods. This is kind of developing into that. You know back in the 1950s it was pretty much like that. Not so much like in Paris, but every neighborhood pretty much had all the things you

## Larry Gabriel
WRITER, JOURNALIST, AND MUSICIAN

needed. I could walk to the market on the corner, there was a tailor shop, there was a secondhand shop. And neighborhoods, they had jazz clubs just right in the neighborhoods. Now everything's in the commercial area; it's like everything was owned by family so you could do small business. But now everything is owned by corporate interests and they have to make five million dollars every year, and if they don't make five million dollars that means they have to cut down. Now we're starting to get back to what we call mom and pop shops.

*From May 31, 2012, interview*

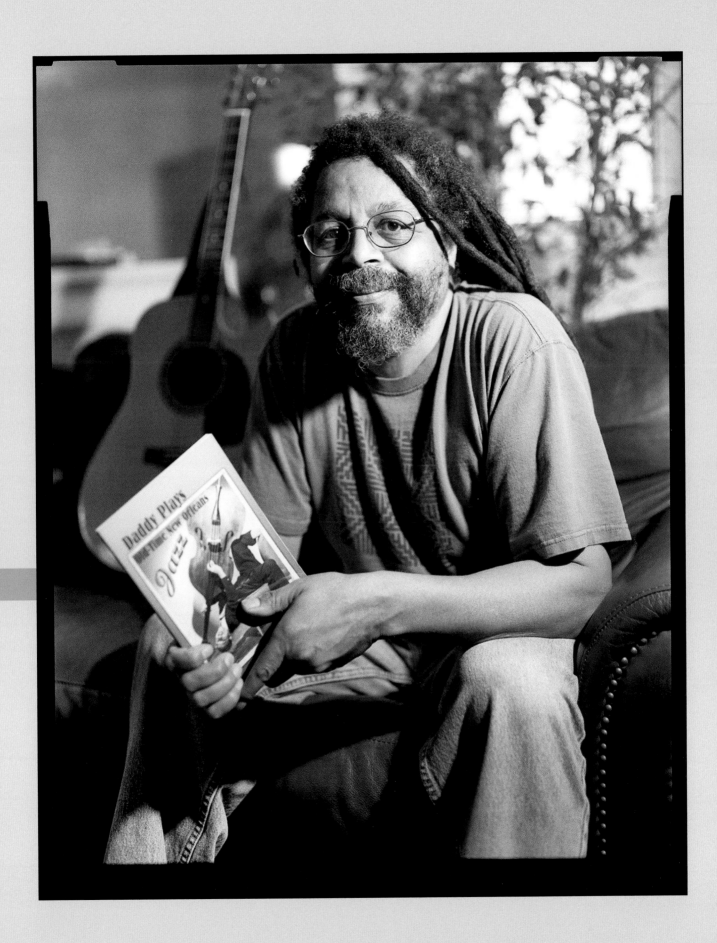

From 2000 to 2010 we lost a quarter of a million people—250,000 people we lost. And 2010 was the last census. Since the last census was taken we've lost about 35,000 more people. We will probably be a city at some point of about 500,000. We used to be two million. The problem is because once people left we have so much abandonment. People aren't paying taxes, there's no dollars coming in. You know we need those taxes to run government. So when they leave, they're not paying any income tax, property tax; you still have a city that's huge—we have 140 square miles. If you look at Detroit from up in the sky from a satellite, there are parts of Detroit that look like a farm, it looks rural, so overgrown. A third of the city is occupied with people, and we have tremendous abandonment, tremendous.

## Burton Leland
WAYNE COUNTY COMMISSIONER

So you know you have to do something very drastic. What you have to do to survive is just downsize, what they call "right size," move people out of neighborhoods where there's only one or two houses and move them into neighborhoods filled with people. You know you can't drive a fire truck, fix the water, fix the lights, provide garbage removal, drive a police car down the street with one person. There used to be twenty-five houses and now you got one or two houses. You just can't service that block anymore.

We're gonna fight the fight until we have no breath left; we're gonna fight the fight and we're not gonna give up, and this is our mission, to just make it happen, you know. There are incremental improvements that go on—you see the village here, the Sweet Potato Sensations across the street, that resource center, the Redford Theater, we're trying to make this a neighborhood, we want to make this a neighborhood. This is a neighborhood and we just have to do everything we can for it to survive.

And maybe it'll spread out and get better. So the town is only as good as its leadership; the town is only as good as its residents make expectations upon their leaders. And folks that live here, it's down to the basics, down to survival, and they don't make a whole lot of expectations on their elected leaders unfortunately, and if they had higher expectations on their leaders we wouldn't be in the hole that we're in right now.

*From June 13, 2012, interview*

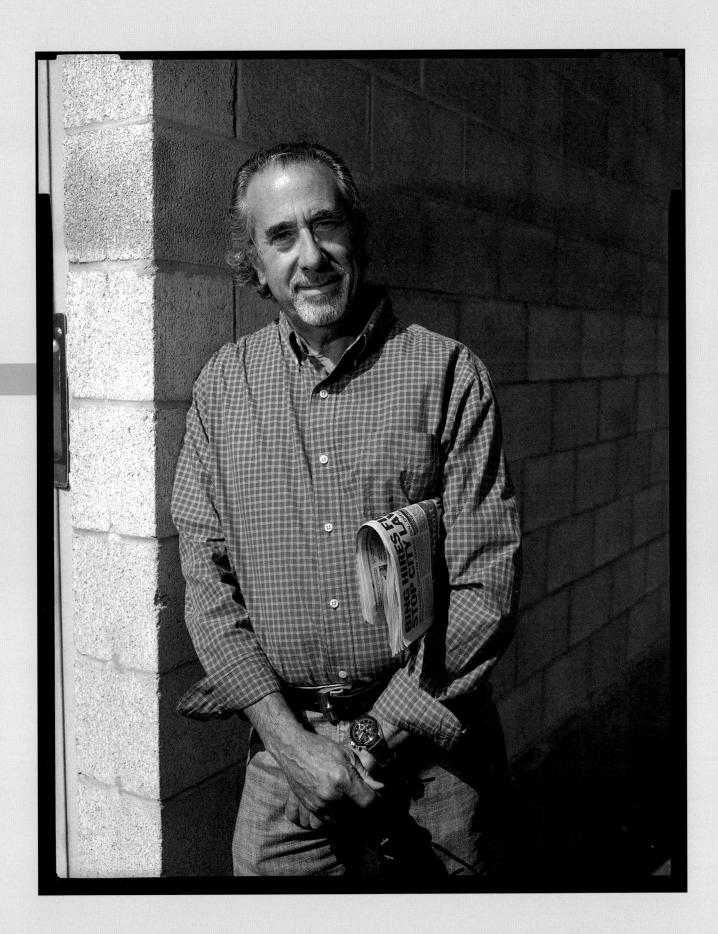

# Yul Allen

FOUNDER, STEM GENIUS

My passion for building things led into my passion for trying to help our city, because our city's in trouble, especially when it comes to the educational component. We have a pretty large dropout rate and that's not good. I believe it's mostly because the children either don't feel challenged, or don't feel engaged, or just don't find learning exciting. My goal is to combine what the real world needs, which is more engineers, people that solve problems, and an excitement in learning that discipline . . . combining it and then packaging and presenting it to the children.

On 9/11, people were running out of the World Trade Centers, and the firemen and the policemen ran into the buildings to save others. So many people are running out of the city of Detroit, and I want to be one of those individuals that run into the city of Detroit to try and save or inspire as many kids as possible, to get them into careers that our country and the world can legitimately use.

*From June 18, 2012, interview*

38

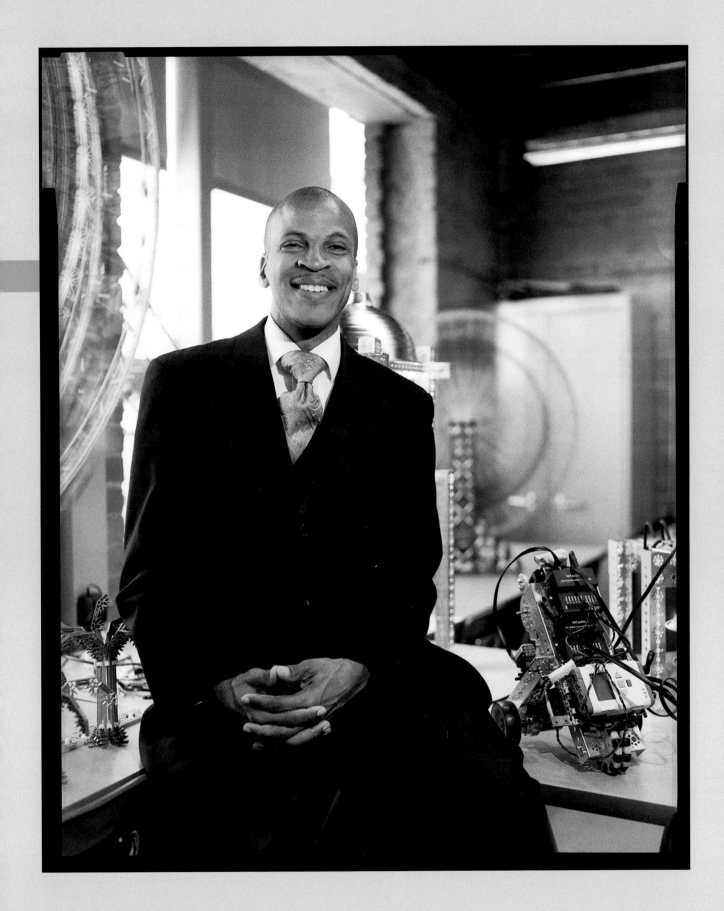

You know the Chinese characters for crisis, it's two characters—one is danger, and the other is opportunity. You have to seize the opportunity. I think the sense you have in Detroit is that it's the end of something and the beginning of something new. It's very rare that someone lives at that time, at that place, where something's disappearing, vanishing into the past, and something new is emerging. That's very inspiring, to be at that particular time.

We're going into a postindustrial society. What form it will take we don't know. But one thing is very clear: we're bringing the country back into the city. When you bring the country back into the city something happens. In the city, one is very de-skilled; so many things get done for you. You're so overwhelmed by the things that can be done for you that you do very few things for yourself.

# Grace Lee Boggs
## AUTHOR AND SOCIAL ACTIVIST

It's an impoverishment of the human being. I think people can become more collectively self-reliant, and local production makes that possible. We're in a world of global production that actually de-skills everybody, including countries.

It's going to take a long time; it took a long time to go from hunting and gathering to agriculture. It took a long time to go from agriculture to industry; it's going to take years to go from industry to whatever it is in the future.

I think that when things are blighted, as they are in Detroit, the alternative really energizes you in the sense that there's an alternative, and you can create it. It's an opportunity. And that is, I think, more likely to happen at the grassroots than at the top, because at the top they never really know how impoverished they are.

Reimagine work, reimagine education, reimagine architecture; you'd be amazed, architectural professors and urban-planning professors come here because they want their students to be planning for the future and not for the past, thinking in terms of architecture for the future and not for the past. All that glimmer-glamour and high skyscrapers was the old American dream; what's the use of planning for that? We're coming to the end of that.

We do visionary organizing. We encourage people to embrace the conviction that they can create the world anew, that that is actually what the soul is: the soul is not a thing, it's a capacity.

It's just amazing that here this is a learning journey in Detroit, exploring a brave new world re-creating itself as a loving community.

*From June 12, 2012, interview*

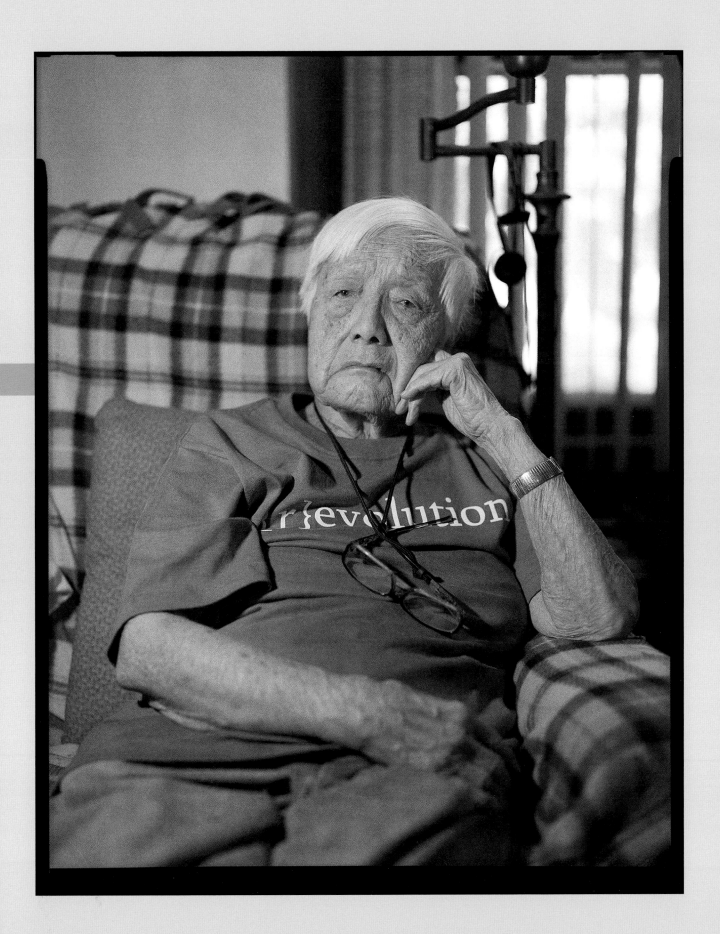

I was born and raised here and have lived here all my life. Detroit is really a fabulous city. Detroit has a really proud history, and one of the things that I think we can do better is utilize Detroit's history to help inform and educate the future. Detroit has certainly had a lot of challenges, but it really has been the home in many ways to what has happened in American culture . . . a whole variety of innovations, both manufacturing innovations and social innovations.

In the future, I think Detroit will be a very different place. In our neighborhood here around the Detroit Historical Museum in the past five years it's transformed dramatically. Right now you can't rent an apartment here, you can't get a leased parking space, it's all full, and the same with downtown Detroit. And there's a very significant influx of young, educated, creative people that are interested in having an urban experience, living in an urban setting—and Detroit is very welcoming. You can be very creative, you can be inventive, you can be an artist, you can be any number of things and get access to space or a facility and start your business relatively inexpensively compared to somewhere like New York. If I look out my window here, I can see people pushing baby carriages and walking dogs—you never saw that five years ago. And you see in the evening here and in downtown, it's very lively, there's lots of people enjoying the waterfront, the riverfront, the new vitality that's really coming across the city.

Detroit has its share of challenges, education and poverty, and the gap between the people who have achieved and have not achieved is big and is growing, and you know those are all issues that you can't ignore, they certainly have to be addressed, but if you look at Detroit's history, there's precedent for solving all of those. Back in the 1800s one of the mayors of Detroit, Hazen Pingree, had an innovative plan to give vacant land to poor citizens that didn't have jobs so they could farm the land,

## Bob Bury
EXECUTIVE DIRECTOR AND CEO, DETROIT HISTORICAL SOCIETY

and we're thinking about doing the same thing today. Some of those things are not without precedent, and in the end Detroit will be a stronger, very different city than it was in the 1920s, '30s, '40s, '50s.

You know there's a trend that people would grow up here, go to college, move away, and then come back. And why did they move away? Because many younger people wanted to have an urban experience—a vibrant urban experience that Chicago gives you, for example. And Detroit did not do that for the last thirty or forty years. Now it's starting to do that again, so we're hopeful that people will stay here rather than move—and some of them never come back, but a lot of them do come back.

*From June 13, 2012, interview*

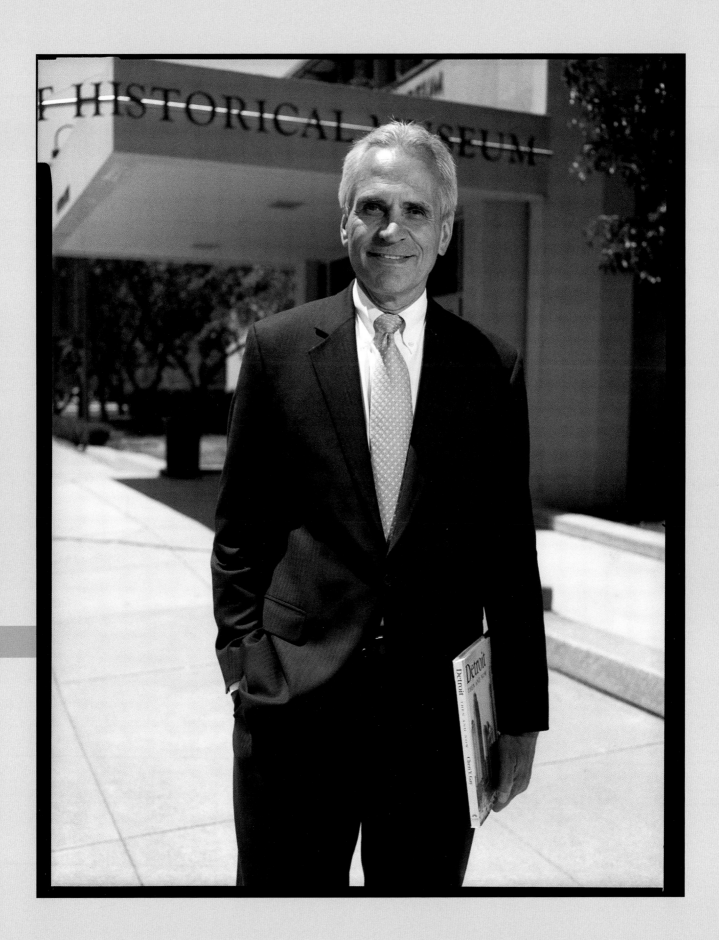

There are a lot of books about how Detroit got to where it is today. But nobody had written a book about the future of Detroit. Where do we go from here? So that's what I wanted to do.

The city is experimenting with a lot of interesting things like urban farming, like using art in public places. The city government is being reshuffled, remade even as we speak because of the financial crisis. We're reinventing the state's economy and schools. So we're in this very interesting period of experimentation in the city in redefining what Detroit's going to look like. What to do with all the empty land? So we'll see where we are in five years. We'll have more urban farming. It will be a greener city. I hope that we will restore the natural landscape. Through the 1950s, Detroit was so industrialized and built up that

## John Gallagher

REPORTER, *DETROIT FREE PRESS*; AUTHOR OF *REIMAGINING DETROIT*

every inch of the city was concrete and asphalt.

I think the city will be greener; the businesses will be more entrepreneurial. Detroit and Michigan for a hundred years was big corporations, big government, big unions. And more and more it's being pushed lower and lower, so you have artists, and urban farmers, and neighborhood people making decisions about what their neighborhoods are going to look like, what the city's going to look like.

Detroit is the car city. It's hard to understand Detroit unless you understand how dominant the car industry was. Not just economically, but culturally. If you go to the art museum, and you look at the donor wall, people that gave money—Ford, Dodge, Chrysler— it's the auto companies. They did everything in this town. And so that's why when they started to collapse in the late nineties, that's why it was so devastating here.

We're working on urban farming; we're working on re-creating the schools. The artists are moving in and taking over. So we are working on a lot of stuff. Its just the problems are so massive, that it's hard to see that you're making progress except in this area. You see a lot of progress. You don't see as much out in the neighborhoods. But we're trying a whole lot of stuff, which is what makes Detroit so resurgent.

*From June 5, 2012, interview*

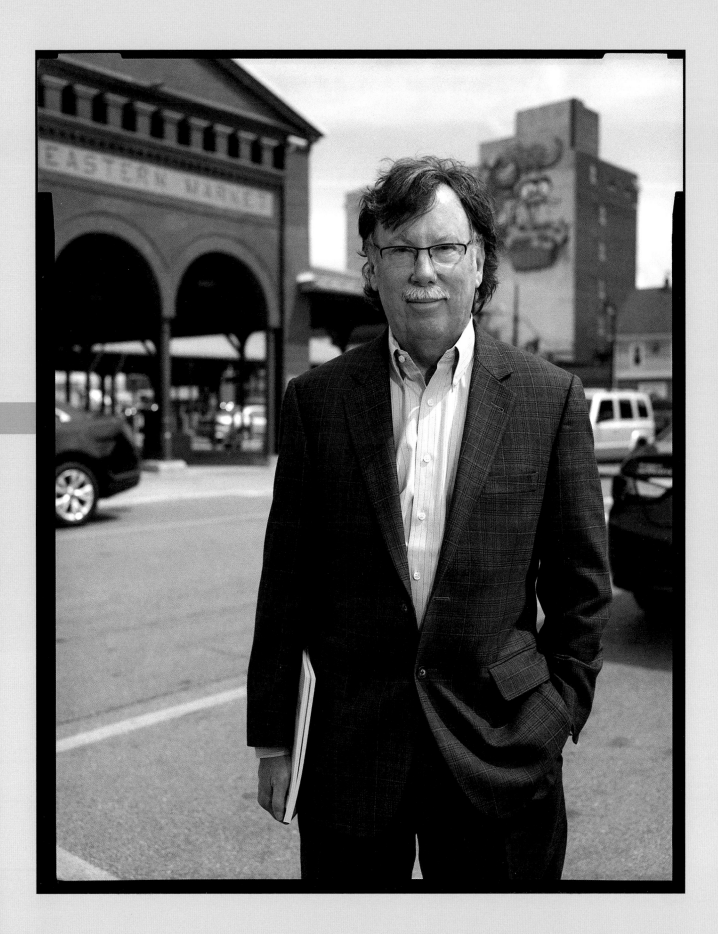

This is a natural hair, organic, full service salon. Here we cultivate natural hair. Meaning that we take hair, African American hair, and we groom it, we style it, we twist it, we braid it, we coil it, and we do all sorts of things to our hair.

I started eighteen years ago in my home. I wanted to do something to financially sustain myself, and my child, as well as help other women to find their inner beauty. At that point that's where I was. I was at a point in my life where I was searching for myself, searching for what's inside—the best part of myself. For African American women, hair is your crown, that's our glory, that's our halo. So it was very important for me to understand how to connect with my crown and connect to my heart.

You know, I see a lot more creativity coming to the city now. So we'll see what happens. The politics have to change. The politics have to catch up with the people because the people are leading the way. The politicians just are lagging; they're not quite getting it. I think that can happen. I really, really do. I really do. You know Detroit is a city of activism. It always has been. The people have always risen to the top in our Detroit.

We're seeing a lot of people who are actually from Detroit, have left Detroit, and are coming back. That's great and I love it. And they're bringing fresh energy because they've been somewhere else. They're bringing a fresh perspective on how to make things better here.

*From June 16, 2012, interview*

## Nefertiti Harris
OWNER, TEXTURES BY NEFERTITI

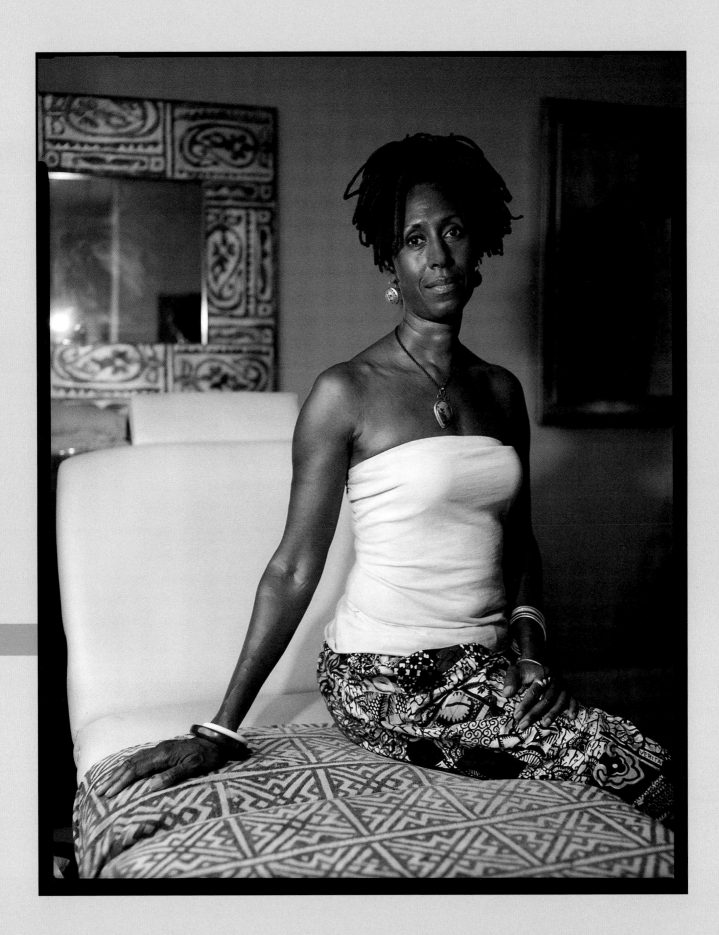

I didn't study art in college; I studied psychology. Though as a psychologist I saw there being a connection between art and mental health. I'm talking about community mental health. I thought you need to have a vibrant art program and that would help the community and the whole mental-health need and how everybody interacts—it's just a better environment. As a young

# George N'Namdi

PRESIDENT, N'NAMDI CENTER FOR CONTEMPORARY ART

man at twenty-two years old I acquired my first piece of art when I was an undergrad in college. I didn't study the visual arts, but I was a person who always had a love for the promoting of culture.

If you go ten years back I'd say most of this wasn't even here, and I think if you go ten years from now it's going to be equally as different. You know, I think it's really changing a great deal and it's really changing fast, particularly this area; this is called the Midtown area, and within Midtown our particular area is called the Sugar Hill Arts District, and this is an area where a lot of the night life and jazz clubs happened back in the '40s, '50s, and '60s.

I started with African American artists because it was like I was working with the African American community. I was talking about the mental-health needs—it's like you have people getting more and more into culture; they have more and more outlets in their lives and stuff. That's what I really started was more like a preservation of African American culture, and I think we've kind of accomplished that and made our mark.

It's been a labor of love.

*From June 7, 2012, interview*

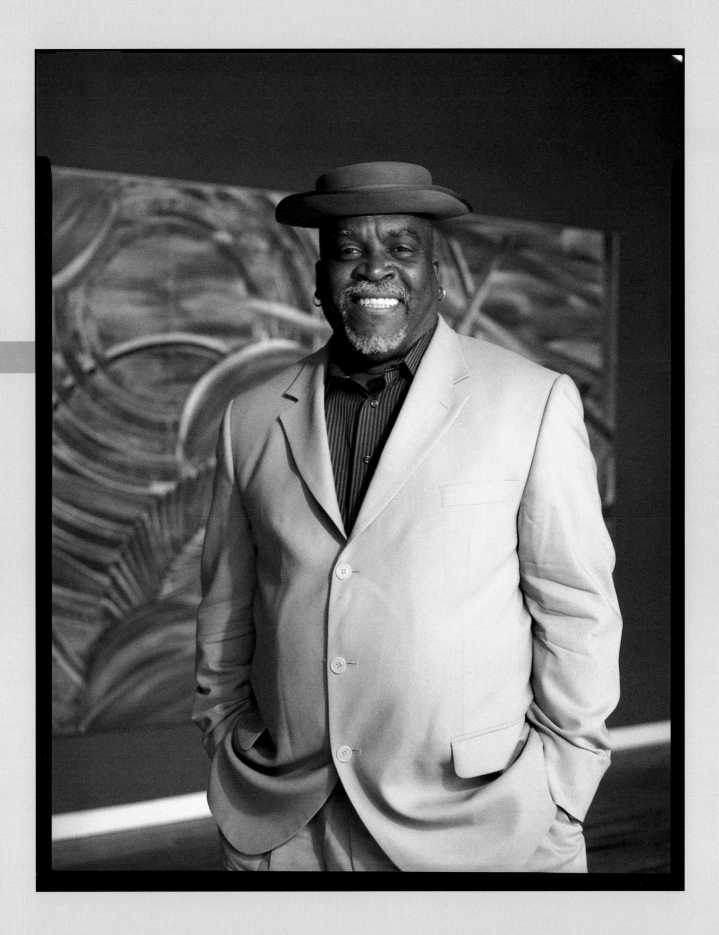

Nataki was the name of our daughter that died. It was her first name, and her middle name was Tahliba. Nataki means "of high birth" and Tahliba means "seeker after knowledge." It's very interesting that she should one day have a school named in her honor; you couldn't even have imagined this. She died when she was fourteen months old.

A good friend spoke at her service and he said, "You're missing her on the physical plane, but don't miss her on the spiritual one." And that's when we decided to open a school and name it after her. We just began. We gave ourselves a deadline. We said we were definitely opening in 1978, come Hell or high water, and that's what we did. We had no money; we had nothing but nerve. And we felt brave because we felt we'd been through the worst thing in the world. What could we possibly be afraid of? Well there's plenty, but we didn't know it at the time. We thought this has got to be it (*laughing*), this has got to be the end of the world, so we're in pretty good shape.

There was a story once that I was hearing. Somebody read to one of the kids, and it said girls can be anything. Well the girls didn't understand it. They kept saying, "Why are they saying that? Why did they say we—they think we couldn't be anything?" And the boys were saying, "Well how come we can't be anything, too?" The kids did not understand it. Somebody being very progressive wrote that story, but she doesn't know that she took everybody back into something, now you've got to explain that. So now

# Carmen N'Namdi

FOUNDER OF NATAKI TAHLIBA SCHOOLHOUSE OF DETROIT

the kids are full of all kinds of ideas about things that they never had. And we don't say "black" or "white," we say European American, African American, Asian American, because these colors also are a problem. If you say, "What's wrong with the black family," it sounds like nothing's wrong with the white one, because opposites just automatically imply something that you don't even know you're saying. So we try to go with the culture; plus this country is very racial, not cultural. Race has so many connotations because it's physical. We can all enjoy each other's cultures, but we can't enjoy each other's races. It's really just an identification that you're using for some purpose that usually is not a good one. We try to keep this natural sense of things.

*From June 7, 2012, interview*

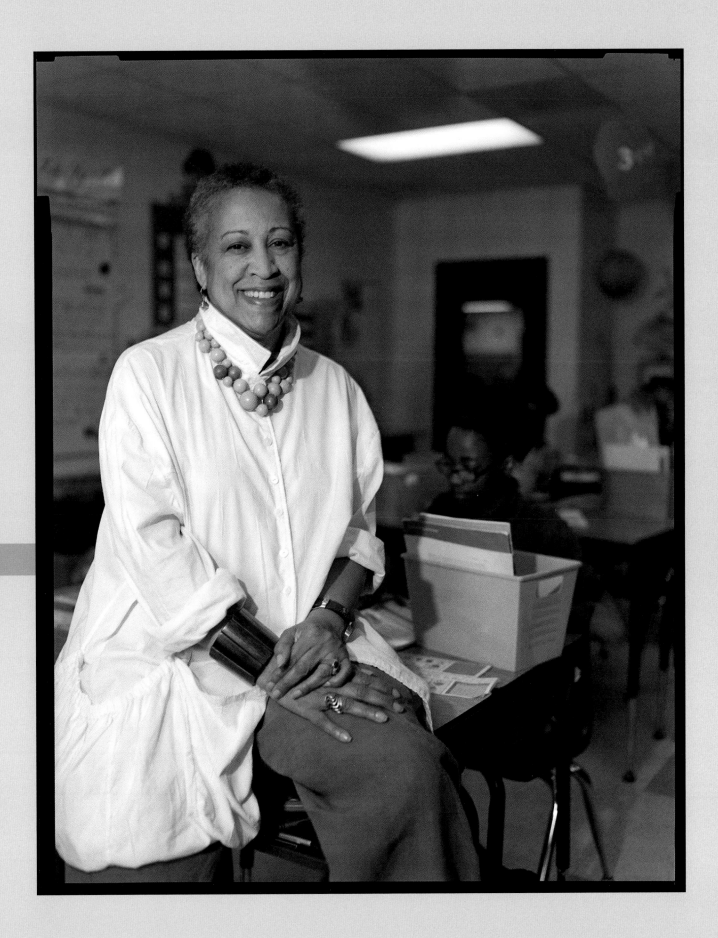

Arab Americans are incredibly misunderstood in this country. I mean we've been here since the founding of America. We're talking hundreds of years. Yet most people perceive Arabs as being an unknown group, a new immigrant group. So a lot of our work is really about educating and dispelling stereotypes and also building community for Arab Americans. So we're seeking to build community, build pride, build community history.

# Devon Akmon

DEPUTY DIRECTOR, ARAB AMERICAN NATIONAL MUSEUM

We work with a lot of the other ethnic groups here in metro Detroit on a grassroots level, building programs together. Really trying to break down some of the silos, some of the stereotypes, some of the misconceptions. So we're doing that locally, and we're also doing some work on the national level and even the international level.

We see an impact. We see people coming together. One of the things that we do to build community, for example, is we hold one of the world's largest free-world music festivals in the nation in Detroit every summer. We basically created an organization of almost seventy different ethnic groups and organizations in metro Detroit that plan this together. So we're bringing together all these people to kind of present culture, and celebrate our diversity as a region. So that's just one way in which we're bringing people together; we're convening, we're talking, we're sharing our stories, our histories, learning a little bit about each other. Maybe dispel some of those stereotypes and misconceptions.

There have always been stereotypes; there have always been misconceptions. All we can do is continue to work to dispel those, to educate people, and celebrate both our uniqueness and the things that make us, you know, one. The American experience is what we're starting to do. One of the main stereotypes we try to dispel too is that everyone just assumes that all Arabs are Muslim. And in the U.S. over 60 percent of the Arabs are actually Christian. So right there we're informing people . . . I'm Arab but I'm Christian.

*From June 14, 2012, interview*

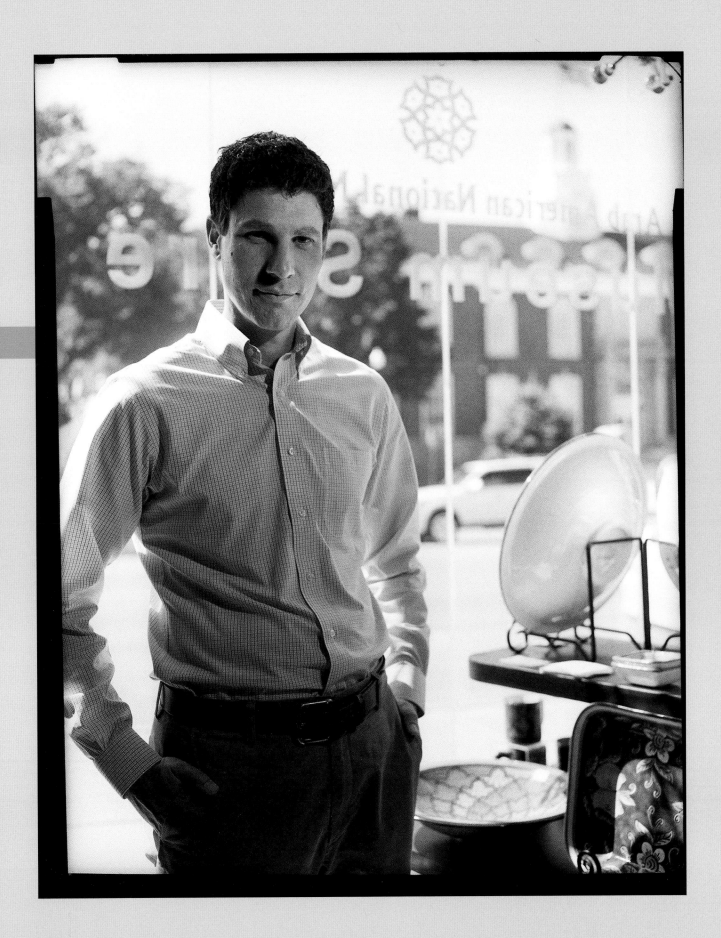

# Ghada Aziz

ASSISTANT COORDINATOR, BREAST AND CERVICAL CANCER PROGRAM, ACCESS

I love working with my community, the Arabic community. The ladies trust me because they like an Arabic woman. They like to talk with emotion about where they come from. But when I start professionally here, I start to do home visits, one-to-one with the counselor program, because first you have to build the trust between you and the community, the woman. So I went to the mosque. They see me everywhere. I went to churches, schools. Dearborn is a very small community. Maybe I will see this person in the grocery shop so they know me very well. I like to do it. I like to see people.

I am a health educator with the women. Cancer is a very sensitive, very, very sensitive word to them. They thought it was a death sentence. But I talk with them . . . and I have a way to talk with them. I don't want them to be afraid. I teach them this disease is like any disease: you can treat it.

[After a woman is diagnosed] with cancer, I have to follow up with her, schedule her an appointment, make the arrangement, give her transportation if she doesn't have a car. Some patients I take to chemotherapy. I don't want any credit. I just like to help them because I feel bad for them. I know what they're going through, especially when I am a cancer survivor from 2009. So I know.

My mission is to help my community. This is my mission. This is my goal. I want to feel like they are in good shape. They care about themselves. They are happy. I want them to feel happy.

*From June 15, 2012, interview*

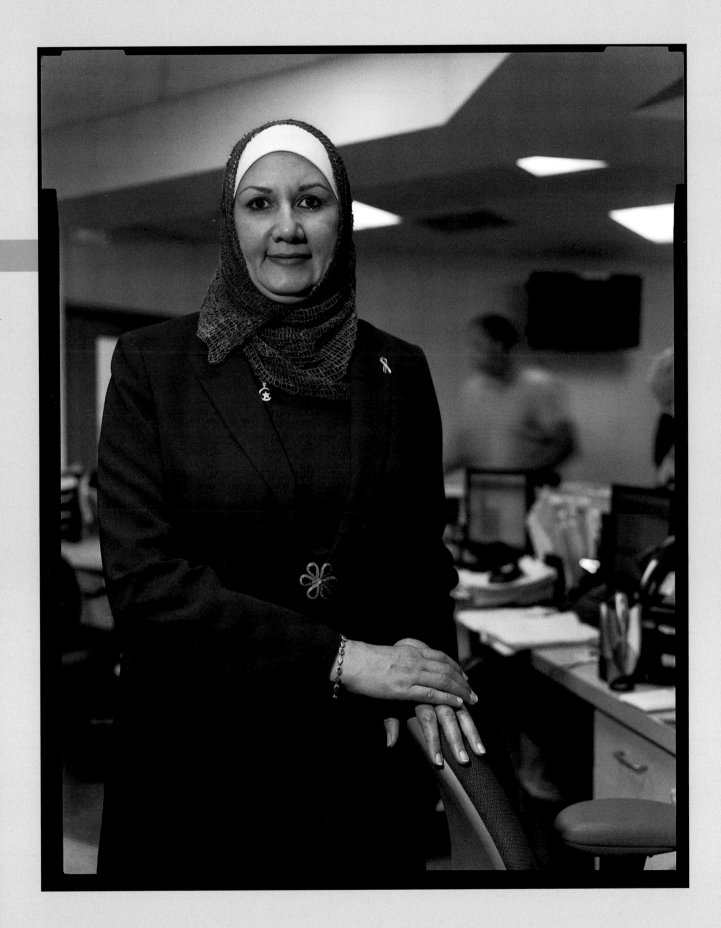

My father's father was a pastor, my mother's father was a pastor, my mother's uncle was a pastor, and so I think I was born to be a pastor. Of course I didn't want to be a pastor and still don't. But I feel compelled to pastor. As a child I wanted to make a lot of money, I wanted to be rich and powerful, but when I turned twelve I had a vision, heard a voice, of a church and people, and I was pretty sure at twelve years old.

My passion is definitely giving back and filling the need. Our community has such a need for spiritual leadership, social, cultural leadership. Our culture is in my opinion almost cancerous, almost poisonous. And so I have tried to position myself on the front lines of that recently, really, really challenging the culture both inside the faith and outside the faith.

One of the things I think spiritual life offers is faith in the eternally abiding things, faith in freedom, faith in justice, faith in truth, faith in righteousness, faith in God. I mean I believe in politicians, but that's just a cheap faith, right?

The people give. And we don't have a rich church, but they give. It's a rough city, but there's hope.

We're in urban farming; we're getting ready to put up some hoop houses and we're going to do some food production. We just got a grant from

# David Bullock
PASTOR, GREATER SAINT MATTHEW BAPTIST CHURCH, HIGHLAND PARK

Whole Foods. We're going to have a training program and we'll be tied to independent grocery stores selling fresh produce, and maybe eventually Whole Foods. I eventually want to [have] a couple chicken coops, some goat farms, and do some dairy products and really try to reclaim the land. If we're not going to do high-rise development we might as well reclaim the land. We could actually put people back to work doing that too. If we get the community involved, they'll maybe own it. In ten years we'd have full-scale production.

We'd like to create a lifestyle so it's not just food production, but it's an eco-lifestyle that changes the culture. Which brings people together, which builds community.

*From June 13, 2012, interview*

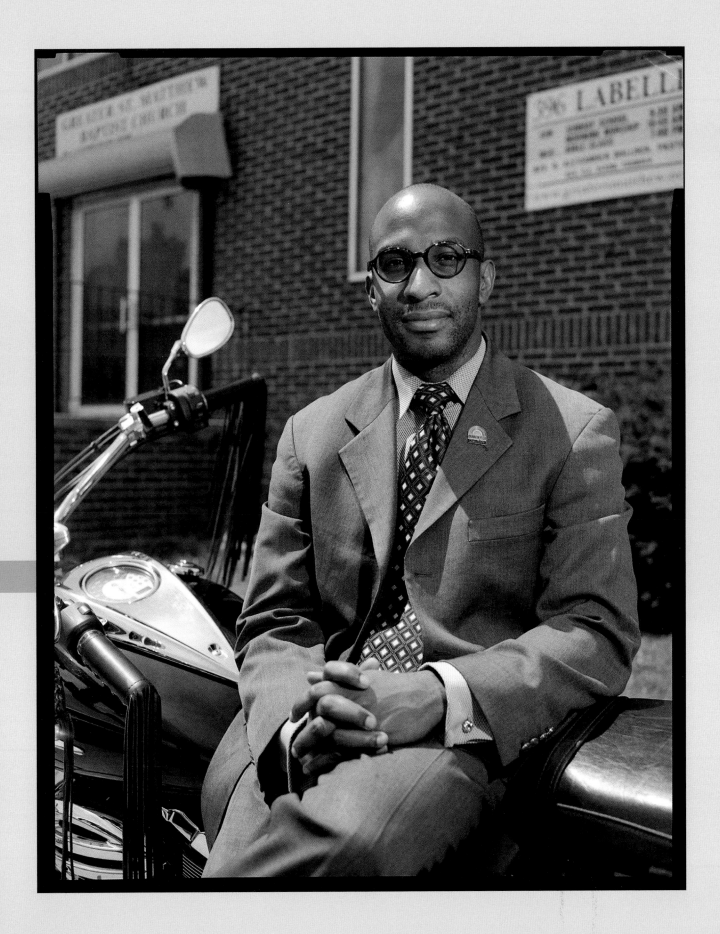

I have a great job in Detroit where I represent the government in civil rights cases. I have a job where my work is in harmony with my beliefs. My office does phenomenal work and it's a privilege to be here.

A couple summers ago, I had a trial where a landlord was sexually harassing and abusing female tenants who were very poor and vulnerable. As a lawyer for the government, I sued the landlord and property manager on behalf of the victims of harassment. The case is called *United States v. Peterson and Johnson*. We went to trial, and the jury found in favor of the victims. Although cases like this one can be a lot of work, they are very satisfying.

I think that protecting civil rights is critical to maintaining a democratic society and to building a healthy and viable community. The sooner we have people's civil rights being honored and respected, we will be a community where people want to live and educate their children.

*From June 14, 2012, interview*

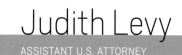

Judith Levy
ASSISTANT U.S. ATTORNEY

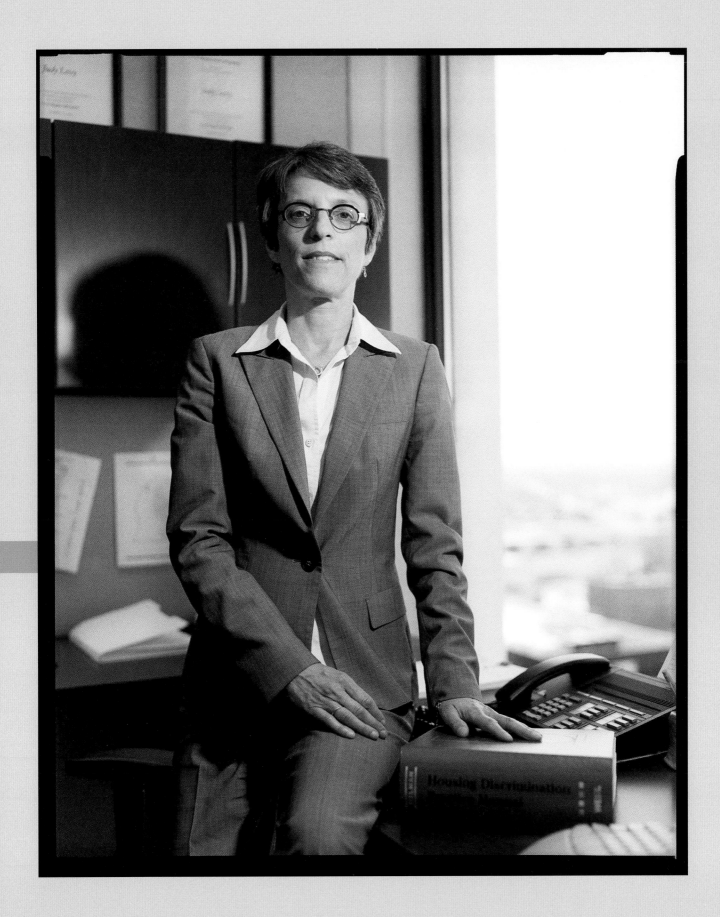

I am with the Detroit Coalition Against Police Brutality. I'm the spokesperson for that organization, and one of our prime activities is Peace Zones for Life, which seeks to avoid violence and murder before it happens.

I like to think what we're doing now is really the public safety of the future, where people spend 90 percent of the time resolving

# Ron Scott

SPOKESPERSON, DETROIT COALITION AGAINST POLICE BRUTALITY

conflicts before they get started by talking, 10 percent involved may be in some form of restraint, because some people you do ultimately have to restrain. But for the most part it's only with 5 percent or so of the population that you actually have that kind of challenge. We are trying to look for a way into evolution into a better species.

I have a real feeling about wanting to save this generation of young people. People criticize this current generation and say how negative they are. I find this generation, specifically those born in the '90s and the 2000s, are probably some of the most creative, some of the most astounding human beings on the planet, because they have found a way to survive and live and maintain their humanity when the whole world is going crazy, when they don't have the jobs that they need, when they're paying too much if they go to school, when they've had to challenge and change and move beyond race and gender and all the other things to really try to become whole human beings. I think that they're a wonderful addition to humanity. If we can create an organization that transforms, that moves to the future from an altruistic standpoint, I'll feel that we've done something important.

*From June 11, 2012, interview*

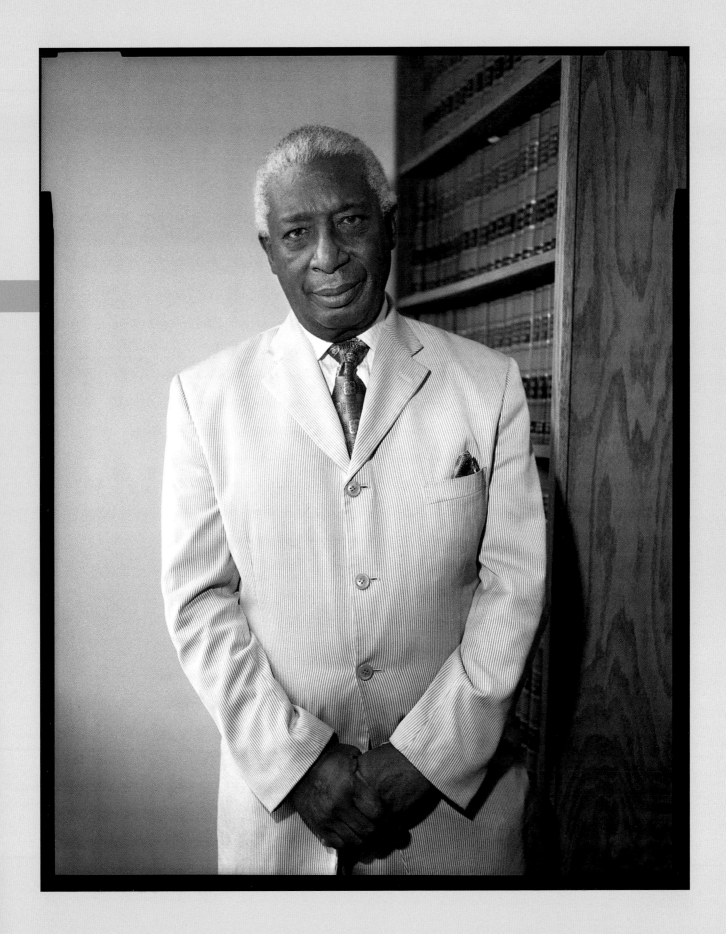

# Richard Brodie

CEO, WICO METAL PRODUCTS

We're in the auto business. We make metal stampings and we sell them to most car companies, certainly all the domestic car companies. And 2008–09 when GM and Chrysler were facing bankruptcy, it had a tremendous effect on our company.

We almost called it quits. The employees worked for half wages for a while, and for a month everybody went with no pay—more than a month. And here we are in 2012; we've bought six new pieces of machinery similar to the ones I'm going to show you on the shop floor. They will arrive in December and January. Our company is twice as big as it was before the downturn, and so you can tell by the smile on my face that business is pretty good.

*From June 7, 2012, interview*

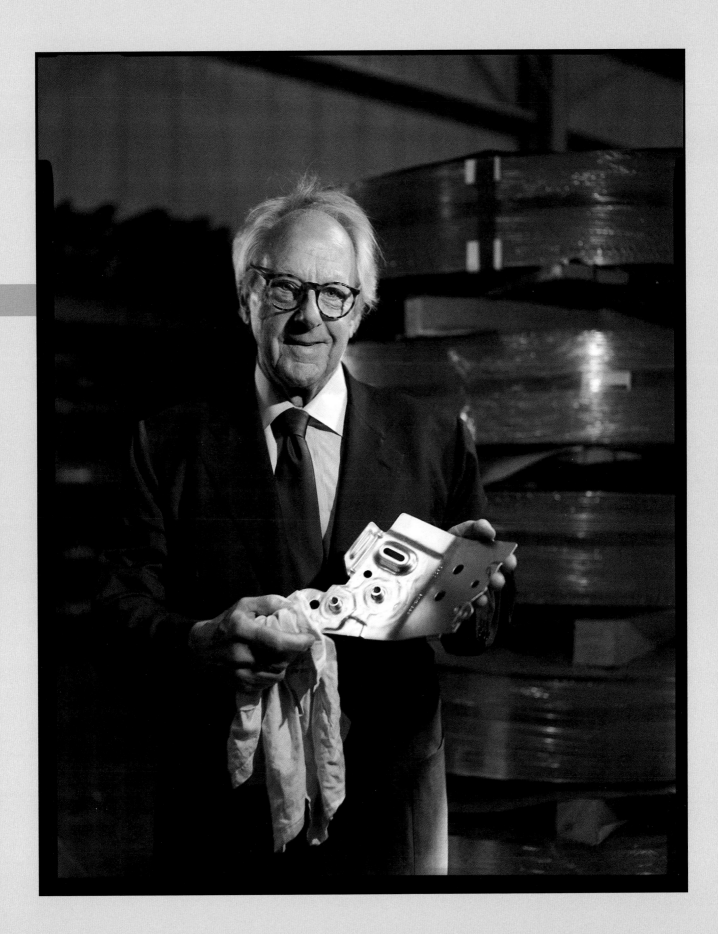

My mom got me in here [Wico Metal Products]. It's a good place. I like what I do. Everybody's nice. You get along with everybody. Hard workers. It's easy going. People help you. There is no dumb question. And if you need help, they will be there to help you. Whether a bad situation or good, you got everybody behind you. This place is wonderful. Everything runs good. You got your ups and downs. I've never had any complaints.

*From June 6, 2102, interview*

## Jett Kulaga
PRESS OPERATOR, WICO METAL PRODUCTS

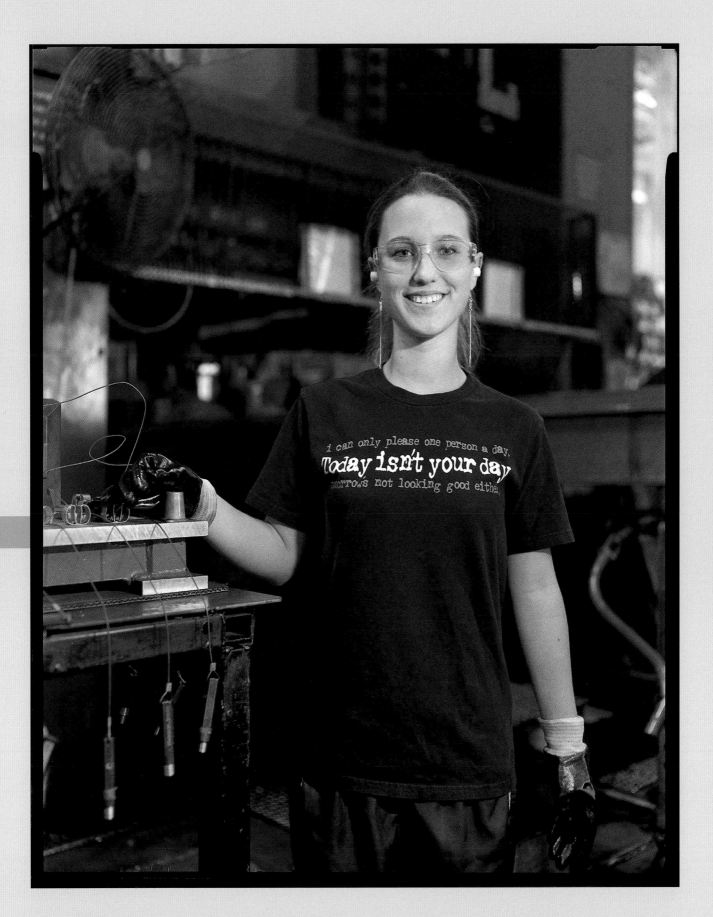

I think Detroit's coming back. I think obviously the auto industry coming back is really helpful to Detroit. It's a wonderful location on the river here; I think there are a lot of natural assets that Detroit has. I think businesses like Compuware, Quicken Loans are coming and locating in Detroit, so I think Detroit will rebound; it'll be a very vibrant city in five or ten years. It's changing—less manufacturing, more different service industries—but there still will be a strong manufacturing component to the success of Detroit.

I think what's really unique in terms of the industry is it's a

## Bob King
### PRESIDENT, UNITED AUTOWORKERS (UAW)

collaboration of workers and management and government who really came together to save the industry. Workers take tremendous pride and will fight about quality if they think the company is doing something that will produce a lower quality product. We feel like the union took a lot of criticism about the crisis the company was in, and a lot of it from our viewpoint was not justified. When good-quality vehicles weren't being made, it was because the company chose to push more out the door instead of maintaining the quality when companies didn't have the vehicles that consumers wanted. It's not workers who decide what the product portfolio is going to be. There's nobody that has more at risk in the long-term success, or more at stake in the long-term success of the company than the workers. CEOs come and go, shareholders come and go, top management comes and goes—workers are there, that's their life. And their pensions and health care and their families' security all depend on success of the workplace; so workers really pitched in, made a lot of sacrifices to save the companies, and now as part of all that, they have a much stronger voice in quality and productivity and what's going on in the workplace.

That's been my experience, sometimes management really gives them a voice and sometimes they don't. The workplace and the manager succeed more when the workers really have a voice.

*From June 7, 2012, interview*

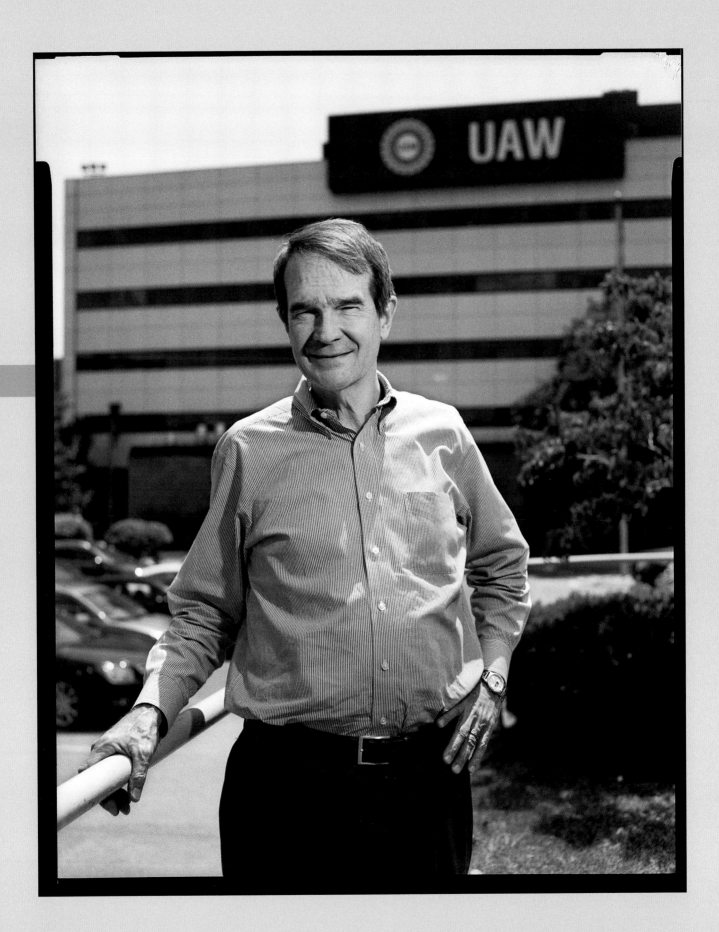

# Monique Watson

WORKER, GENERAL MOTORS CHEVY VOLT PLANT; MEMBER, UAW LOCAL 22

Being a single mother of a little boy was hard. Getting a job at General Motors gave me a chance to better take care of myself, and my son. On the outside looking in, you don't know how much work it takes to make these cars. So it was a little overwhelming, but seeing the part that everybody plays in their job, it made it a little easier. Once you got into the swing of things, it wasn't so bad.

We have people coming here from all over the world to see what we're doing [with the Chevy Volt]. It makes me have real pride in my job and everything we're doing here at General Motors. It's just amazing to see the expressions on their faces, how impressed they are . . . it's a good feeling.

I think a lot of people don't understand the importance the auto industry has for this region. When we were going through all the bankruptcy and all the bailout talk, I feel like people didn't see the bigger picture. It's not just all our jobs. We work in this factory, build our cars, we work hard. We're also business to so many people. If we're going strong, it brings the economy up around us. I think as long as we're thriving, it's going to build the whole region up.

I just want people to understand the importance of the auto industry, how it allows us to take care of our families and not have to struggle, and the importance of the impact it has on the whole economy, the whole community.

*Portrait, June 7, 2012. From May 27, 2013, interview by John P. Beck*

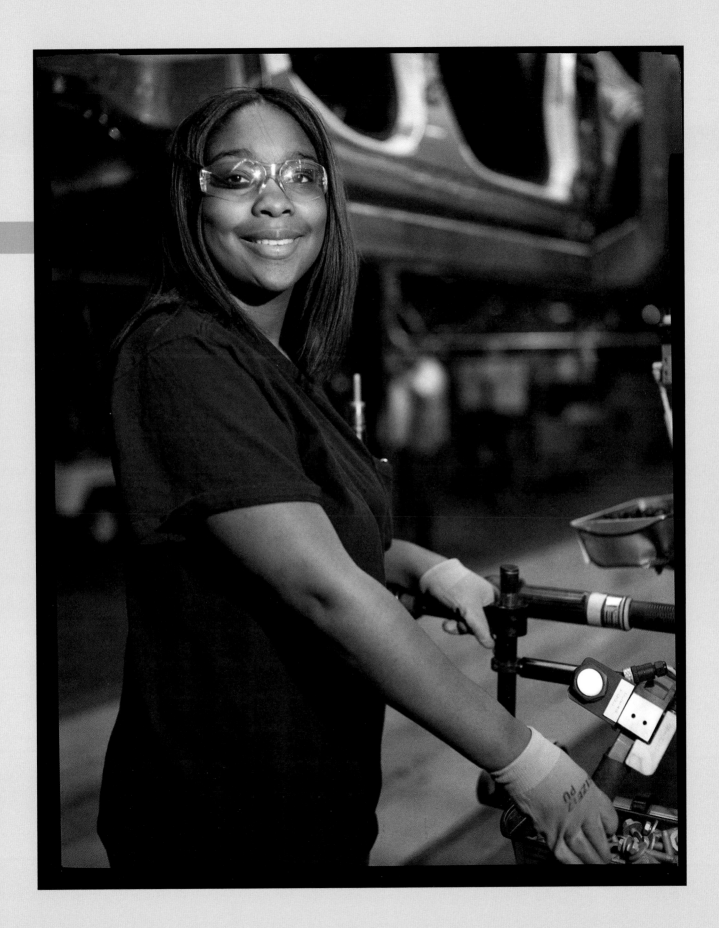

I've been drawing cars since I was two and a half. At age eleven, I wrote GM and said I wanted to be a car designer . . . for GM. They sent me great information and I just followed their lead. I've been with General Motors my entire adult life.

The future? Well I think there's going to be a radical change in the market. Fuel-economy standards are going to cause some very different changes. It's going to be very competitive. Everyone will have the same technologies; so design, the aesthetics, will be the great differentiator. It was that way back in the 1930s, it is today, and it will be in the future. If everyone has got autonomous driving, fuel cells and all that, the good-looking car will do better than the other one. You know if everyone has great quality, then the aesthetics will have an influence, will make the difference. How we communicate the designs with our customers may change in many ways, but it will remain to be very, very important. The customers don't want to hear about our challenges; they just want a great car.

*From June 15, 2012, interview*

## Ed Welburn

VICE PRESIDENT FOR GLOBAL DESIGN, GENERAL MOTORS

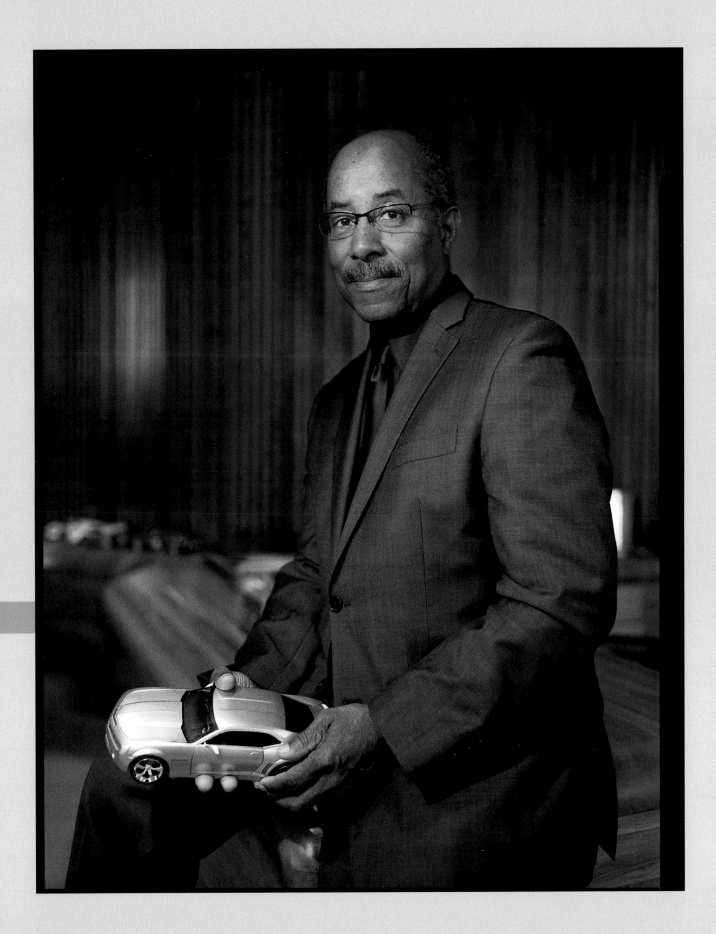

# Joseph Keys

OWNER, CORRECT CAR CARE

I was born here, lived only here. We get to see all four seasons [in the] Motor City. I don't have no desire to go anywhere else.

I think in my heart people fix old cars compared to buy new ones; we've seen more of that in the last five years, that people are fixing their cars rather than buying new ones. Not every part's interchangeable anymore. I can make exhaust systems to put on cars; I don't have to buy the systems. I make my own.

The more they design and build cars, the better they get. Let's face it: they have been building cars for a hundred years. They're going to get better and better and better the more they build. They are more and more difficult to repair, but they are better. I mean you got cars that can park themselves; you can make phone calls out of your car. You couldn't do that twenty years ago.

*From June 1, 2012, interview*

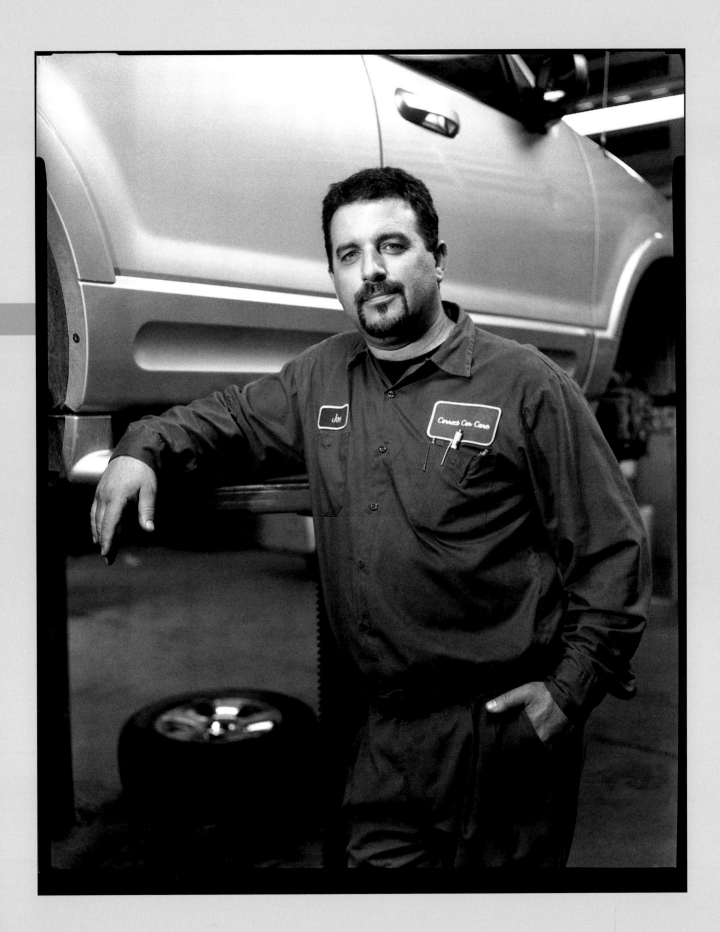

I've always had a passion for the city. I always talked about Highland Park and let the world know that I'm from Highland Park. People used to say, where is that? In the middle of Detroit.

I'm out in the community. I work all day and all night. I mean at night I'm riding around the city, really getting engaged. Talking to people, just being up and close in person and let people know that there's someone here to care. I'm not saying that I can change everything overnight. It's a process that I need you to be involved. So if you see something in the community, call right up to City Hall and we are going to take care of it. It's a rebuilding. And that's my theme: it's the rebirth of Highland Park. We want to get back to being that model city that we were in the past.

I know it used to be a community. I know the people next door used to care about everybody on the block. So we got away from that. And that's what happened to our community.

And once people see that people care, that's when you change the mentality. And that's when people start picking up paper, that's when people start to worry about someone else throwing paper around, that's when people start speaking up—they see people doing things, they start making phone calls.

# DeAndre Windom

MAYOR, HIGHLAND PARK

And that's my message to everybody in the city; this is your city. This is your house. You wouldn't allow anybody to come to your house and tear up your house; so why do you let people come to your city and tear up your city? You have to live here every day. If we don't take a stand, who will? Nobody is going to come from the outside and come in and clean it up. It has to start from right within. Once we start doing it, then people from the outside will start coming back.

*From June 6, 2012, interview*

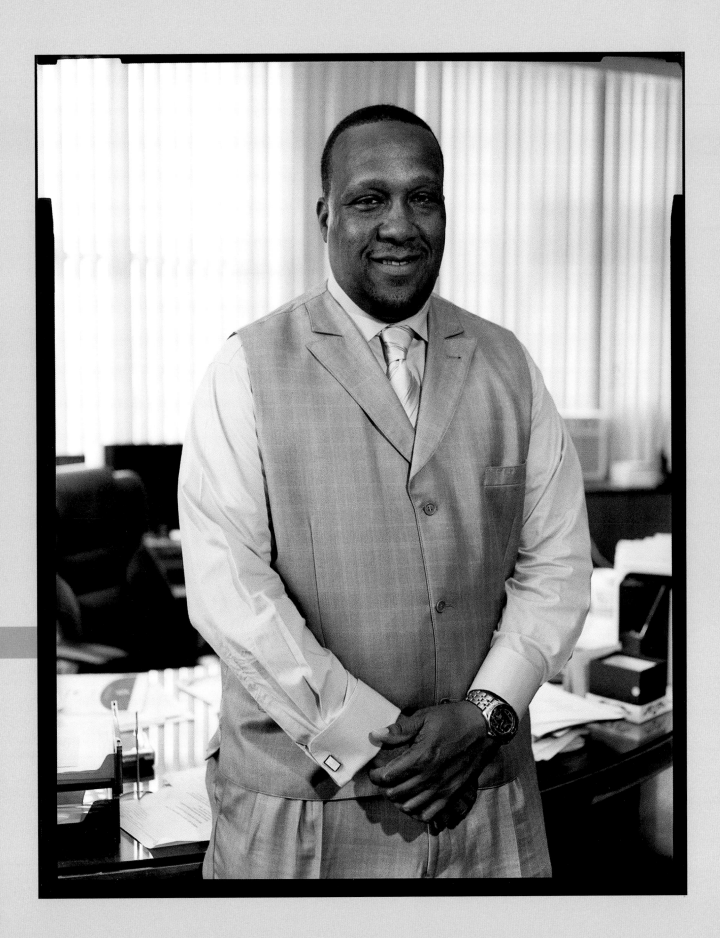

April 1st of 2008 I walked into my office, I looked at my partner, and I said I can't do this anymore. And he said, why? I said I'm fifty-three years old and I don't need to be in business anymore. It's just not about the money. It's my time to give back. I didn't know what I was going to do. A friend of mine took over as the CEO of Share, which is a substance-abuse treatment program in the city. He asked me if I wanted to help organize the agency; that grew into trying to find jobs for Share's clients, about 6,000 people a year. Very challenged people: a lot of them are coming out of prison, a lot of them have mental-health issues, most of them

# Gary Wozniak

## PRESIDENT, RECOVERY PARK

can't read and write on an eighth-grade level. So I started taking a look at assets in the city, and the city's got a lot of land, and a good infrastructure, access to water, an available work force, and farming just kinda . . . so here I am.

Recovery Park is a project to create jobs for people and communities in recovery. Jobs for people that have normal barriers to employment; people coming out of prison, people with mental-health issues, people that are educationally challenged, people coming out of substance-abuse treatment programs, which is about 70 percent of Detroit's nonworking population, about 140,000 people.

I'm having a ball. All the skills that I've built up for thirty-five years in private business—you know you use one skill here, one skill there. I'm utilizing all my skills for this project, and a lot of them are being challenged. I'm being taken into areas I never thought I would go into, dealing with government agencies, which I've never had to do in the past. We have ninety different organizations that are partnering on our projects, so I'm having a ball.

We're triple bottom-lined. Triple bottom-lined is social justice, so taking care of people in the community, doing things with the community; environmental stewardship, so doing something different with the land so we can leave it to our kids and our grandkids, like Boy Scouts, in better shape than we found it; and then the third one is the one that most nonprofits generally don't do well and that's fiscal sustainability. And so we think with our licensing fees and our branding opportunities we got that fixed.

I love what I do. (*Laughing*) The smile never leaves my face.

*From June 14, 2012, interview*

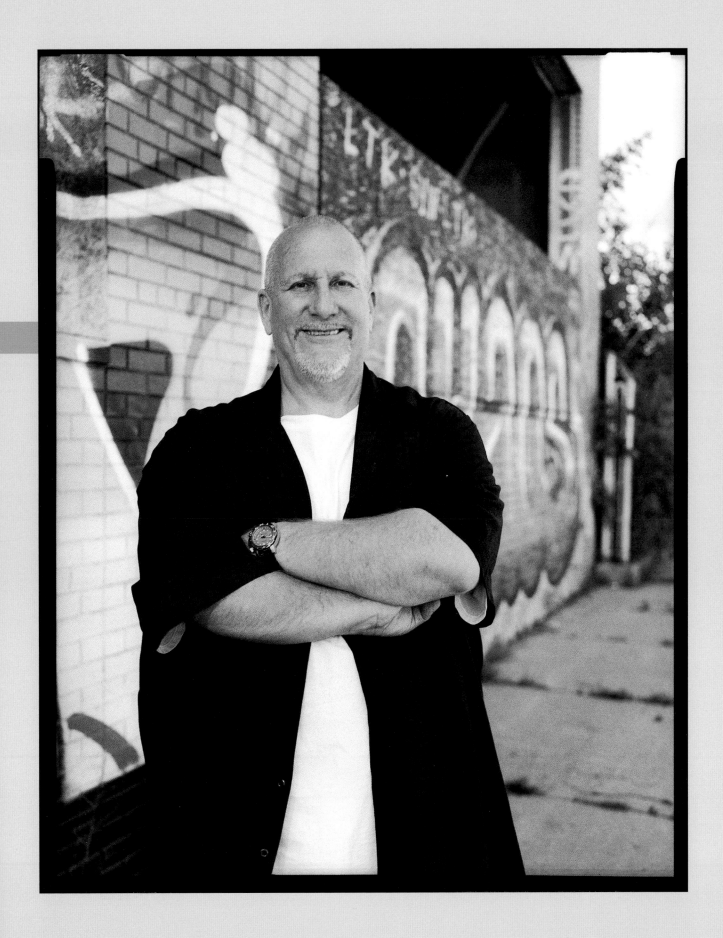

# George Stewart

MANAGING PARTNER, WOODWARD GARDEN DEVELOPMENT

I received a lot from Detroit. I think Detroit has been super great to me. I recall some of the great entertainment and excitement that was going on in this city when I first came here. We used to have some of the real renowned institutions like the Flame Show Bar, the Garfield Hotel, the Chesterfield, and the Twenty Grand Restaurant and Bar. Then all of a sudden Detroit started to begin to lose that. So I really think it would be a great opportunity if we could bring back Detroit even one block at a time; if we can get the entertainment and excitement going that we visualize, I think it would be a tremendous plus for the city.

*From June 11, 2012, interview*

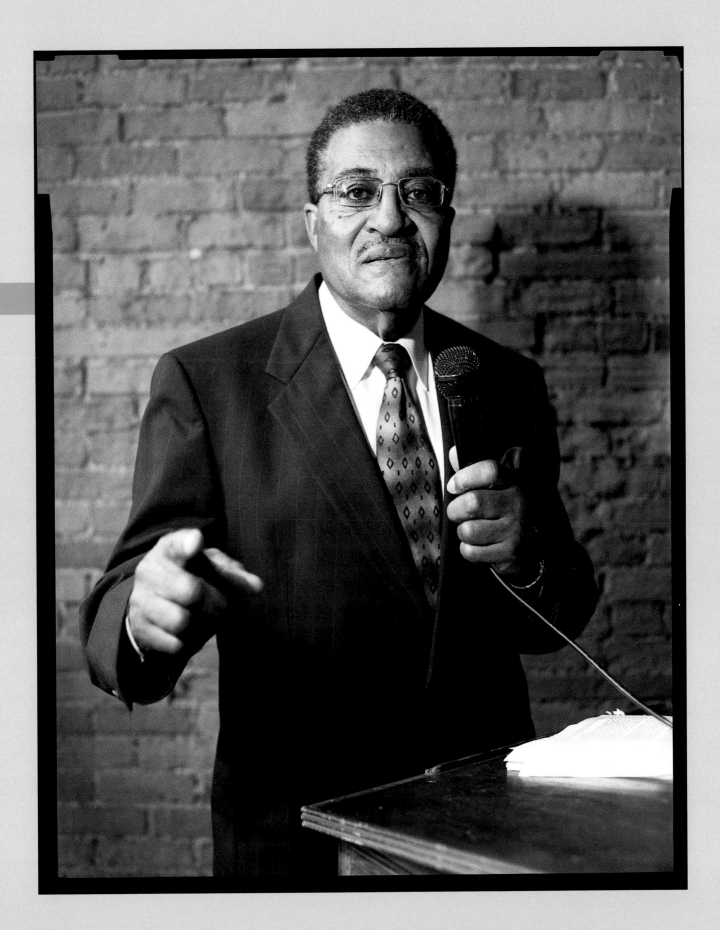

I was born in 1952 in Detroit on Grand Avenue. But my parents after a few years moved to Oak Park, a suburb. I always wondered why you see a lot of abandoned buildings. Why we didn't fix 'em and the rest of the world did. But we have this culture here, more than anywhere in the world, that we want new. We don't care if it only lasts five years. We don't want old, we want new. We wrote laws that you couldn't fix old buildings.

In Detroit, when we break even we're happy. I didn't get into it for the money. I believe that follows as long as you do the right thing, and you're smart, and you've worked at it hard. This building, twelve years ago, I spent six million dollars to update it and do a historic renovation. The historic renovation actually provided a million dollars of the construction.

In 1982 there were ten of us fixing our houses down here, and we thought it would all be done in five years. (*Laughing*) But that being said, I've been here thirty years. It didn't just happen. We cleaned it up, we cut the crime . . . the crime was already very low. We changed the perception.

# Joel Landy
BUSINESS OWNER, DEVELOPER

We renamed it Midtown instead of Cass Corridor. And it is a finite area, the central city. It will fill in; this central city will fill in. This area is going to get all built out.

We are not going to be a farm community. We are a city, and we have factories and skyscrapers. People were really whining when the census came out. We had less than a million people, we had 750,000—but I love that. I have a city with skyscrapers and factories, and I know everyone.

*From June 15, 2012, interview*

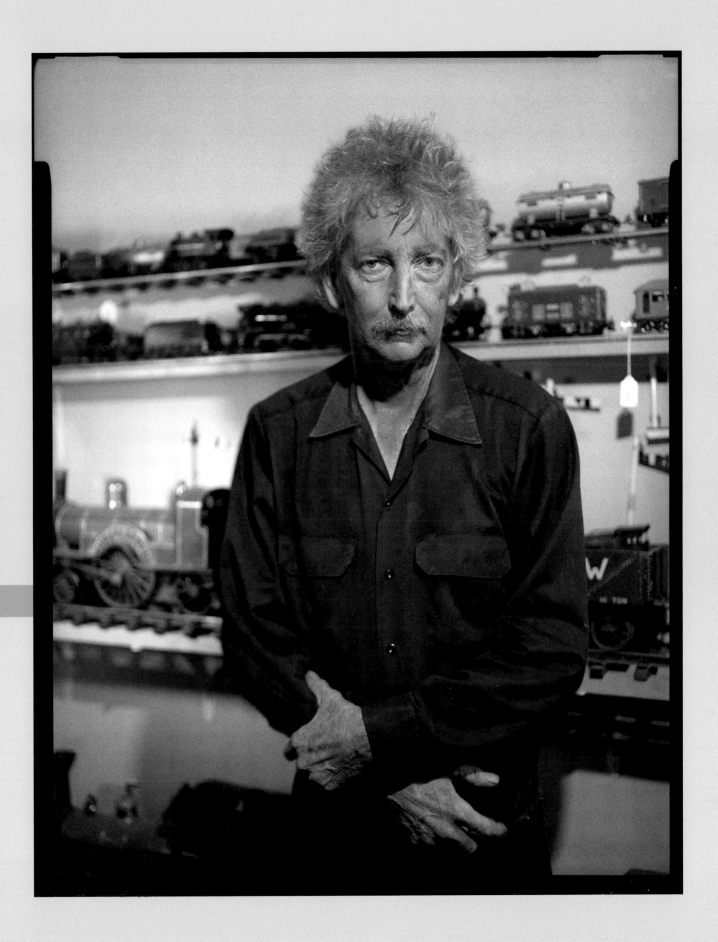

W e're nonprofit; we were originally formed by groups of people who didn't have access to traditional financial services. So in our case, our credit union was formed by people in the newspaper printing press floor; we were originally Detroit Newspaper Industrial Credit Union, and it was the union leaders, actually, that realized

# Hank Hubbard

PRESIDENT AND CEO, COMMUNICATING ARTS CREDIT UNION

that the banks were not servicing their members, so they created their own financial institution to provide credible financial services to them—that was back in 1935.

Our mind and our mission shifted. We said, you people of means, you don't really need us, it's these people at the lower end of the spectrum that need us—and we changed our focus. So now everything that we do kind of goes through a low-income filter, and if it helps those people then we try it, and it doesn't cost us too much money.

Well I was just speaking with a member who thanked me; I introduced myself and they're always surprised that the president was just wandering around meeting people. He said, I want to thank you because I was really down; I needed $500, and the credit union that I'd been working with for ten years wouldn't give me $500 because of my credit score. Somebody told me to come here, and you guys looked at it, and you were able to look behind the score at what that situation was behind that credit report, at the man, and took a chance on me, and I paid it back and I've had two other loans since. I would have been in a world of hurt if nobody had done that, so thank you.

*From June 6, 2012, interview*

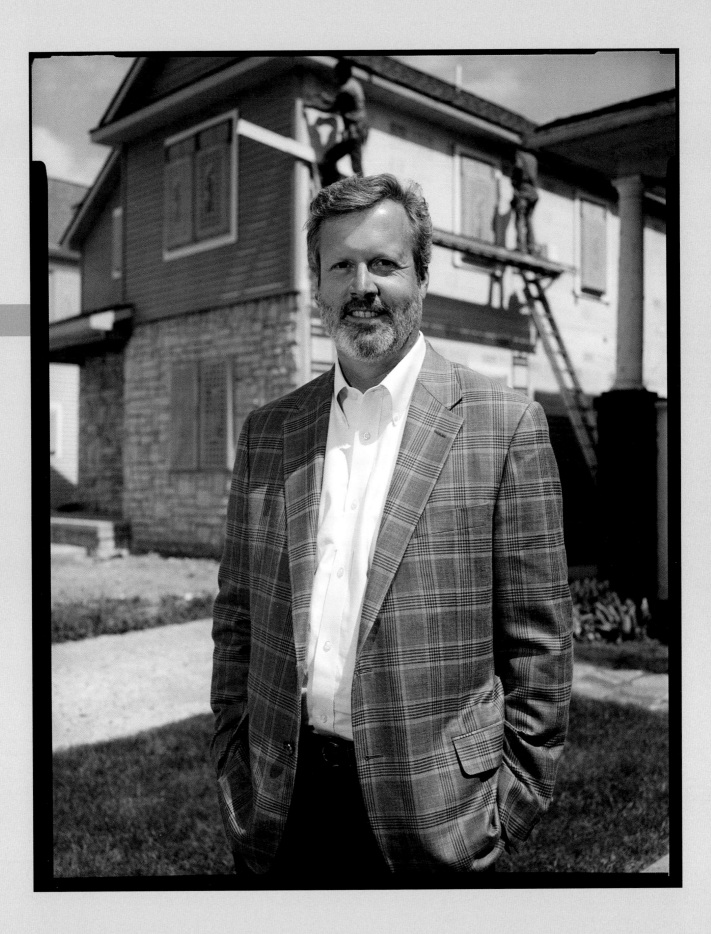

I was an engineer, I found work, so I was a mechanical engineer for General Motors and a company called Quaker Chemical, and then in 2008 when everything hit the fan I was like, "What am I gonna do next?" And I was like . . . (*laughing*) recycling.

I just looked all around and it was everywhere; there's cardboard, there's paper, there's plastic, and people would throw it—including myself—throw it in the trash. . . . Wait, that's engineering, right? To take unproductive material and make it productive.

In five years I think every auto center will have recycling, not only for scrap metal, but they'll have it for the cardboard and the plastic; and then restaurants—widespread, including McDonald's—will all recycle. That'll just be the way they handle all their waste. They recycle some of their stuff [today], like

# Damany Head

OWNER AND PRESIDENT, ESSENTIAL RECYCLING

cardboard, but really one of the biggest issues businesses are dealing with is that they have limited space. . . . Where I see it going in the future is that two things will happen; one is we'll share more, so we'll eliminate the need for lots of dumpsters, and then we'll have more recycling centers available. People, instead of saying, "I'll take the trash out," will say, "I'm taking the recycling out."

*From June 1, 2012, interview*

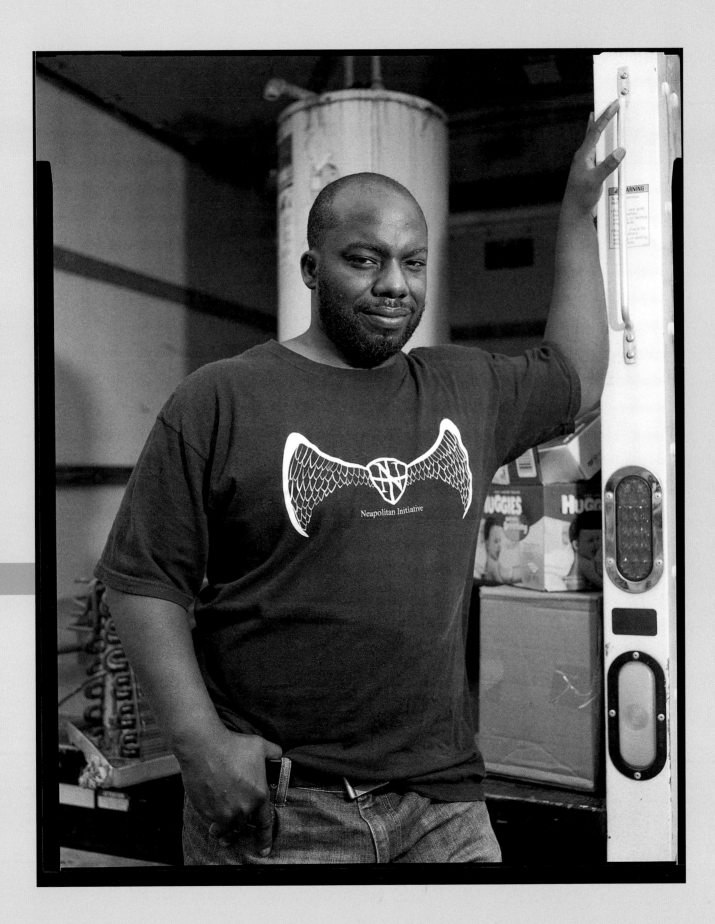

# Mike Prochaska

PARTNER AND CO-OWNER, DETROIT GEOTHERMAL

Detroit Geothermal is a heating and cooling drilling operation. We go into the earth sometimes 200, 300, 400 feet.

I always wanted to stay here and do this kind of work; it's just great work, a lot of opportunity, so I just wanted to be here from the ground up. And Ernie [Zachary] and I have been doing it, in terms of restoration of buildings and the geothermal work, for a number of years now. We've been talking about sustainable energy and trying to get our buildings so they are sustainable. We wanted those buildings to be as efficient as possible in terms of heating and cooling, which is a very expensive process. It's a slow, hard process. I had dark hair when I started and now it's very gray (*laughs*). But it's a very slow process. We just stick to it and it gets done.

If you go to Ohio or Illinois, those areas are doing a lot of geothermal for heating and cooling, and Michigan, southeastern Michigan is just starting that process. So I think in five or ten years it's going to be a very, very good business.

*From June 12, 2012, interview*

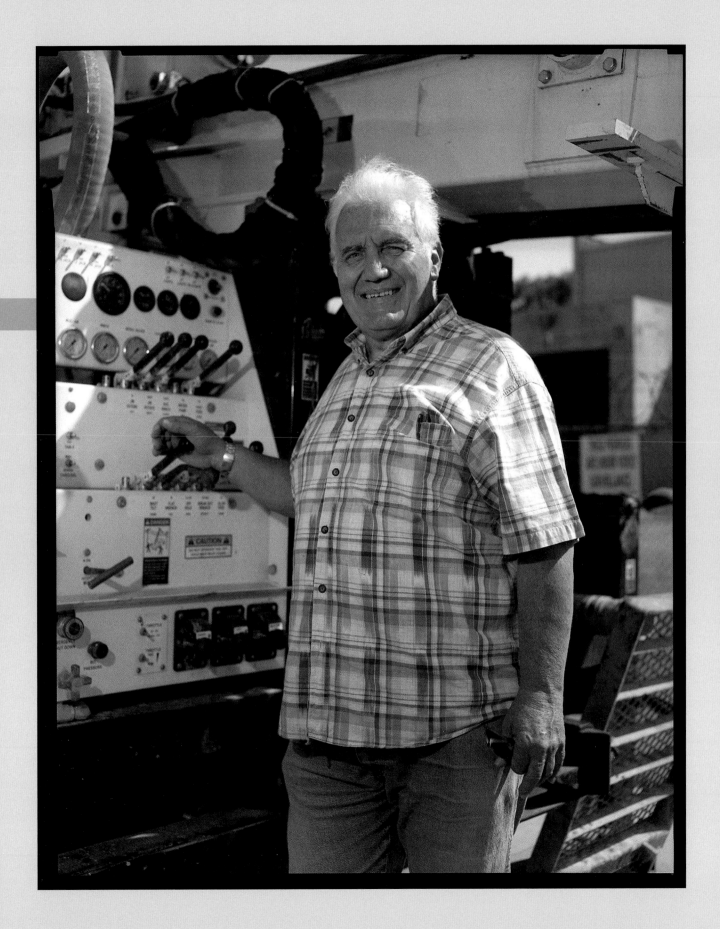

We work on environmental justice issues of environmental pollution and environmental health and educating people around how to protect themselves and how to participate in government, to speak up on the issues. We also have a workforce development training program where we're helping people get into the job market by finding work in the construction field, but that's related to energy efficiency and cleaner technology.

I'm a founding member of this organization; we started in 1994. In the late '80s I was new to working on environmental issues, and I learned about the disparity of suffering of people of color and poor people around pollution, and then it came to become my life's work, basically to look at remedy and try to create change—positive change—and relieve the suffering.

*From June 12, 2012, interview*

## Guy Williams
PRESIDENT AND CEO, DETROITERS WORKING FOR ENVIRONMENTAL JUSTICE

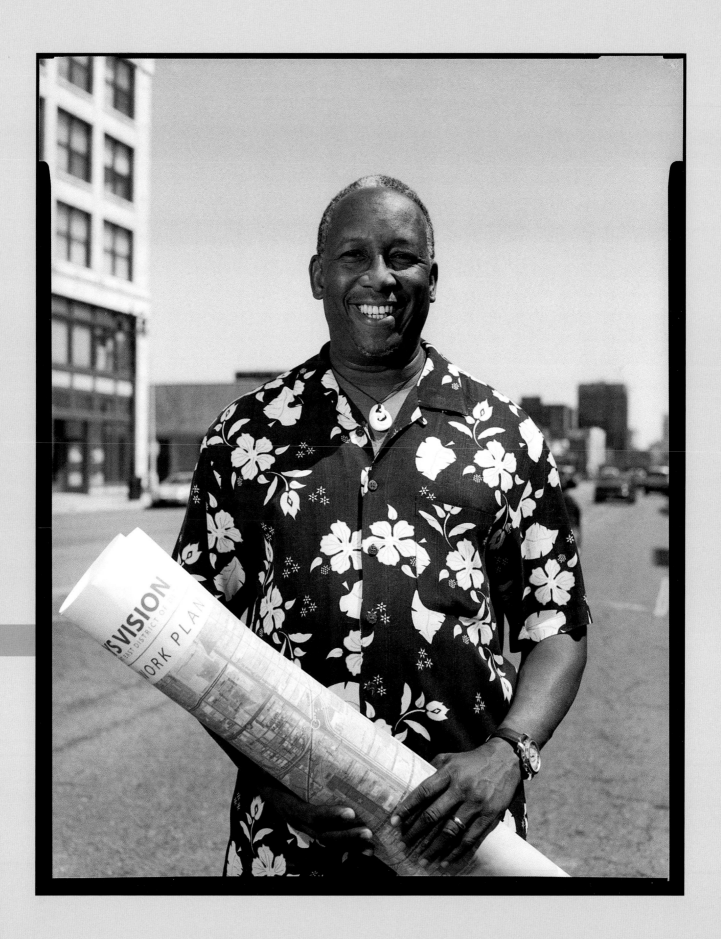

If you intend to make the world a better place, the environment is number one. If we're working in economic development and historical preservation, then the next step is to rebuild in a way that does not impact negatively on the environment. Too often the cheapest system is the system of just throwing everything away and building new in a very cheap way. With historical preservation, its not the cheapest way to do it, but it's the way that you get the most character. We're deeply committed to the history of Detroit. So we

We see this city [as] a changing city. It's not the same city it was fifty years ago or a hundred years ago. To think about the future, you have to have a vision looking forward. It's an important thing that cities need to do. We have not done that.

## Diane Van Buren
PRESIDENT, ZACHARY & ASSOCIATES, INC.

## Ernest Zachary
FOUNDER, ZACHARY & ASSOCIATES, INC.

wanted to preserve that history of Detroit . . . tell the story. Otherwise it's gone, it's just completely lost.

Then you put environment in the mix; how do you create a building that doesn't negatively impact on Detroit? So that's why we decided with this one, since it all had to be rebuilt anyway, to create a building that has the smallest carbon footprint possible. And what we have found is that people say, that's a building I want to live in because it's a green building.

From a political point of view in recent years, we've only been concerned about balancing the budget, laying off policemen, turning the lights off, anything to reduce the costs; not enough thinking about where we're going to be ten or twenty years from now.

This city has been in many people's eyes a declining city. The way we've seen it is that there's always opportunities, you can do things even in decline. There's always a market if you think about it.

There are a lot of young people that are moving to Detroit. The people that are coming are all very educated, and many of them are in the arts. They're coming to live here because there are opportunities. 'Cause you can come here and you can do what we did; you can do anything you want in Detroit. You can think broader, you can think expansively; you don't have to be constrained by what other people or commissions or laws dictate.

*From June 5, 2012, interview*

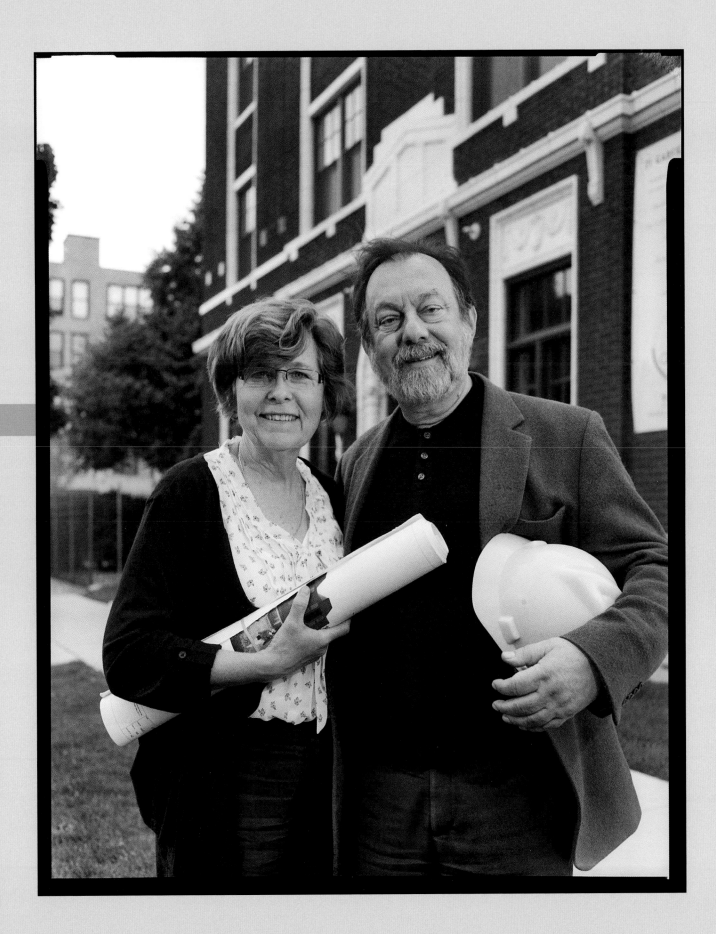

The key is we're showing regionalism is alive and well and that these counties and the city and the state can work cohesively as one unit. We're also showing what can be done in a facility like Cobo Center when there is cohesiveness about direction and focus. Our mission is to make it better. We're not here to serve any political interests. We are good stewards of the taxpayer dollars. And we want to be sure that we make a

## Larry Alexander

PRESIDENT AND CEO, METRO DETROIT CONVENTION AND VISITORS' BUREAU

facility that is the best facility that it can be, better than any other competing facility across the country.

Detroit has a very strong work ethic. I moved here in 1993 and Detroit[ers] just don't quit . . . no matter what. They may get knocked down, but they always jump right back up and they continue to work hard. There's no quit in the Detroit makeup.

Detroit is home and it's a great place to have a home. The quality of life here is phenomenal. And I'll tell you a story. Before I accepted the position to move here, I talked to people who had lived here and moved away and people who were still living here, and they all bragged about the quality of life that Detroit had to offer. They told me one thing, no matter where you are or who you are, you always have to defend Detroit. Because we know that Detroit has an image out there. It has a reputation. We always tell people, if you haven't been to Detroit in a few years, you haven't seen the new Detroit. You need to come back and see Detroit. If you haven't been here for ten, fifteen years, you don't know what Detroit has to offer.

*From June 18, 2012, interview*

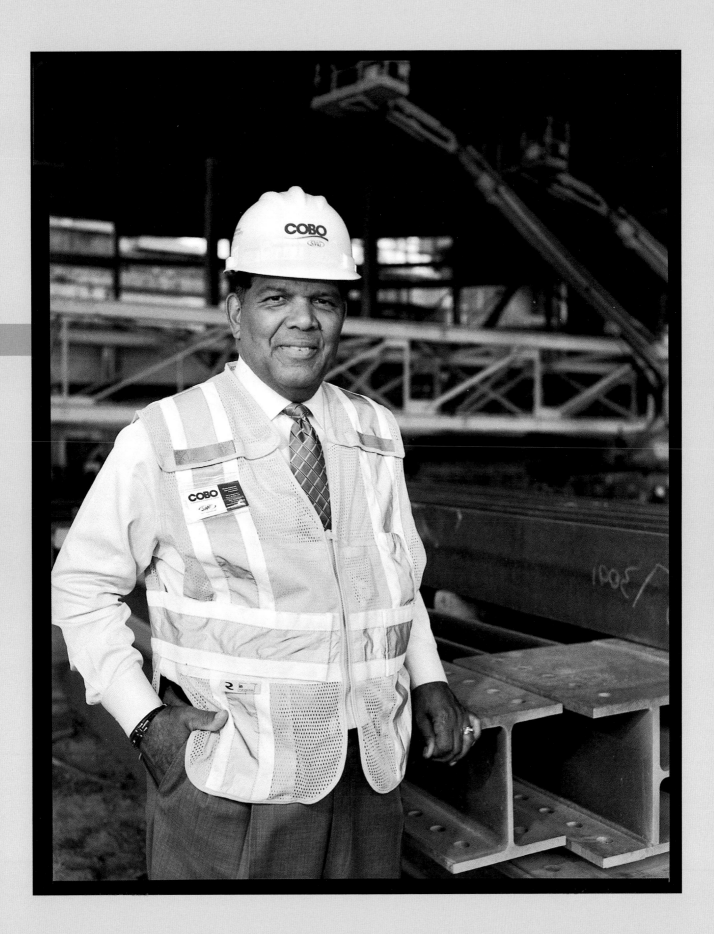

My first degree in the '70s was a double major in biology and zoology. I went off and I worked in that field for almost ten years. And then the economy became a little volatile, so I left that position. I started an apprenticeship in 1981 and worked for ten years in the trade as an electrician. Then I got hurt, which was not so good. But I kept my membership as an electrician. I went back to school and got my electrical engineering degree in 1994. I started working for one of our contractors as an estimator. The school called and asked me to apply to become an instructor. So I did that. And you know, my qualifications were outstanding because I had already worked as an electrician for ten years and then I got my engineering degree, and you know, they're always looking for qualified instructors. So I began teaching here in 1996 and then I'm still here seventeen years later.

## Kathy Devlin

HEAD INSTRUCTOR, DETROIT JOINT ELECTRICAL APPRENTICESHIP PROGRAM, IBEW/NECA

I'd like to see more apprentice women apply to get in. I certainly would like to see that. So I'm not sure why women don't view this as a viable profession for them. I mean my experience has been terrific. I wouldn't change a thing. I love being an electrician. I loved working in the field, but actually I love what I'm doing now. I think it's a great trade for women. They can earn the same amount as the men do because it's mandated. You go to some professions, and even though they claim that the women earn the same as men, they have ways to make that not happen. People here don't discriminate.

*From June 6, 2012, interview*

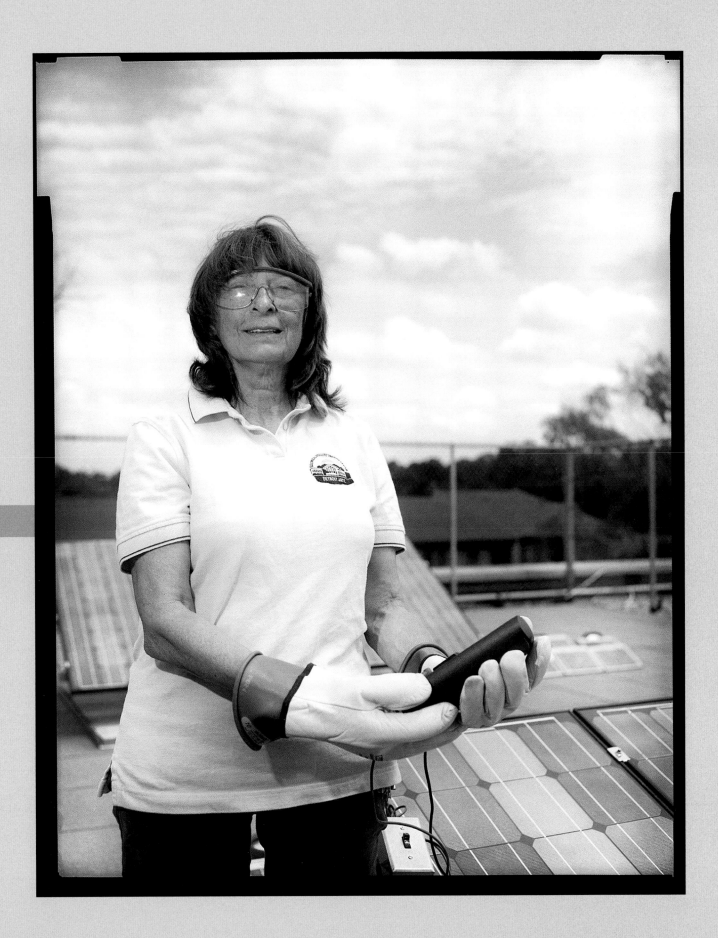

# Kyle Smart

APPRENTICE ELECTRICIAN

My father was an electrician. He's still in it, been in it for twenty-four years. And I wanted to follow in his footsteps. I had the opportunity to get in on the low voltage side, and I think that's just the wave of the future, getting in with all the fiber optics and telecommunications cable and all that.

I mean it's no big deal to me if I have to go to another state to work or anything like that, but I'd rather stay here for family, friends—and I just like the city.

It's going to be a whole new wave. We're working out at Oakland University, and just the technology that's going into that building between all the solar and geothermal . . . This industry is going to be really booming because they're going to be doing a lot of energy-saving conversions. I think the construction trades industry in the next ten or so years is going to be booming.

*From June 6, 2012, interview*

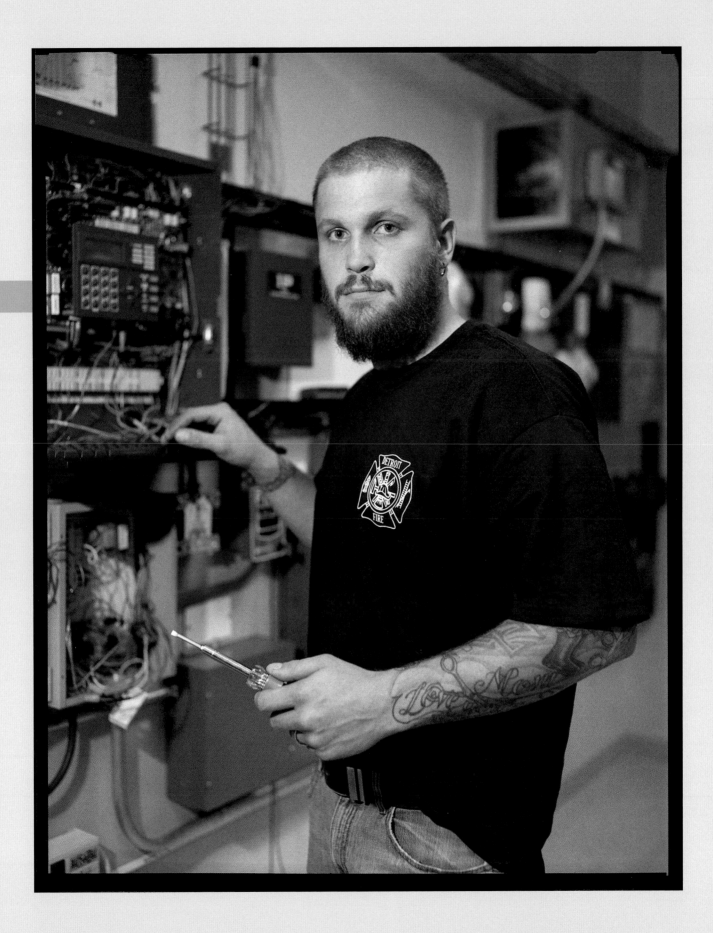

The first patient whose life I changed, whose life I "saved" as a medical student, I didn't actually perform any procedure at all. I was just sitting there talking to him, convincing him to have a life-saving surgery, whereas nobody else would bother. He was ready to die. As a medical student I had no skills, but I had time. And that was the one thing I could give this guy was time—time listening to him, time talking with him, and time getting to know him so he trusted me. I convinced him to have a surgery that saved his life. The doctors didn't have time to do that. Well if he's not going to sign for surgery, if he's not going to sign the consents, then fine, we can let him die. And he said, "Fine, I will." They said, "Tony, why don't you go talk to him and see if you can get through to this guy." And as a medical student that's what you have, you have time.

It's all about technology. When I started practicing, a lot of the

# Anthony Youn
PLASTIC SURGEON AND AUTHOR OF *IN STITCHES*

procedures and techniques I learned as a resident, I do very differently now because the techniques have gotten even better in the last eight years. The future of my field is two things: it's transplants, like face transplants, and stem cells. Stem cells are basically cells of our body that are so young they can turn into whatever organ you put them into. With women with breast cancer now we do reconstruction, and we use implants, or we move muscle from the back to the front. With stem cells, hopefully, eventually, you'd be able to literally use stem cells to grow a new breast. The future, I think, of medicine is stem cells. Technology is advancing in leaps and bounds. Lasers are a lot of times taking the place of surgery. Injections are taking the place of surgery; injections instead of cutting. Advances in the field occur literally every month; it's exciting.

*From June 15, 2012, interview*

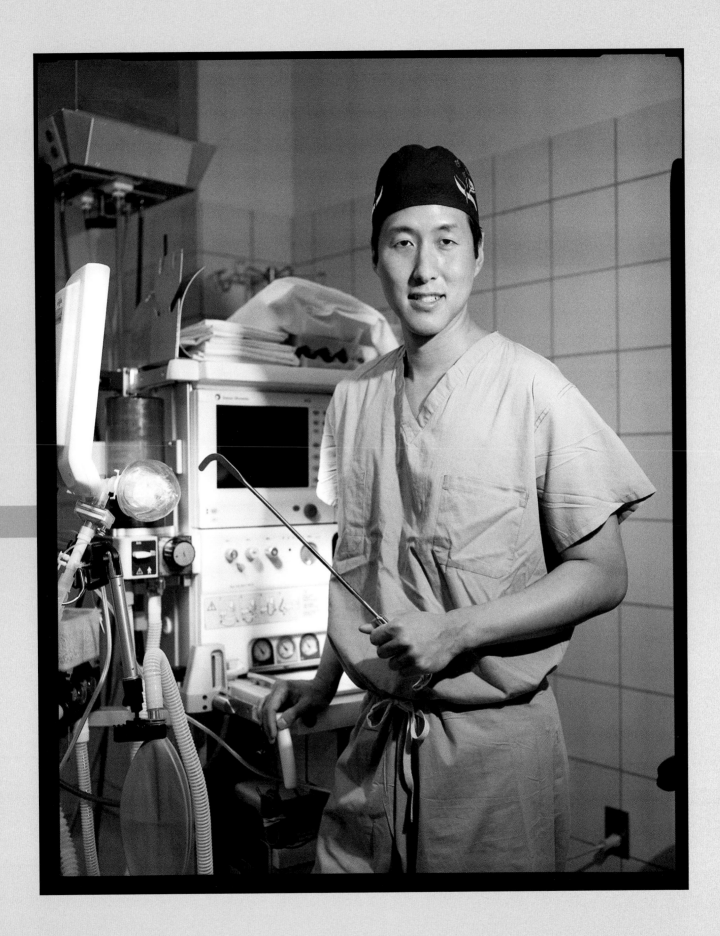

I'm very sad for Detroit. I love this city and I really hope that it gets better soon. I think it has potential, and I can't wait for it to actually come to life again. I have big hopes and dreams for Detroit. I'm hoping that it's going to be a booming city in five years' time, hopefully in ten years' time, so we'll give it that bracket. It's got so much potential. There're so many huge buildings and so much to work with. I'm hoping it's back on top again.

*From June 1, 2012, interview*

## Sara Felarca
ACTRESS AND MIME

## Michael Lee
ACTOR AND MIME

I've lived in Michigan my whole life. I've given up on saying if it's two years, five years, ten years, or twenty. We have a Renaissance Center here, and it's always kind of in a renaissance. I know that in the last few years there have been a lot of artists that have moved back into the inner city. Theater groups, circus groups that have moved back in here. That's usually what happens first: the artists move in.

*From June 1, 2012, interview*

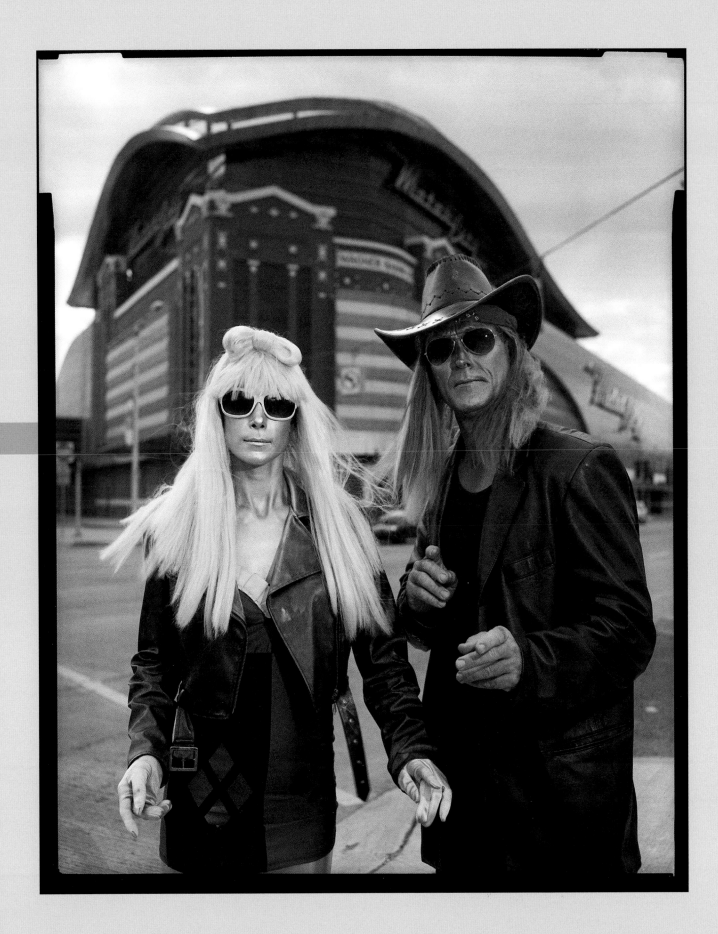

I've lived in this city my whole life. And you know at one time this city was called the "Paris of the Midwest." I remember it as being quite a beautiful and vibrant place, and never thought in a million years it could turn into this. And one of the things with Detroit is that just when you think it can't get any worse, it does. But there are signs of things happening. This place [the Russell Industrial Center] is becoming a kind of artist's mecca. There are more and more people that are starting businesses. There are a lot more artists here than when I first moved in. They have the People's [Arts Festival] in the fall, and there are open houses that encourage people to come here.

## Alan Kaniarz
FURNITURE DESIGNER, WOODWORKER

There's a lot of enthusiasm for the city with young people. [People] that are willing to invest their time and energy. You see it happening. There's a lot more movement. I'd like to be an optimist and say that I think it'll be better in five years. I would like to think that it will be a lot better in ten years. Am I confident that it'll be a lot better in ten years? No, but you see some really positive signs.

*From June 12, 2012, interview*

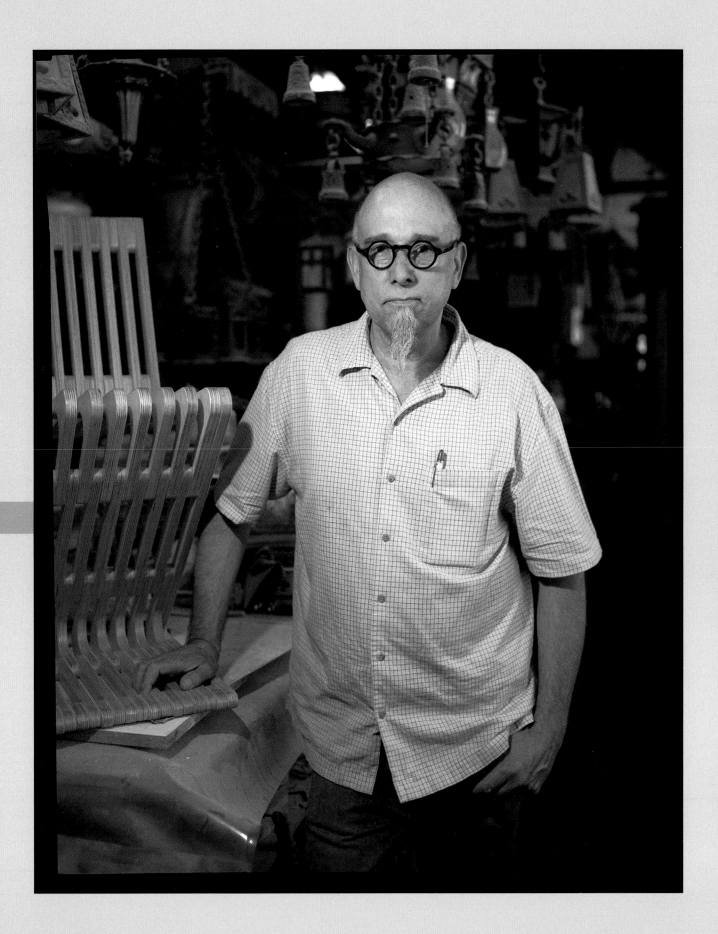

I was born in Detroit. I grew up here. I've traveled, but I like this area. I wanted to stay here.

Detroit always surprises me. I mean we have our issues. I like it because I can find a very comfortable place to make my work, a large place to make my work.

The arts have always been an important part of this area. We have a number of arts organizations, groups—factions, as it were—that are all cognizant of one another. And everybody does their job and gets their work out.

I think [Detroit] can't help but get better. As a young artist, going to school as an undergraduate and then a graduate, I saw firsthand the Cass Corridor group of artists. And they were not like a club. They were just people who lived together in the same area, who did their work. I saw that. So I see this now. I have a frame of reference that's maybe thirty years old, where thirty years ago—I really hate to say that because it makes me sound old, but thirty years ago I saw these things happening. I saw other things begin to happen. I saw things continue to happen. I've seen artists come and artists go. Right now we have really dynamic groups of young artists who are doing things in all these different groups. I have a connection to that because I'm an art professor at CCS. I see the young artists and I see what they're doing. They're doing pop-up galleries, and they're starting arts organizations where they find a building, they get together, and then they craft a space out of it.

*From June 18, 2012, interview*

# Gilda Snowden

ARTIST AND PROFESSOR, COLLEGE FOR CREATIVE STUDIES

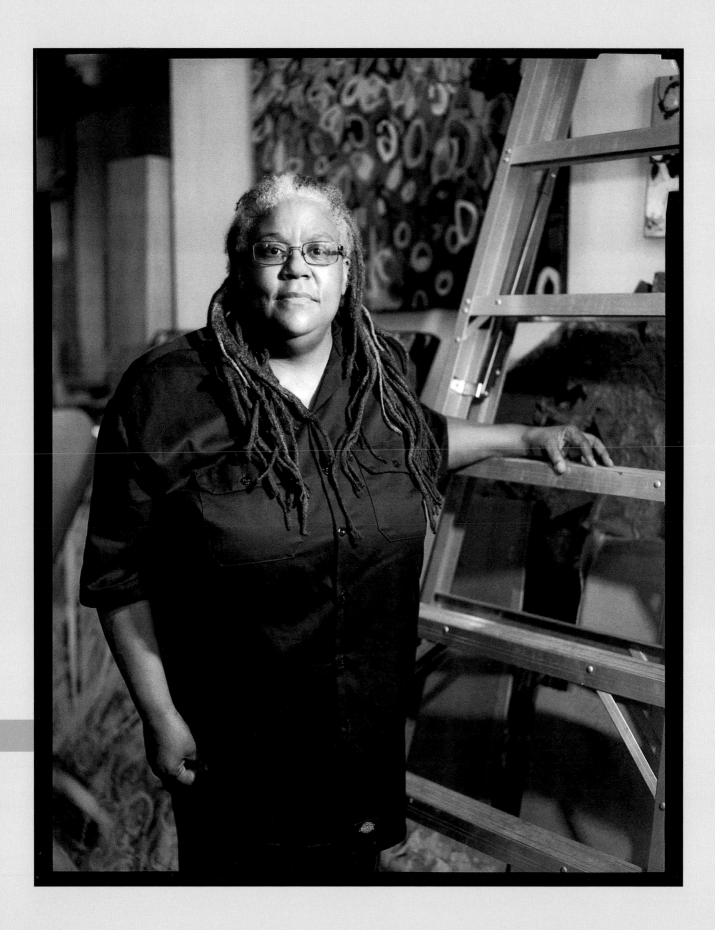

Ve are not a theater in a building; we are a theater company. Theater and music company actually. We've been around for twenty years. It's really youth development through the arts. It's about excellence in the arts. We have data from the University of Michigan that shows that this pursuit of excellence helps the students in every facet of their lives.

# Rick Sperling

FOUNDER AND CEO, MOSAIC YOUTH THEATER OF DETROIT

When I started going into these schools through this professional theater and seeing all the kids, the theater and music programs there, it was very inspiring. The talent was incredible, and the hunger. We did a show with these kids at the professional theater, and the quality of the show was so much better than any of us expected. We thought we were doing a nice program for these kids. Artistically it blew us all away. And that's really where the idea for Mosaic was born.

I think a lot of people say this about Detroit—you can accomplish more, you can have a greater impact in Detroit than a lot of other places. In New York, or Chicago, or L.A., it takes years and years just to make a dent, just to be there. In Detroit the opportunities are so strong. There's a tremendous amount of creative people, but there's great need and there's great talent. So I often wonder whether I could have done Mosaic somewhere else. There's something unique about doing it in Detroit.

There's a lot of talk right now in the education world about twenty-first-century skills that our kids have to learn. They're innovation skills; there's the four Cs: creativity, communication, collaboration, and critical thinking. If you take those four things, nothing does all four of them better than the arts.

And if you can figure out what a young person is passionate about, then everything else will work around that. So these young people are passionate about theater and music, and they're becoming more responsible, they're learning time management, they're learning how to collaborate; they're doing all these things that are going to help them in life. But they're doing them not because they should; they're doing them because it has to do with what they're passionate about.

*From June 15, 2012, interview*

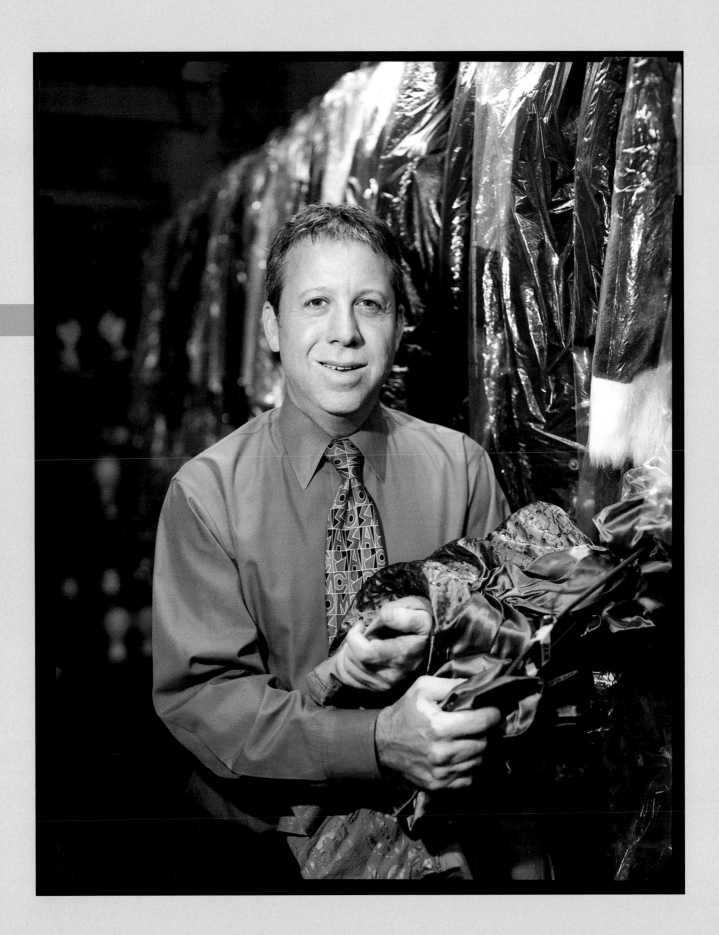

Well I've always loved music. I just always knew that that's what I was going to do. I never wanted to sing anything else but jazz. I enjoyed all kinds of music. But jazz was definitely what I wanted to sing.

We're trying to get this city back together. You know, artistically there are many talented people here in the city of Detroit. I'm just hoping that the arts will still be supported. What's really sad is that music and the other arts are really lacking in the school system, you know, and that's just . . . that's just sad. Culture and music are necessary for our souls and our existence.

*From June 4, 2012, interview*

## Shahida Nurullah

JAZZ SINGER AND TEACHER

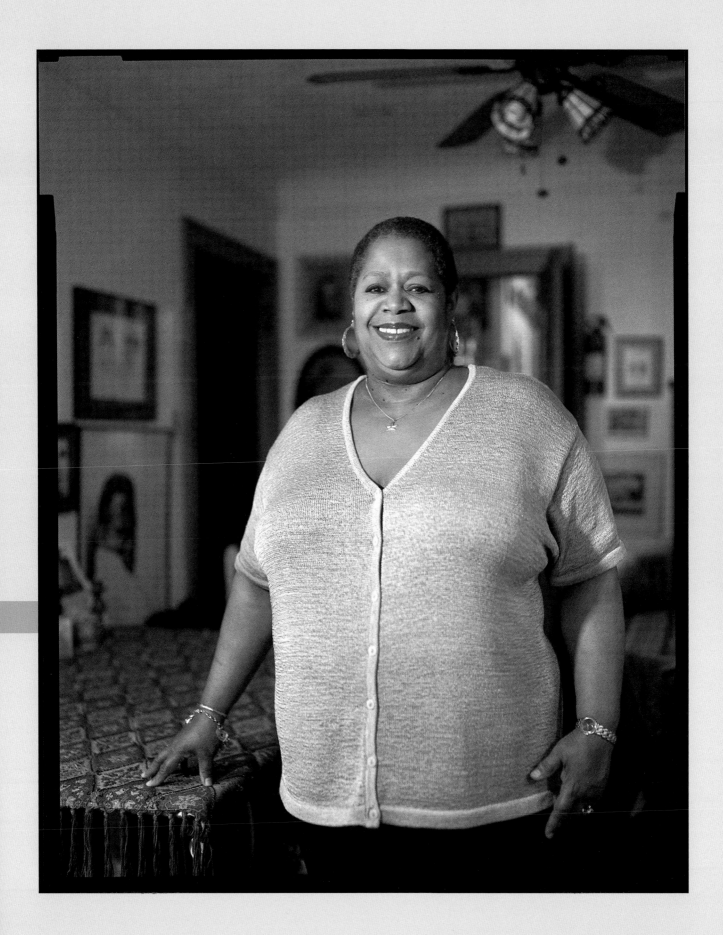

It was amazing twenty years ago. Detroit had a brand and people didn't know it, people here didn't understand that. People from Europe had been coming to explore Detroit and techno since the '90s. There's a Detroit techno market in Europe, a Detroit hip-hop market in Europe. When my old boss Derek May would go to London, he'd get mobbed. Here he's just an average Joe

## Dominic Arellano

FOUNDER AND EXECUTIVE DIRECTOR, FORWARD ARTS

on the street. People have no idea that he's one of the Elvis Presleys of techno music. And people don't understand that Juan Atkins has these master tapes and he really is the Elvis Presley of Detroit techno. His master tapes are sitting in someone's basement right now; if a flood happens in the summer, they could waste away. That's a real shame. People don't understand they have these really national and historic treasures in the city. They're living legends and people don't understand that. You're starting to see that tipping point, but before that, at least on a major scale, that wasn't happening. Now people from Europe understood that. People maybe at a small scale like myself and the underground people understood that. Now Detroit is a totally different animal than it was ten years ago. It's so different in so many ways.

*From June 11, 2012, interview*

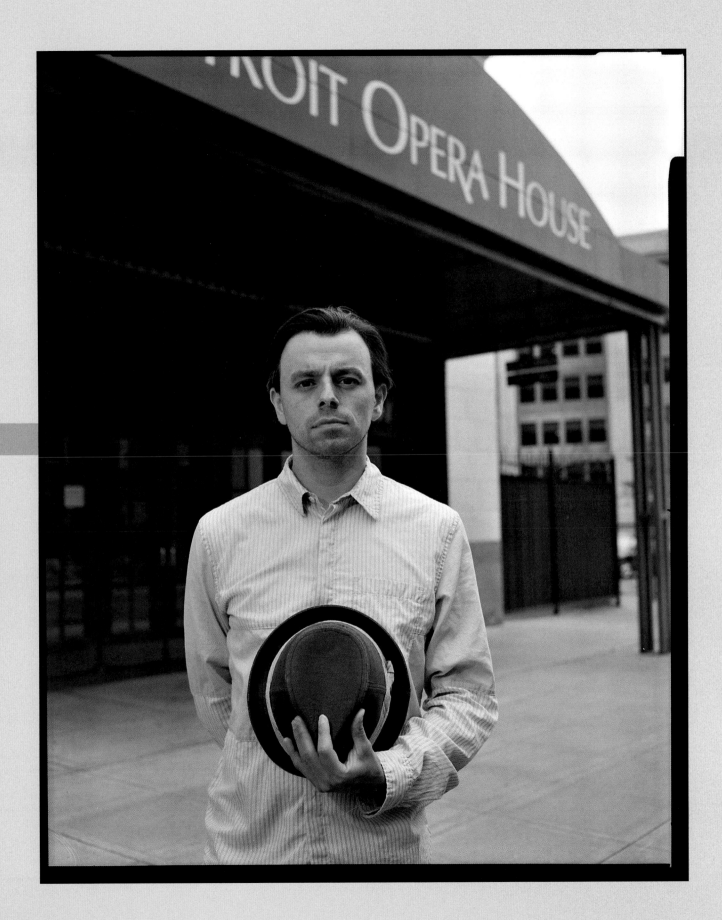

# Tim Burke

ARTIST, DETROIT INDUSTRIAL GALLERY WITHIN THE HEIDELBERG PROJECT

I started doing artwork twenty-six years ago. Friends of mine, when I was living down the street, friends of mine said, "Hey have you been to the Heidelberg Project?" They brought me here. They did that, I think, because I didn't consider myself an artist, because I hadn't been to school to get the degree in art. My dad had a degree. All his friends had degrees; they were art teachers at Wayne State University. So I thought I had to have a degree. And here I was finding things—pieces of wood, metal, glass—screwing them together, gluing them together . . . I have ten tons of granite behind the house here that came from the Detroit Institute of Arts when they did their renovation. Much of my work out here, you don't know it when you first look at it, is from fifteen historic buildings in Detroit that have been torn down [including some of] Wayne State University, [the Grand] Riviera Theater, the Hudson's building, a bunch of different churches, the Lucy Thurman YWCA, the Detroit College of Law, and on and on and on and on.

*From May 27, 2012, interview*

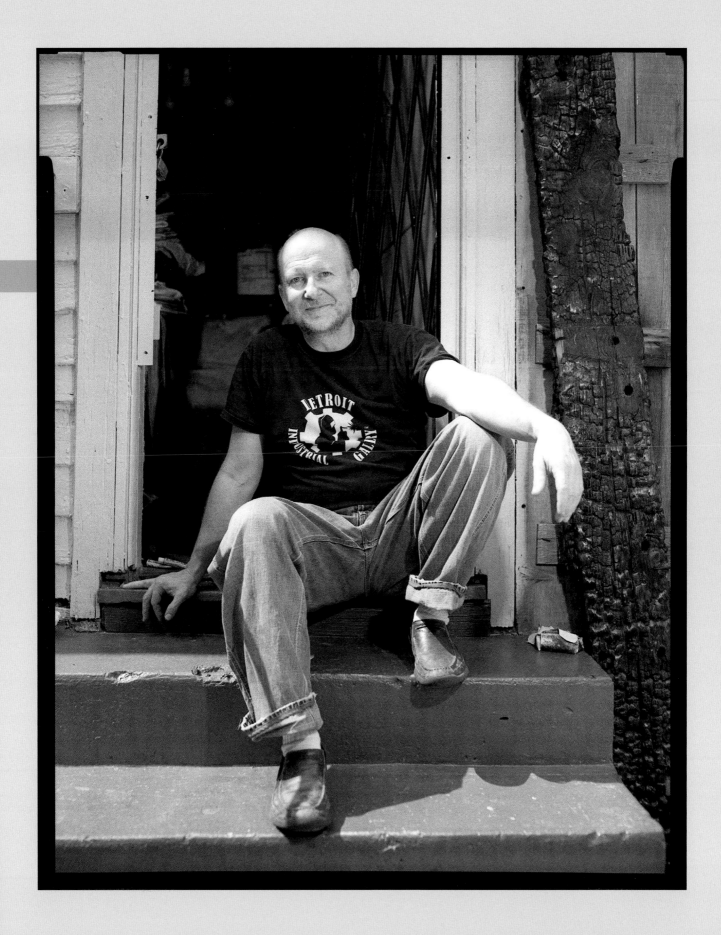

I'm a teacher; I teach. I really believe, truly believe that you can save lives when you teach kids to be able to tell their own stories, when you give them the power to be able to articulate something they feel through something as simple as a ten-line or fourteen-line poem.

I really believe that you can actually make this place more literate—that's why I work in the jails, and juvenile detention

# jessica Care moore

POET AND MULTIMEDIA ARTIST

centers, and in the prisons. I feel those people are forgotten and will come back into the world if they have the opportunity to learn how to write and express themselves through a poem or prose or a piece of short story. I think that we can make better people, so I do that work because it made a difference in me growing up in Detroit, that poems helped save my life.

I'm a poet at my core, and that's what I'll be for the rest of my life.

*From June 7, 2012, interview*

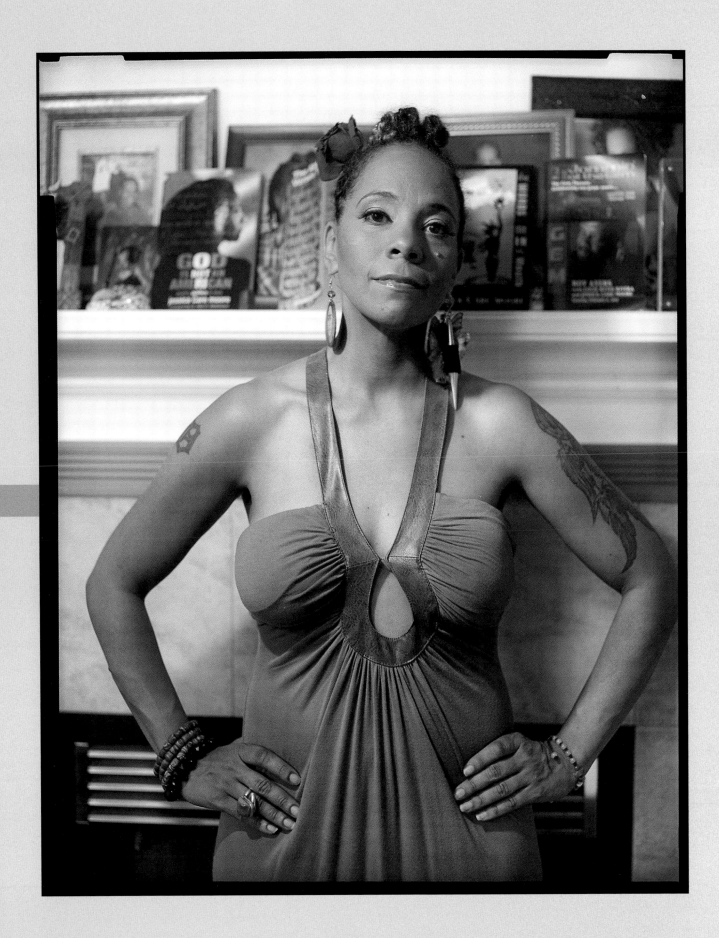

For Hispanics, it's all about art and food. There's a marriage between art and food! It crosses every nationality, because if you have art and you have food, you don't need to have language. You could be from a whole other part of the world and we could communicate by just art and food.

Young people need inspiration, they need mentors; they need people that aren't going to take them for a ride, that aren't looking to take advantage of them. It's very rare that somebody will give you guidance and direction and not really be looking to make a profit. But there might be some really great opportunities for us to come together and to develop additional products and grow businesses.

I was asked to be part of a Pan-Hellenic entrepreneurialism [workshop], and after the meeting one of the young ladies came up to me and she said, "I have this problem: I've got these two girls and they're helping me, but they really don't have the skills that I need in order to help my business grow. I don't know what to do with them." And I said, "Well are they people that you feel are loyal to you?" And she said, "Yes, but they don't have the skills," and I said, "Then your job is to develop them." And that's what we do here.

*From June 8, 2012, interview*

## Lydia Gutierrez
PRESIDENT AND CEO, HACIENDA MEXICAN FOODS

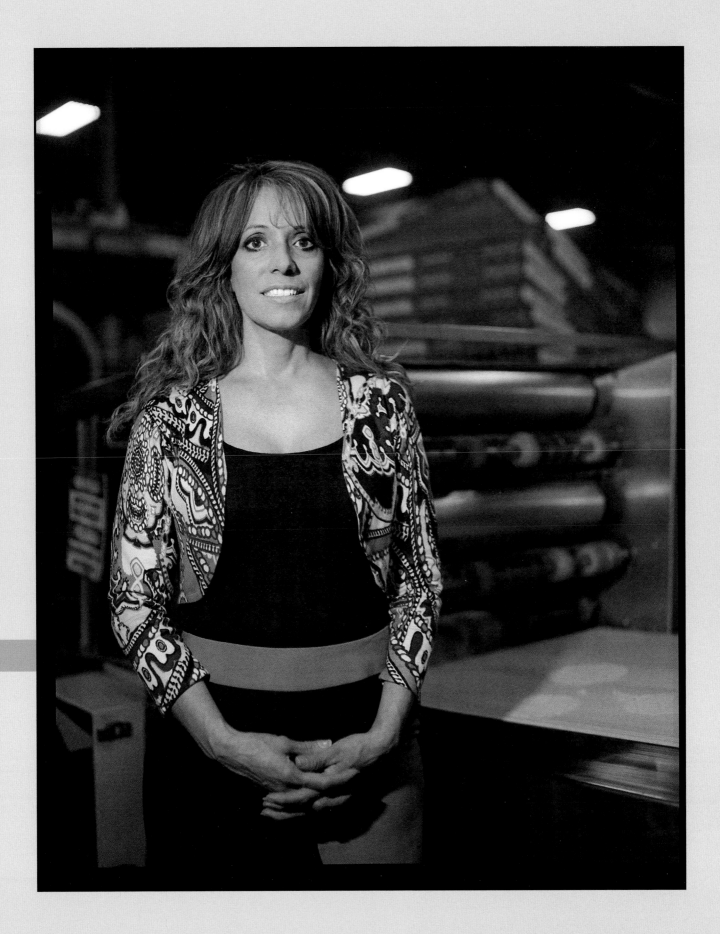

# Anthony Curis

REAL ESTATE DEVELOPER AND FOOD TRUCK OWNER

I'm Detroit born and raised, been here my whole life.

I started the first food truck in this city about nine months ago. The laws restricted them, they weren't allowed in the city, so I worked with the city for about six months. If you came in the city they would ticket you, you'd get thrown out. So now we worked on some things with the city where there's a process—you still have to get approval for each location, for where you're going to be, but at least the use is acceptable.

It's an industry that's been around forever, it's not like we started it; we wanted to bring the industry here. The problem with Detroit is there's a lot of people here; there's so much demand for restaurants and good food, and there's just not enough options.

Wayne State is the city's largest university. It's right in Midtown. Wayne State contacted us and said, we want you to bring this to the campus. So they gave us a contract to come on campus, and now, starting in the fall we're working with five other truck owners. We'll have six trucks on campus; it's really worked out well for them and for us.

It's starting to become a really booming industry.

*From June 11, 2012, interview*

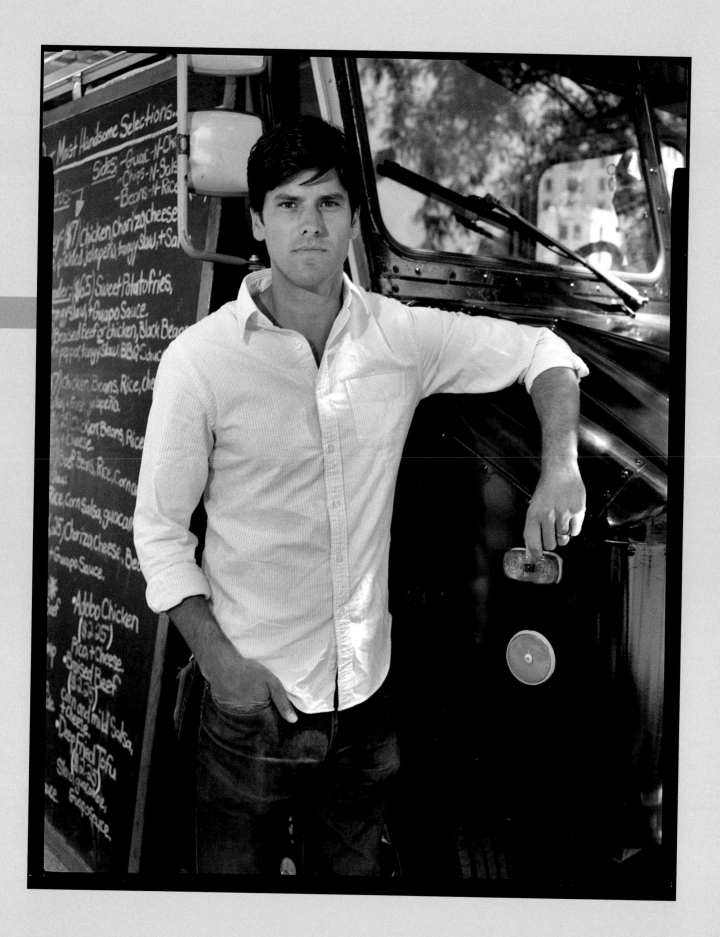

Sweet Potato Sensations is a bakery café that specializes in everything made from sweet potato. This is my husband pulling up right here, and it all started when we got married. He liked candied yams and I didn't. He used to bug me all the time at Thanksgiving and Christmas. People traditionally make candied yams with turkey and dressing, and I would

## Cassandra Thomas

CO-OWNER, SWEET POTATO SENSATIONS

never make it, because I don't like them. I thought sweet things should be part of the dessert and not part of the meal. I've liked baking cookies since I was a little girl; so I came up with a recipe for sweet potato cookies.

I used to be in that building across the street. And prior to that I worked out of my . . . I started in my kitchen at home. We moved on this side of the street three years ago.

We want to be the change we want to see. We want to do good things and be positive and keep things moving forward. If that's what you want to see, you have to do that yourself and others will follow.

*From June 6, 2012, interview*

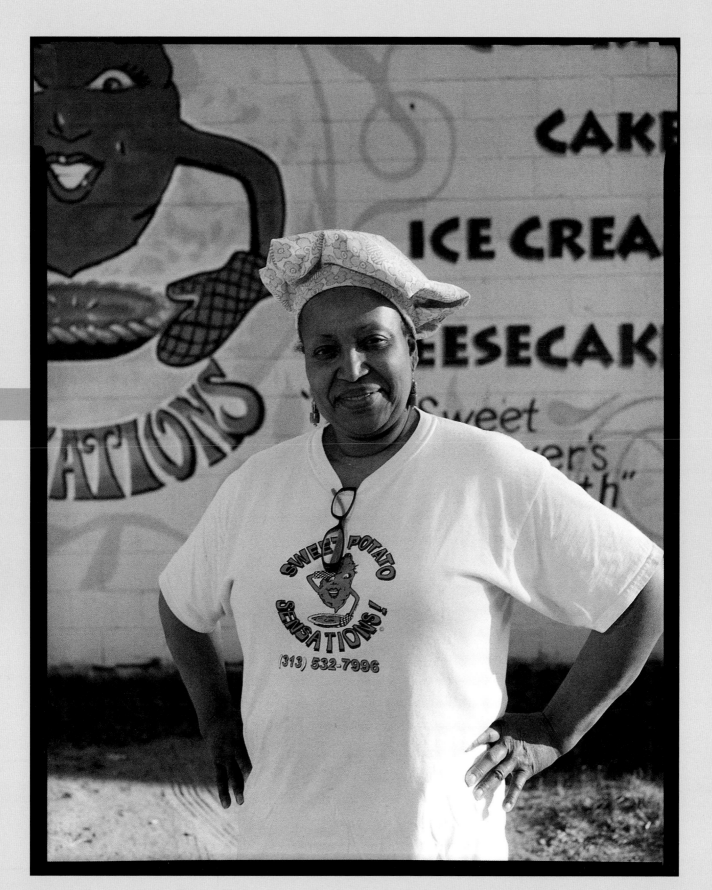

We are a microbrewery, and we make beer in the city of Detroit.

I wanted to make beer since I was a little boy. John [founder John Lindraos, Scarsella's co-owner] was already doing it and he was my idol, and I wanted to come here and work with him. I always wanted to go on a tour of the Stroh's brewery, but my parents would never take me. It closed down and I was very sad. I always had this urge to make beer, because I never saw it.

We wanted to have a brewery business in the city. But everyone just kept leaving. Friends, family, they wanted to abandon the city, but that's not the way to do it. You have to stay and make it better.

I think the more youth and younger people you can attract to the city, and it's almost like you're homesteading again and creating a whole new life. People forgot about what it takes to be involved with the community, to make a community successful.

*From June 7, 2012, interview*

## Daniel Scarsella
CO-OWNER, MOTOR CITY BREWING WORKS

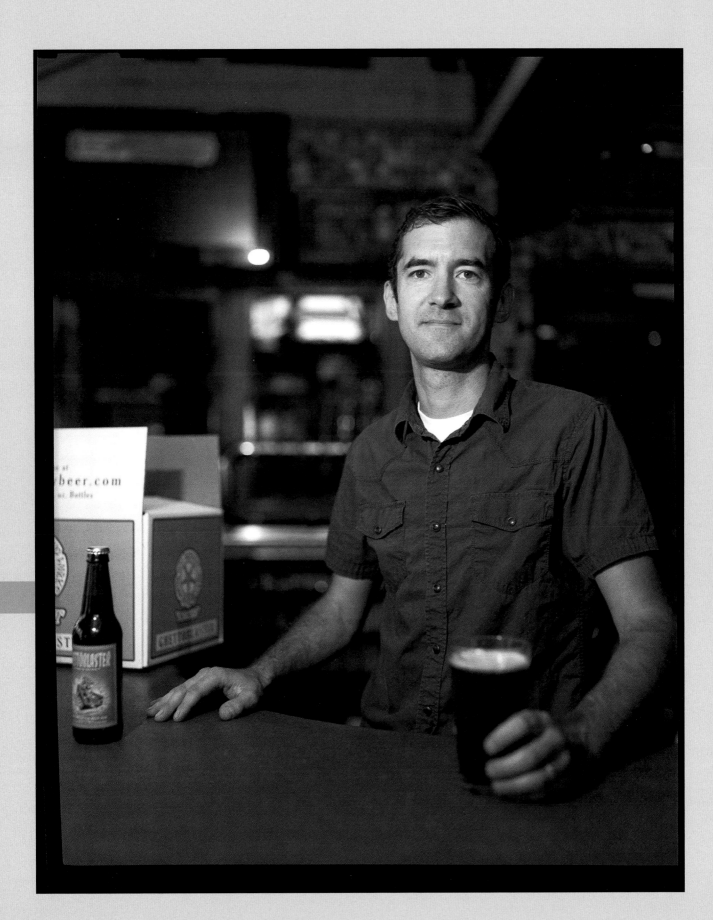

# Alicia Marion

OWNER, MOTOR CITY JAVA HOUSE

Motor City Java House is the place where the world meets. You get more than coffee. You get to have great company, something to eat, volunteerism, community programs . . .

It started ten years ago as a dream, five years of building, and we've been open twenty-one months. Five to ten years from now I hope to have many more employees. I hope to have at least two more of the Java Houses in the city of Detroit, and I just plan to prosper and grow.

I am blessed, and I know I'm supposed to be here. This is my calling.

*From June 6, 2012, interview*

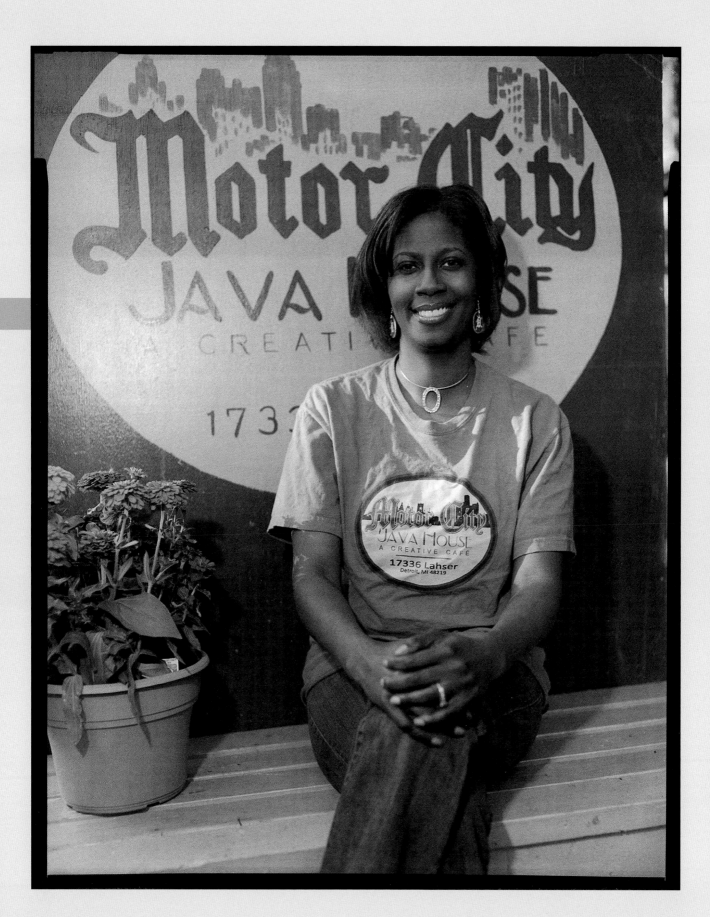

I am the third-generation owner. The company was started by my grandfather in 1924.

My grandfather was the first person to import pistachios into the United States. It's an old company and it's always been in Detroit. My grandfather had a brother, and his brother had a nut company in New York. During the war there was no way people could get pistachios, so we were the only two people that had pistachios, my grandfather's brother and my grandfather; there was no other place to get them. Back then they were all imported, but now they grow them in California.

Well I hope that we have a few more locations for our stores, and we'd like to have stores like this with our name, as opposed to giving them to a supermarket. And what's most important to us is to make sure the brand, Germack, is always the highest quality, the freshest that you can get, which we have a reputation we enjoy now.

The nice thing is people; when things are hard in Michigan, people want to support the local businesses. Even though it's harder to buy corporate gifts, like a business gift, people would rather buy them from us than from a national company. That helps us and we

# Frank Germack III

OWNER, GERMACK PISTACHIOS AND GERMACK COFFEE ROASTING

feel that helps them too, because when things are hard . . . people I think really want to show that they support the region that they want to do business here . . .

I think it's just a way of saying to the world you know we're still here and we're proud and things will get better. That's always the optimistic point.

*From June 8, 2012, interview*

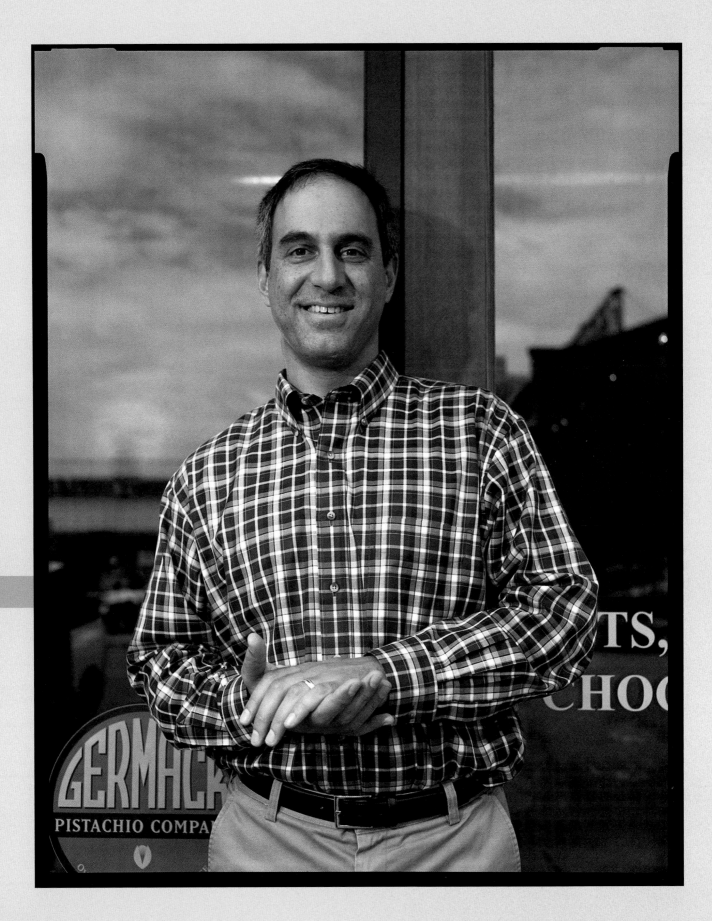

I was born in Detroit. I've always been very interested in Detroit. I was interested in activating the street grid again in a way that brings people back to the city and lets them interact with each other.

This is going to be spectacular. Right now I think it's at a crossroads: you need somebody who has a driving vision that keeps things consistent over a long period of time. Because sometimes when areas get popular, big money corporations come in and say, hey, let's put a Walmart here. You need an overall cohesive vision to develop a particular place over a particular period of time. So now it's great because you have the DMC [Detroit Medical Center], you have the Center for Creative Studies, you have Wayne State, you have crackheads, you have senior citizens, you have young people that have money that live

## James Cadariu
CO-OWNER, THE GREAT LAKES COFFEE ROASTING COMPANY

in the area. This is the crossroads of everything going on at one time. What's going to improve about this is that there's going to be more street traffic which will connect this whole block to the Symphony Orchestra, Orchestra Hall, and then keep moving toward Downtown. With the development here, the funding upstairs, the new restaurants, housing there, housing here, this area is going to be incredible, incredible. This is going to be a place where people can come and spend time, go from place to place.

What we need in Detroit more than anything is people. People on the street, because people see other people and they want to get involved, and that's really activating the street front. You don't improve this, you can go out in the suburbs and you can see that and have your little piece of property, but it's based on cars, and cars are impersonal. I don't see you, I'm speaking French with you, this makes no sense; if I'm in the suburbs driving to the pharmacy in the back of my car, I don't meet you. But down here you're rubbing up against people that aren't like you, that may be like you, that may be somebody that you didn't think you'd ever talk to and you're learning from—people sharpen people and that's a good thing for everyone.

*From June 11, 2012, interview*

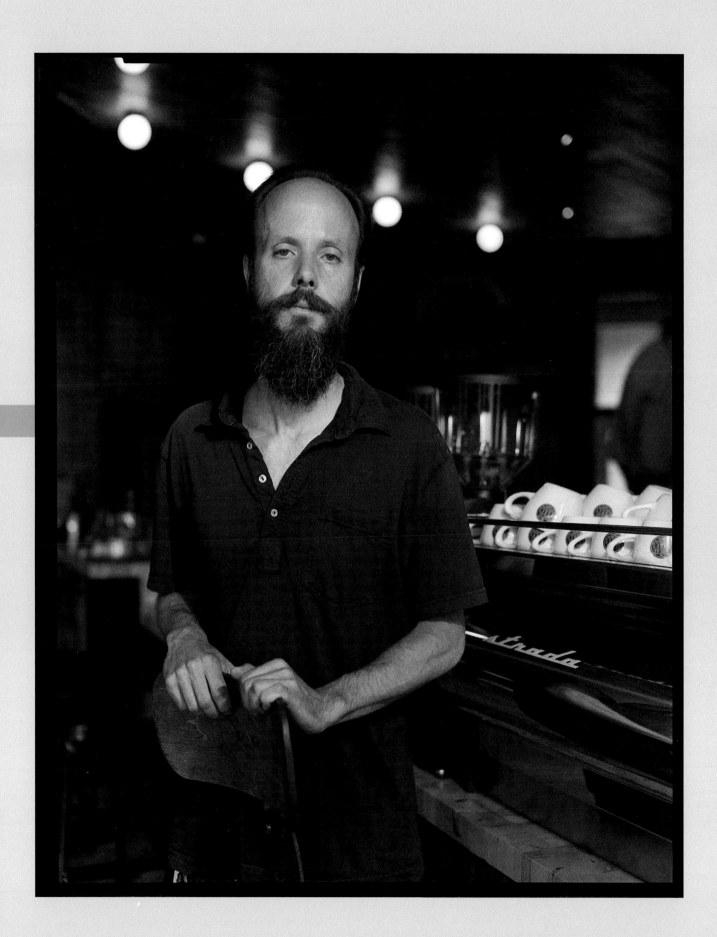

I was surrounded by people like Jimmy and Grace Boggs, who were involved in the Black Panther movement, in the National Organization of the American Revolution, who were grassroots people trying to do things to change the living conditions of people in Detroit. Worked on actively trying to get neighbors to come out against drug houses on their blocks, and get food to people. And so I was connected through them. Jimmy was one of my really good friends.

I never wanted to leave Detroit. I really didn't want to leave this area. I was very connected to the people . . . And to people that had a passion for change. There's a big group of people in Detroit that have a strong commitment to Detroit. That's what keeps me here. It's livable in a way a lot of other cities aren't livable. You can live here on less money.

In five years and ten years, hopefully we can use the brand that we've developed here, and the triple bottom line; look at not just focusing on business but also focusing on the community, and feeding yourself and eating local, and being small within big.

All the small growers come and they funnel into a nonprofit, which is run by quite a big organization that's been around for thirty years. The farmers come give over their goods [to the nonprofit] and they sell them for them, rather than individual farmers trying to make it on their own. For a ten dollar membership, they provide them with all the seeds and they provide them all the training. They've [built] this model of a two-acre plot that could produce an income of $35,000 a year.

When we first came, our bottom lines were very clear; we were going to recycle, we were going to try to compost, we were going to work on a zero

# Ann Perrault

COFOUNDER, AVALON INTERNATIONAL BREADS

waste company. To do that, we had to reach out to try to find someone that was going to take compost. That beginning person was a Franciscan monk from the Capuchin Soup Kitchen. He just would get our coffee grounds, and he started trying to use our starter, but it became overwhelming to him right away because that's a lot of organic compost . . .

About 300 people [were originally] involved in plot farming. Now there's 3,500 people in the city involved in plot farming. It has grown [by] leaps and bounds. There are a lot of things we are still trying to work on; the hoop houses are coming, and the extended-season things are coming so that we can get more above ground.

We are a postindustrial city.

*From June 4, 2012, interview*

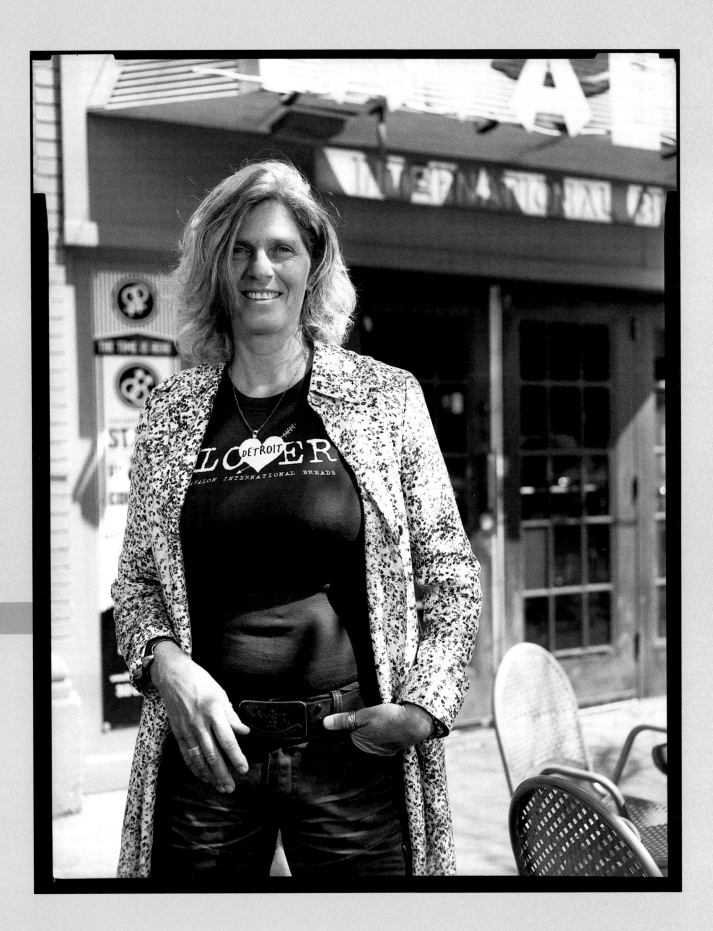

# Curtis Wooten

HEAD BAKER, AVALON INTERNATIONAL BREADS

Fourteen years back, this was an area you did not want to come in. When they put a bakery here, when there was no other businesses or lots on the block, they changed this whole block. And now, from then to now, we not only have other businesses around, we have nice lofts. I see people walking the streets three or four o'clock in the morning and everything is safe around here. We have a stadium downtown now; everything is growing. So in the next five to ten years, I expect Detroit to be way better than what it is now. I've seen a lot of things just growing. It's just a safer environment; Detroit's going to be the place everyone wants to live. We've gone through some hard times—true, we did—but five, ten years we're going to be past that. It's already happening in Detroit; things are starting to shift in a better, more progressive way.

Any of my employees will tell you that live in Detroit, we were here. We've seen how Detroit has declined, but then it's coming back up again. We're still in it. And we see it every day.

*From June 4, 2012, interview*

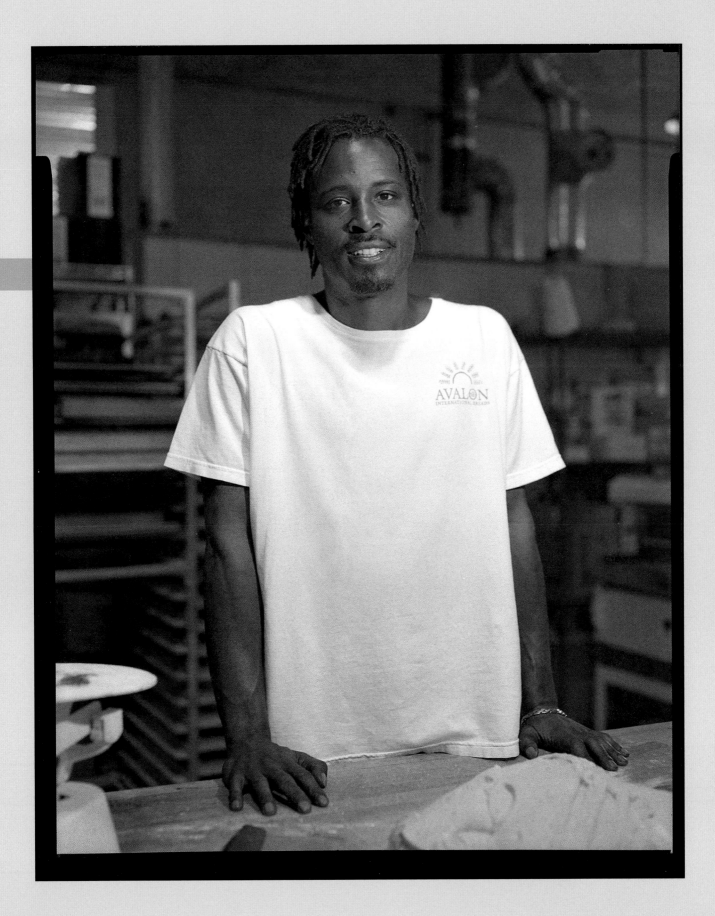

Someone said, oh, let's start a farmer's market. I didn't know any better than to say, sure, I'll try that, and so I did. I've never worked harder in my life and I've never had more fun.

It's a struggle every year to raise the money because [the market] is not self-sustaining; the cost to operate it is far beyond what we get from the vendors. But my organization that I work for is a neighborhood nonprofit. People see it as a social good. This is meeting an important need in our community for access to fresh, healthy food, and people need a place to be with each other. So you'll see lots of shoppers have already a relationship with the vendors, they're on a first-name basis, people are meeting their neighbors here; people are showing each other pictures of their grandchildren. Detroit is a food desert, but it's also a place desert. There aren't places for people to be with each other in a social way. So in a very small, micro way we meet that social [need]. Many neighborhoods in Detroit don't have anything like this. They would love to have this.

It's a lot of work. We're kind of on the border. This neighborhood [Grandmont/Rosedale Community] is reasonably middle-class and comfortable. And just next to us is the next neighborhood, Brightmoor, which is desperately poor, one of the poorest neighborhoods in Detroit. So we try to assist the neighbors from Brightmoor, two-thirds of whom have no transportation. Last year we got a grant and organized a shuttle.

# Pam Weinstein
MARKET MASTER, NORTHWEST DETROIT FARMERS' MARKET

I was very lucky last year. The Detroit planning commission sent us to Turin [Italy] to study the neighborhood markets. Oh my God! What amazing markets! They operate seven days a week, and they're embedded right in the neighborhood. They have everything; not just food, there's clothing, there's underwear, there's a hardware store, there's everything you could possibly want. It was revelatory because a big problem in Detroit is not just that there's no access to food, there's no access to anything. There's no retail. There's no place to go shopping. So the model in Turin, even though it's very ambitious to think of it, it's a model that really would work in Detroit.

*From June 14, 2012, interview*

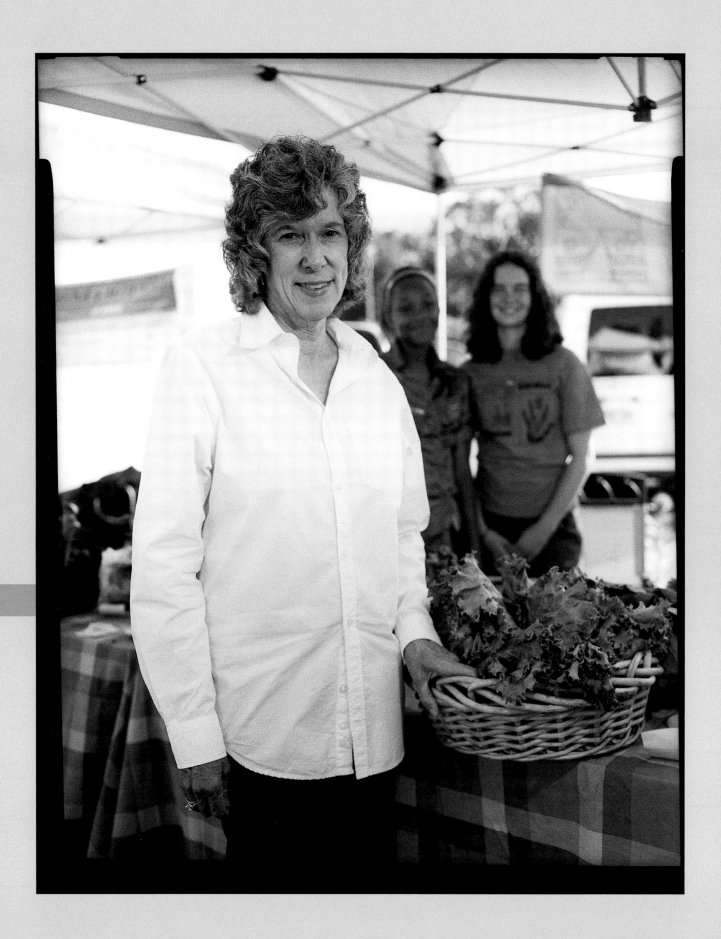

I am a farmer here in Detroit. I work with a soup kitchen to grow food for their use and to train new farmers and youth about growing their own food.

In 2003, there was an opportunity to work here, so that's what I did. I came here and I didn't really think that I was going to stay here long. I thought that I was just going to come and learn. A lot of people think of Detroit as a nasty, dirty city that's unwelcoming. I don't want to give the impression that it's not without problems—but the people in Detroit are really warm and friendly and creative, and I just appreciated the ingenuity and the fact that folks weren't waiting for the government to come up with solutions.

I'm really interested in how can communities come up with solutions, how can we have more community control over access to resources; urban agriculture is just one example of that. You see all kinds of interesting community art projects and, you know, folks looking at how they can reduce their power consumption locally, and all those things are really fascinating to me. So, you know, Detroit is a hard place to be, but it's also a very exciting place to be.

*From June 8, 2012, interview*

# Patrick Crouch
URBAN FARMER, CAPUCHIN SOUP KITCHEN

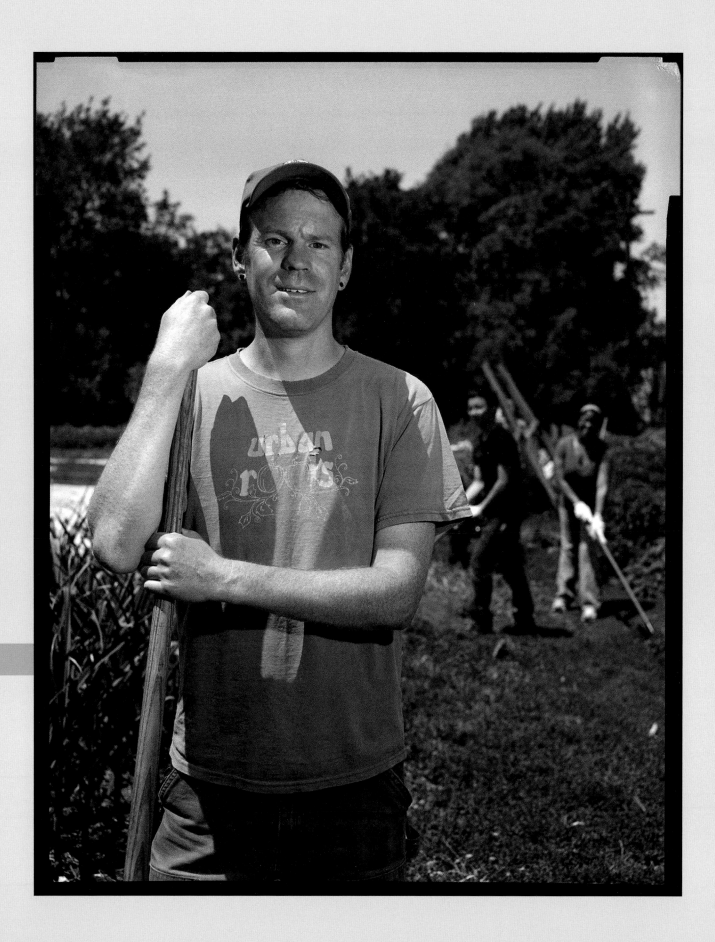

I was a copywriter and ended up being an account executive in New York. It was great. I made money, had fun, traveled, learned a lot—then it got to the point where the thrill was gone. And then I came here. They only had that one little garden and it was looking really pitiful. And I said wow, okay. So I was trying to find some way to fit in, something to do. So I started doing the gardens.

We've got a melon farm that's not far, about a mile and a half from here. So it's all spread out. We're going to try to do a

## Cornell Kofi Royal
MASTER GARDENER, ARTIST VILLAGE

permaculture site—permanent agriculture. Creating a forest and then growing in the forest. It cuts down the need to water, the need to weed. You know, in a way, you sort of create an alliance or relationship with nature as the grower. You're really following nature's lead.

Personally I think for me, it's to try to create a model of how cities ought to be, how urban places ought to be. To me, the ideal urban community would have a lot of vest-pocket farms, gardens . . . where vegetables and produce were being grown not so much for a mass market thing, but just to cool people out, bring about some sense of neighborhood, as a meeting place, as well as offsetting some of the cost of food. When you look at the fact that most of the food has to travel great distances, and a lot of the time it's been stored for a long time, so it's not fresh. So essentially I could see Detroit as having these little vest-pocket farms or gardens all over; it would make an interesting contrast to what cities have traditionally become.

*From June 6, 2012, interview*

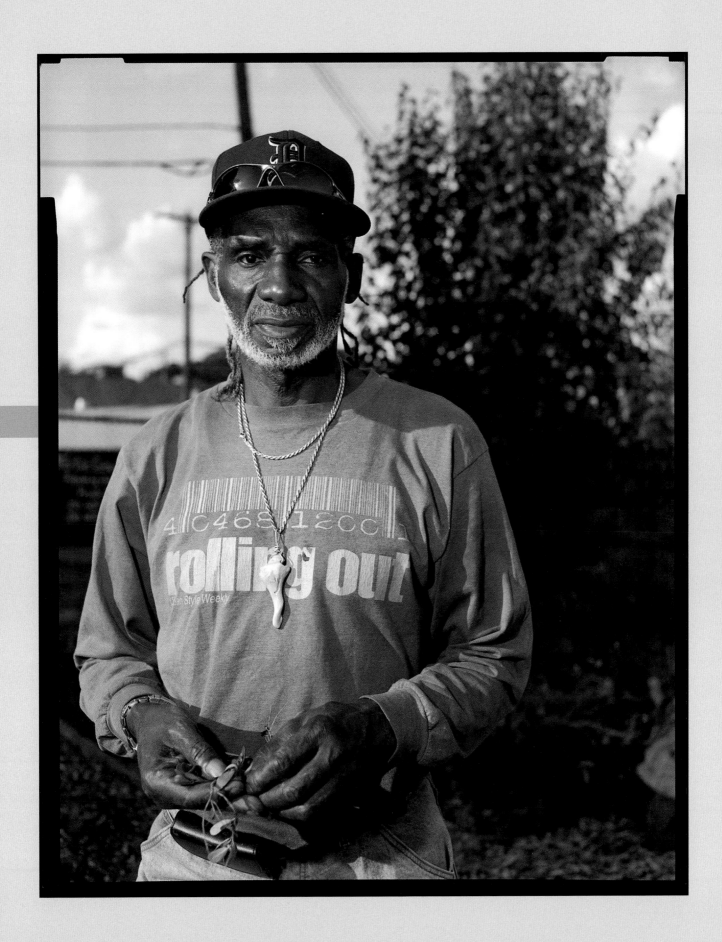

**W**ell, I had worked on a number of organic farms, and so had my partner Alex. We decided it would be a good idea to jump into this movement in Detroit and build the best farm we could with this vacant land that is so readily available.

It's a really exciting city to live in because so many people are just doing everything they can on their own, coming up with new ideas, creating new projects. There's room to do whatever you want to do in a lot of ways.

Well, the State of Michigan Land Bank wants to sell the land back to people who are going to invest in the community and not just flip the land to make a profit. So we sent them our business plan and they liked what they saw. It used to be Peck Elementary School right here, so we started a company last year that we're calling Peck Produce. We're growing all the kinds of food we can: vegetables, fruits, mushrooms. We'll be raising chickens for eggs and meat, raising fish.

# Noah Link

URBAN FARMER

Another reason we wanted to do this here because it's so hard to find good food in the city. There are more grocery stores than some people make it sound, but they don't have the best produce, they don't have the best food.

*From June 5, 2012, interview*

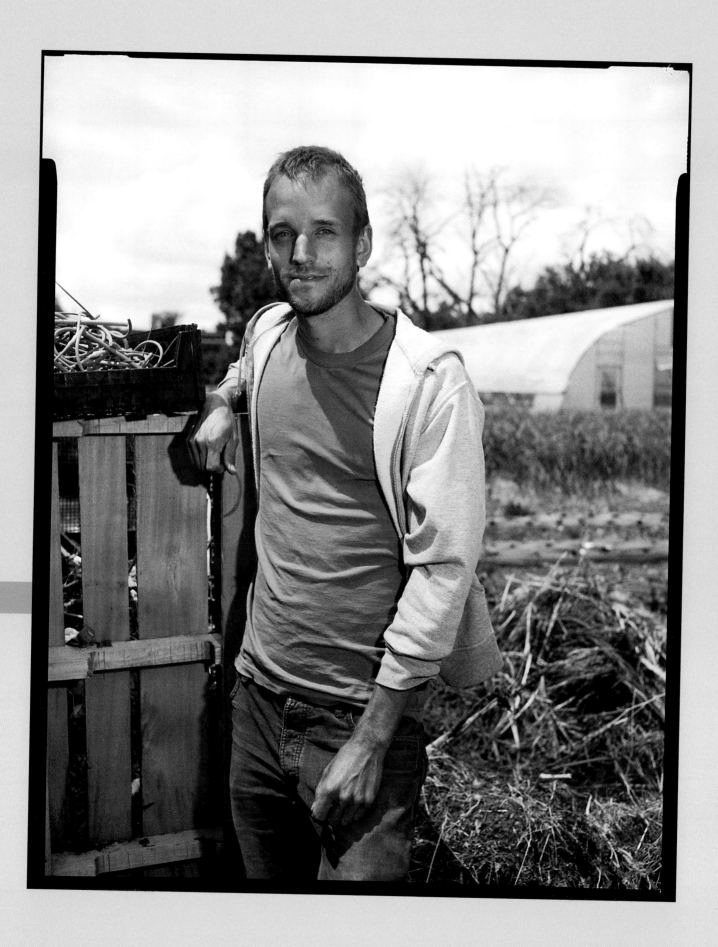

FoodLab Detroit is a network of socially and environmentally responsible food entrepreneurs. I'm an organizer of food entrepreneurs, and a researcher who studies the role of business and social movements. I do action research. I work with business owners and people who are starting food-related businesses in the city to help them not just participate in a free, open market, but envision new ways to work together to contribute to [the] quality of life here in the city, and the well-being of residents—not just profit. We're one of the only organizations that's really pushing things like considering worker-owned cooperatives as a business model.

# Jess Daniel

FOUNDER, FOODLAB DETROIT

After college I worked at Google doing marketing. I did that because I knew I wanted to do social-change work, but I knew I wanted to do it with an understanding of [the] private sector and business. I went [to Google] knowing I would leave. After a couple years, I went to work in Cambodia. At the time I was working in educational development, but I soon realized that, especially in Cambodia where 25 percent of people are still involved in agriculture, all of the social-justice issues I was interested in were tied into the food system. So I became more and more interested in food and the way that food is a very tangible, beautiful, sexy way to talk about things that are difficult to talk about in other ways—things about race, racism; things about the way workers are treated; things about what we're putting into our bodies and our health. All of these things we can talk about through food in a joyous way and not in a painful way. And so I got more and more interested in food.

The future? That's a great question. (*Long pause*) I'm an idealist, and I'm a realistic idealist, so I think a lot of things are going to be the same. I don't think that the landscape of a lot of the neighborhoods is going to change drastically. On the other hand I see this very tight social fabric being woven; a lot of the stuff that is changing is invisible. People feeling more empowered to take control of their own destinies. And so I think that that's what's going to change, is that not only new residents coming in are going to be creative, but people are going to start recognizing the ingenuity and hustle and drive of existing residents and start to tap into that more. It's gonna mean more small businesses in neighborhoods. It's gonna mean stronger community organizations. It's gonna mean more of these gardens everywhere.

*From June 18, 2012, interview*

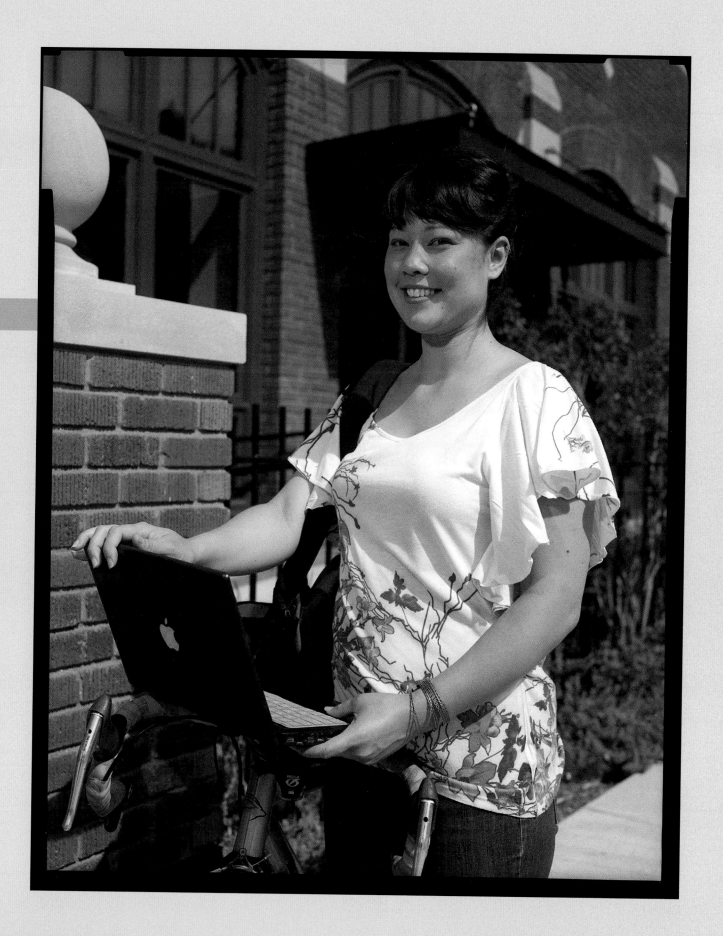

# Thomas Wilson Jr.

COMMUNITY ACTIVIST AND TEACHER

I'm a realist and I'm an optimist. The realism in me says that right now, Detroit's not a well city. We've got a deficit that if things don't get right, we could possibly, on the city side, run out of money. But on the business side, downtown is gorgeous. Ultimately, down the road, Detroit is going to be okay. Now will Detroit be great again? You'll have to read the history in terms of Detroit being great. But Detroit is going to be okay. We will be a smaller city, we will be a better-managed and run city, but we're going to be okay. And I hope I'm here long enough that I can see it happen.

All in all, we are all one, all the same; there is no "I" in "we." There are a lot of "I's" in "we," but collectively we are all one.

*From June 9, 2012, interview*

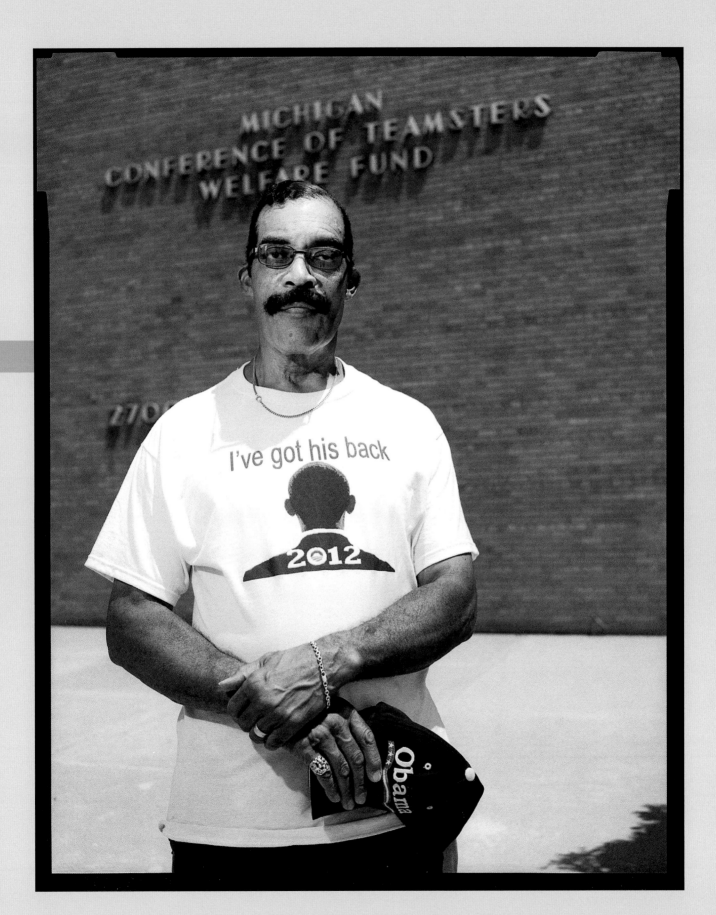

I was born in Windsor. My mother is Afro-Canadian. On my mother's side we can trace the family all the way back to the Revolution in the States. My father's side is Jamaican, and his family moved here when he was young. I came here when I was eleven and went to Cass Tech for high school and then to Michigan State. I worked in Lansing and was a journalist for four years, came back to Detroit for a "little while." In '79, I went to work for the *Free Press* and I was there till '95, when we went on strike. After that I went to work for the *Metro Times* and I'm the editor now.

When you've been in a place for a certain length of time, you kind of get an energy from so many people that you know. You can see more things happening and more energy.

# W. Kim Heron

EDITOR, *METRO TIMES*

I think there's kind of an acceleration of some things. You know the difficult thing is the city budget; the city is more broke than ever, with less leverage to do anything. On another level, there are more people coming into certain neighborhoods; there's a garden over by Eastern Market. Eastern Market itself is bustling more than it was ten years ago, even more than it was five years ago. So it is kind of an excitement to see what everybody's doing and what's happening next.

*From June 2, 2012, interview*

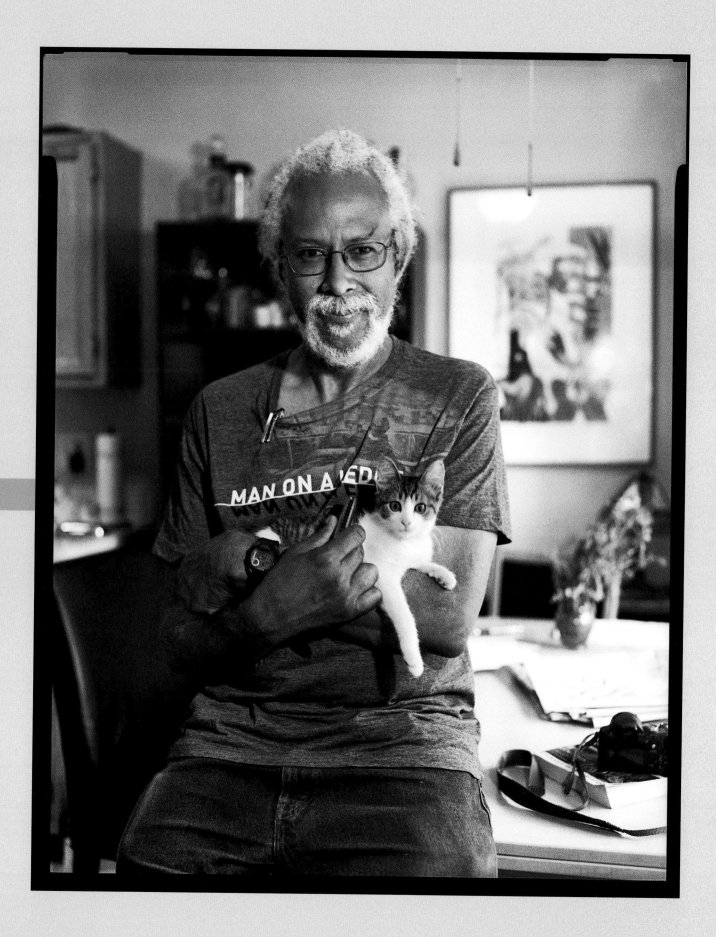

# Andy Linn

CO-OWNER, CITY BIRD AND NEST

My sister Emily and I own City Bird and Nest; they're two boutiques in Midtown Detroit. We opened City Bird about two-and-a-half years ago and we sell work by about two hundred artists from Detroit and other Rust Belt cities. And at Nest we sell housewares, kitchen items, sundries, and other items for the home. My sister and I started making things that were Detroit-themed in our basement about six years ago. And we found that they were very popular, and the business grew organically. Over time we decided it was time to open a store, and we wanted to add to the vibrancy of the neighborhood here.

We grew up on the east side of Detroit, near the water. I think that our parents always instilled in us pride in the city and a desire to make it better and to share it with others; that's part of the reason to have the stores in the first place.

One of my favorite things about this city is that it is very accessible for people to do things. It's a city where there are lower barriers to entry in many ways. It costs a person less to live day-to-day, and it costs a person less to do something. So if you don't have quite as much money, you can open a store that you couldn't open, say, in Chicago or New York.

*From June 16, 2012, interview*

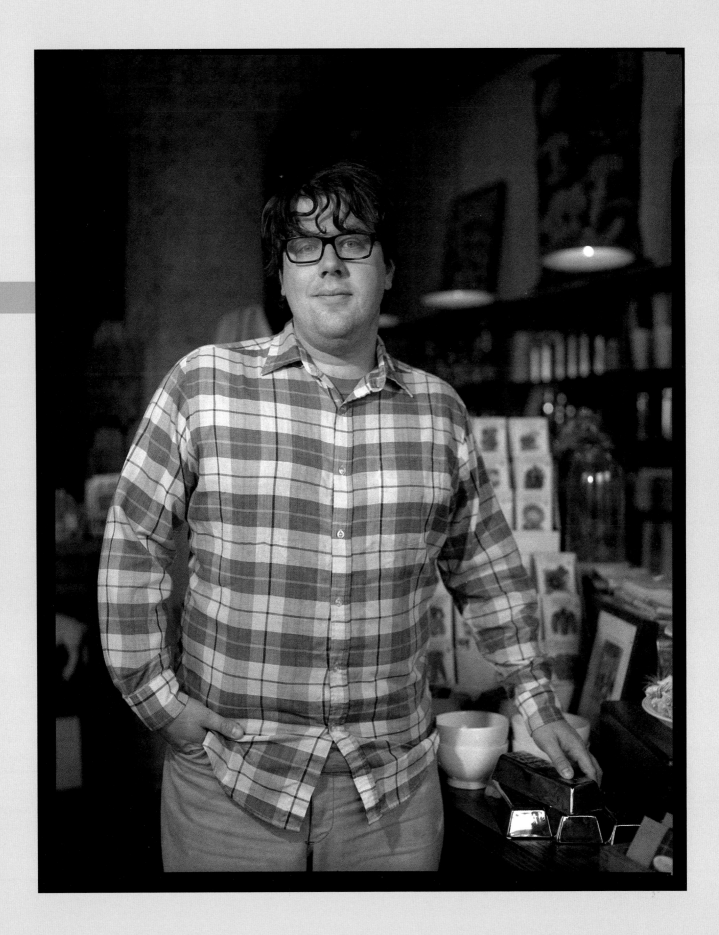

I was born in Detroit, right up the road here in Grand Circus Park. I was raised in Los Angeles. I came back to Detroit in 1985, because I was getting in a lot of trouble out there as a youth. I came back to live with my uncle, who was an ironworker who got me into the industry. I always wanted to be in some sort of construction field, and ironwork seemed to be the best suit for me.

What's interesting to me about Detroit is the history of the city. It's a city that's three hundred years old. It's older than our country. And there's a lot of history here that I'm proud to be a part of.

I see the city expanding, growing. I see the suburbs and the inner city collaborating on rebuilding the infrastructure. And I'm hoping Detroit becomes another global force for commerce and trade, like it used to be.

## Tony Hernandez II
FOREMAN, MIDWEST STEEL

What I do is locate and find all the pieces of steel—the puzzle pieces, so to speak—and get them in place, get everything orchestrated and lined out, and then I put my men to work and assign them their duties for the day. I expect them to complete those tasks. That's what we do on a daily basis. Take small bites and erect steel.

*From June 18, 2012, interview*

150

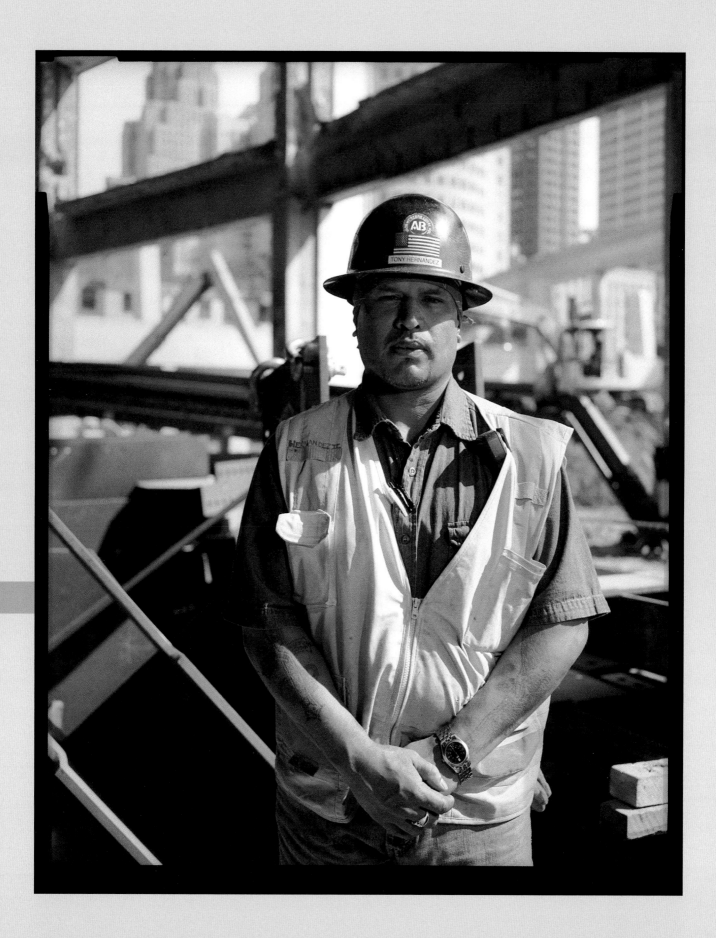

We have been here as a unit of three independently owned businesses for ten years. But I've been selling books in Detroit for twenty-three years. I always was doing something with books. My mother was a librarian. In the years I was growing up, we went to the library. There was no TV. We did a lot of work with the library. And I always loved teaching. I taught for many years.

Detroit is my home, so I'm going to have a biased opinion because home is always the best place possible. And Detroit is an old city. We've been here about 325 years as a place; this is counting from when the French came. Prior to the French coming in, it was a trading space for Native American people because of the river. So it's an old place where

## Janet Webster Jones
OWNER, SOURCE BOOKSELLERS

people have settled. So because we're having a revival now doesn't mean we haven't had other revivals. There is always great hope. Without hope there's no life. And as you can see, there's a lot of life in Detroit.

Detroit has always been a place of teaching. Detroit teaches a lot of people, and then they go places and do what they were taught. And then we teach more people. That was true in the arts. In music we have people all over the world who learned what they know here in Detroit. So Detroit is a place of getting to know who you are. And I think this new wave of people that's coming through . . . they will learn from Detroit.

Well, in five and ten years nothing is going to be the same. I think we're on an upward motion now and I think we'll continue to be. We've had about forty years of loss of population, loss of jobs, income. Our social fabric has been shredded in a lot of ways. There've always been people in Detroit who live in Detroit, who work in Detroit, who raise their families in Detroit. Whenever people have left, we've always had people here. Nobody ever left and it was all gone.

So I look at Detroit and it is huge, huge. And what it will be, how it will look is all going to depend on the people, because it's always the people and not the place.

*From June 16, 2012, interview*

152

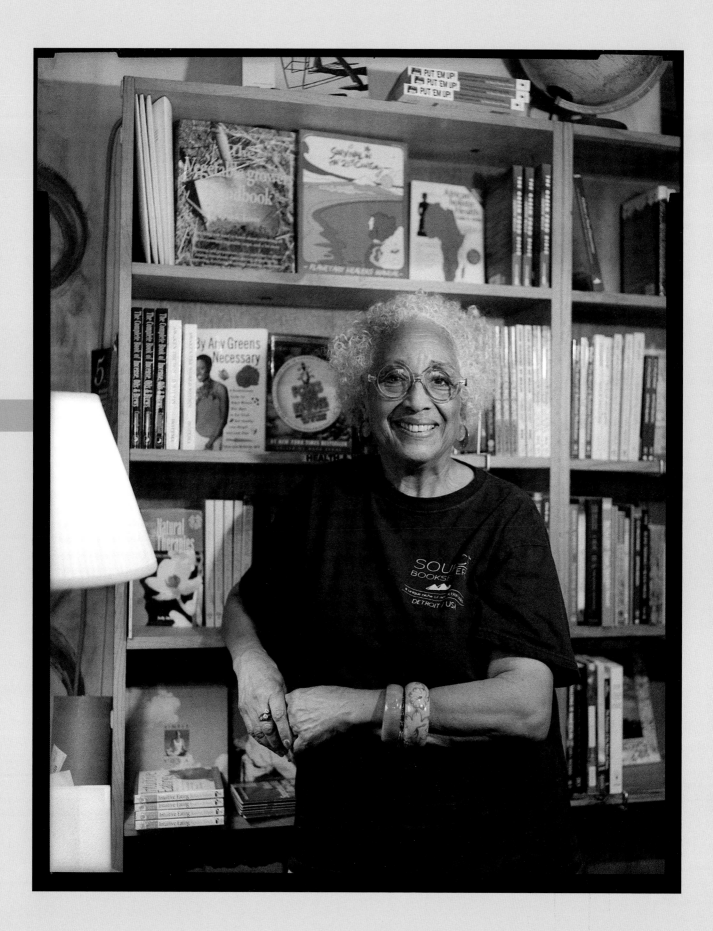

This is our twenty-fourth year of bringing folks together from both the city and the suburbs in an effort to re-create Detroit—to stabilize it, to revitalize it, and to beautify it. We create ownership, both in the business district, like we have done here at the Motor City Java House. This is one of the projects that we've built, as well as creating homeowners in the neighborhoods. So it's been quite an adventure.

There was an abandoned house behind our home that turned into a crack house, a drug house. And we couldn't get rid of it; we called the mayor, and the city, and the police, and no one would do anything. One Friday night it got out of hand, and I boarded it up the following morning. A couple neighbors joined me. We spent about eight hours out there cleaning, and painting, and boarding, and fixing, and raking, and you name it. When the drug dealers came back, they couldn't get in and they left. And that's how the organization started in the summer of '88. And we've been at it ever since.

We have spent twenty years and about $20 million tearing down and fixing up. We have the community center across the street that houses offices not only for us but [also] for Michigan State University. We have a banquet facility that will be back open in about two weeks. And then the Artist Village in [northwest] Detroit where we are today, when we acquired these buildings nine years ago they were all vacant. There was a hole in the roof, all the windows were broken out; there were bars on the window, a complete wreck. And we have spent the last nine years now building the coffee shop, the candle shop, the café, the jazz club, the art gallery, the lofts. So it's been a team effort to really stabilize and revitalize this business district. Alicia, who owns the coffee shop, used to be my executive assistant and always wanted a neighborhood coffee shop. So we built her one. Miller, who is a master muralist, lives out back. When we met him, he said he wanted to teach kids and paint murals, so we helped create an art studio. Kofi

# John George
DIRECTOR AND COFOUNDER, MOTOR CITY BLIGHT BUSTERS

Royal, who we met in '05, said he wanted to create a community garden, so we knocked down two crack houses and we built a garden. We create ownership, and we create value, and we build community assets.

Blight is like a cancer: if you don't nip it, it spreads. I mean look, it just killed this whole block. Now there used to be an abandoned house here that we took down. If you look, if you stand here and look this way, and use your imagination, and just imagine green grass and a path and fencing and again just what you saw on the other side. It's going to be beautiful.

Failure is not an option.

*From June 6, 2012, interview*

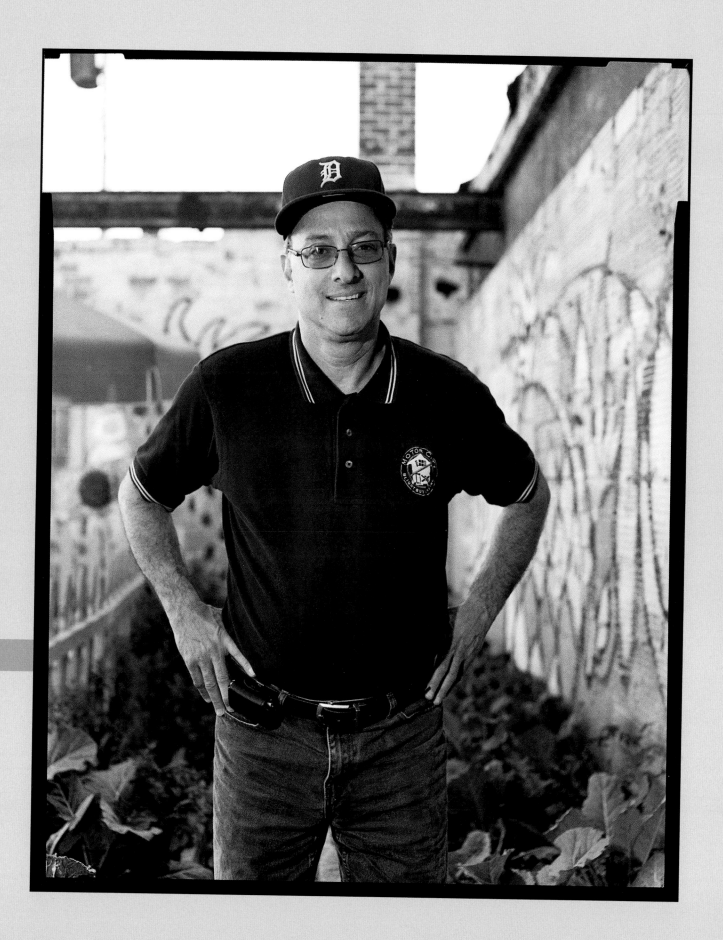

# Yusef Bunchy Shakur

AUTHOR AND ACTIVIST

Who am I? I'm a native Detroiter, I'm an author, I'm a revolutionary, I'm a visionary, I'm a father, I'm a man, and more importantly, I'm the one that believes in Detroit from the bottom to the top.

Detroit is my mother. Detroit is my father. Detroit is everything. I am Detroit, the good, the bad, and the ugly. It's the place I've always known. It's part of who I am. Detroit is part of my story of redemption. To complete my story of redemption is to see Detroit's redemption. She never forsake me; I can't see myself forsaking her.

Detroit is a proud city; it's a great city.

*From June 5, 2012, interview*

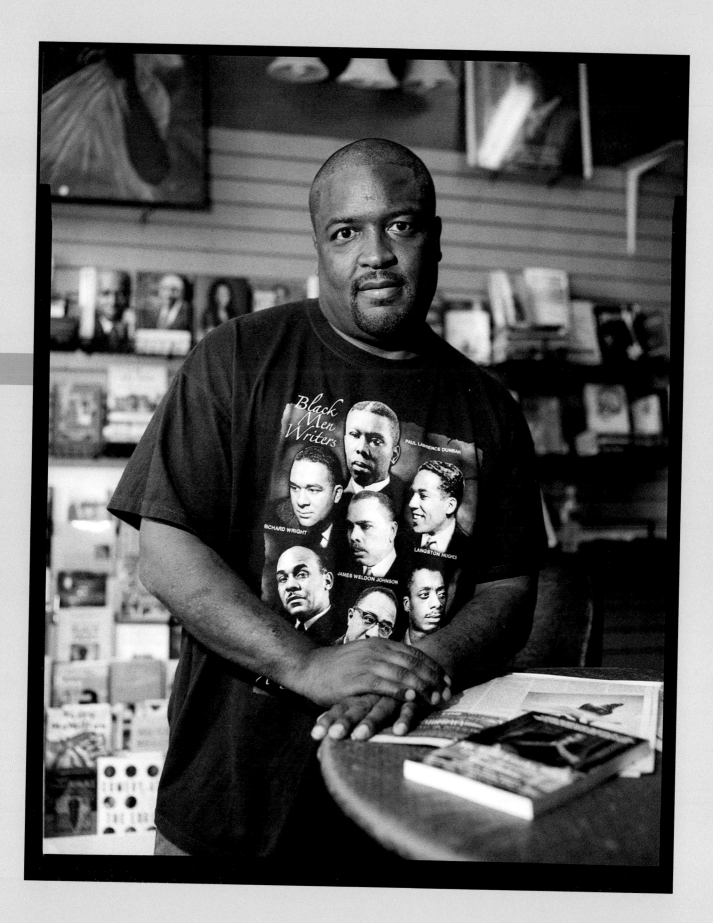

Detroit is my home, so I'm going to have a biased opinion because home is always the best place possible. And Detroit is an old city. We've been here about 325 years as a place; this is counting from when the French came. Prior to the French coming in, it was a trading space for Native American people because of the river. So it's an old place where people have settled. So because we're having a revival now doesn't mean we haven't had other revivals. There is always great hope. Without hope there's no life. And as you can see there's a lot of life in Detroit.

—*Janet Webster Jones, owner of Source Booksellers*

# detroit dreams:
## no rust belt scene

**ON THE CORNER**

LARRY GABRIEL

Janet Webster Jones has always perched regally behind a short counter in her small Source Booksellers retail space. Her gray hair is splayed out about her head like a woven crown as she warmly greets visitors entering the Spiral Collective, a space she shares with an art gallery and gift shop on the northwest corner of Cass and Willis Streets, in the booming section of Detroit called Midtown. There is always a tinge of incense in the air. Art on the walls, shelves of books, and glass cases of knickknacks create an intimate, transformative space where Jones hosts yoga and tai chi classes. Jones absolutely beams as she chats with visitors about books, issues, and cultural events.

The strip at Cass and Willis, known as the Willis Village, is one of my favorites in Detroit; it's one of the little enclaves that are increasingly speckled about the city, flavored with the hope and ingeniousness of Detroiters. Along Willis and next door to the Spiral Collective—which includes the Del Pryor Gallery and Tulani Rose Gift Shop—is Flo, a boutique selling clothing, accessories, and small home furnishings. Next to that is Goodwell's Market, a natural-food store and restaurant. And next to that is Avalon International Breads. The anchor for the strip, renowned for delectable pastries and great coffee, is a

159

neighborhood meeting spot. It's become prime evidence that new businesses can sprout up in Detroit and thrive. Avalon has something more: a commitment to an underserved community in the Cass Corridor.

On warm days, Willis Village is lively. Avalon and Goodwell's have open-air tables for patrons to sit and chat. People pass. People linger to chat. Familiar faces smile at each other. They call out and wave to each other. It's the model of modern urban conviviality that seems to spread out through the neighborhood.

This has been a great intersection for decades. The Spiral Collective space was formerly occupied by the Cass Corridor Food Co-op, a pioneer in what we now call food justice issues, which helped keep the corner humming in the 1980s and 1990s. It brought healthy, natural foods to an area where nothing seemed natural anymore. Concrete and asphalt ruled the habitat along the Cass Corridor, now one of the Midtown neighborhoods.

Rosa Parks used to come into the co-op. I never really spoke to her aside from what was necessary to ring up her purchases, although I was always aware of her calm presence in the store. She seemed a quiet, almost shy woman who just came in to buy her vegetables and didn't want to be at the center of any hoopla. One time I pointed her out to a shopper. The woman rushed over to Parks to speak to the hero who had started the Montgomery Bus Boycott that kicked off the modern civil rights struggle. Parks seemed disturbed by the attention, as though her privacy had been violated.

Before the co-op was there, the now-legendary Cobb's Corner bar roosted in the building featuring some of Detroit's best jazz in the 1970s. Organist Lyman Woodard's Hammond B3 organ sat in there like an altar where musical offerings were proffered. Trumpeter Marcus Belgrave and many of the adventurous musicians associated with the Tribe collective played there regularly. Griot Galaxy played there when saxophonist Faruk Z. Bey and the band numbered as many as sixteen members before it settled down to the quintet that later found an international audience.

Back in those days, the Willis Gallery—an alternative, cooperative art space founded in the late 1960s—displayed explorative art on the walls of what later became the Avalon bakery. Visual artists and their challenging images once ruled where wonderful smells later piqued imaginations. Dan Moriarity directed the gallery early on; Gilda Snowden directed it in the 1980s when it returned to the original space after a sojourn in the Fisher Building.

"They were abstractionists, some realism, some sculpture," Snowden, now an instructor at the College for Creative Studies, told me when I recently ran into her. "They all came together as a unit in this one little area; this one gallery was extremely significant."

The corner of Cass and Willis means more to me than most locales in Detroit. Cobb's is the first bar I ever went to in Detroit, shortly before I moved into the Cass Corridor neighborhood. I went to shows at the Willis Gallery on a regular basis, especially the openings, which were neighborhood events. I was a cashier and then a board member for the food co-op when it was there. It's on this corner where I ran into artist and poet Ibn Pori Pitts one afternoon after a doctor's visit when I got bad news concerning my daughter. I don't remember how or why I got to Cass and Willis. I broke into tears as I told Ibn my troubles. He reached out and engulfed me in a comforting, loving hug in a moment I will cherish the rest of my life.

There have been good moments and bad ones associated with this corner. Drugs and prostitution were common in the Corridor. The manager of Cobb's Corner bar was shot dead in a passageway behind the bar one night. Rumors claimed it had something to do with cocaine

trafficking. During Prohibition, a building a couple of doors along Cass from Willis was a garage for Detroit's notorious Purple Gang—known for bootlegging, smuggling liquor from Canada, and hijacking loads of booze from other gangs. In the late 1920s, the Purple Gang ruled the city's drug trade.

Ah, Detroit, it seems there is always another twist to the tale.

## A MIGRATION STORY

My family came to Detroit in 1951. It wasn't planned. Daddy was a jazz bass player based in New Orleans, part of the third generation of musical Gabriels in the Big Easy. My great grandfather migrated there in the 1850s from Santo Domingo—a black man with the chutzpah to voluntarily come to the United States while slavery was still established in the land. He was a bass player, too. For what it's worth, so am I.

Daddy had been traveling across the United States playing music with jazz, blues, and R&B bands since 1938. He'd played with the likes of Paul Barbarin, Sidney Bechet, Jay McShann, and Jimmy Witherspoon. On the trip that changed the trajectory of our family, he was headed to Cleveland for a job with traditional banjo legend Danny Barker. He stopped off in Motown to visit his brother who had moved here in 1948, following a route previously set by other relatives. Actually they were headed to California by a circuitous route, and this is where the car broke down. Uncle Manny was working at the Ford Motor Company River Rouge Plant. He talked to Daddy about getting off the road. Daddy had five kids back in New Orleans, and sometimes when traveling he didn't make enough money to send home. Mom had been pressing him about the same thing; actually it was closer to an ultimatum—get off the road

or get a new wife. Uncle Manny said he could get Daddy a job at the Rouge Plant. The next morning Daddy was hired. He sent another bass player to Cleveland, and started at Ford right away. A few weeks later he sent for Mom and the two youngest kids. The older kids stayed with relatives so they could finish the school year and give Mom and Dad a chance to settle in.

My family was part of that storied migration from the South to northern industrial cities. And, as was the case with so many others, once we were established, we often had other relatives staying with us as they moved here seeking a fairly steady paycheck at the auto factories. I was the first one born in Detroit. There were four of us born here, and there was a natural demarcation between the "big ones" and the "little ones" denoting where we were born.

The first place they stayed in Detroit was on the east side in the predominantly African American Black Bottom neighborhood. The apartment building had a shared kitchen in the basement. However the rats who shared the space were scary and plentiful, so the family moved to a house on the west side. By the time I came along in 1953, we lived at 3351 Humboldt Street, near Myrtle and Lawton. Detroit was still near its peak population of 1.85 million then. The arc of my life has been to witness the majesty of monolithic industrial power that the Motor City once was, its long and tortuous decline in population and fortune, and now it seems we are witnessing the nascent stirrings of a city whose people know that they must be the change that makes Detroit prosper again.

Coming to Detroit and earning union wages brought my family out of poverty in one generation. My mother didn't go beyond fourth or fifth grade; Daddy never went beyond middle school. All of their children got some kind of post-high-school training, with three master's degrees and a doctorate among us.

In my earliest years I remember riding around in the car with Daddy and seeing the downtown you sometimes see in those old black and white photographs of the city. The streets were crowded with pedestrians making their way to the big department stores. Streetcars rumbled along on rails with sparks flying from those poles where they connected to the electrical grid overhead. The lunch counter at the Woolworth store across from Hudson's was always a beacon on a trip downtown. Sooner or later you had to eat, and the neatly made tuna fish sandwiches, grilled cheese and tomato soup, hot French fries, and milk shakes were a great way to top off a shopping trip.

But the days of shopping trips downtown were numbered. Northland Mall had opened in 1954 in Southfield, just across Eight Mile Road from Detroit. The J.L. Hudson Company had the mall built, and a new Hudson's was its anchor store. Mall developments began to ring Detroit to take advantage of suburban shoppers. However it was a double-edged sword. The malls sucked retail activity from downtown Detroit over three decades. By the 1980s, downtown was dead. Malls destroyed big city downtowns across the country.

Downtown was fun, but it was a once-in-a-while experience. The neighborhood where I lived was where I roamed and explored with impunity. Folks were packed into small wood-frame houses with lawns in front and large backyards. It wasn't unusual for families to have twelve or fourteen kids. These days you might not have that many kids on one block. In the evening we would have massive games of hide and seek, tag, or kick the can.

Nearly everyone had some kind of fruit or berries growing in their yard—something that we lost and only now are restoring. We had two kinds of cherries, a pear tree, and a peach tree in our yard. Other yards sported apples, plums; berries and grapes were common. We grew tomatoes, carrots, and collard greens in a backyard garden. When we moved to a new house in 1965 we had grapevines.

The intersection to the north was Myrtle, where an A&P supermarket, a dry cleaner's, and a German beer garden stood. To the south was Ash Street, where a storefront Baptist church blasted out energetic gospel music on Sunday mornings. We were Catholic and weren't allowed to hang around there lest a blast of Holy Roller spirit infect our souls. Another block further south was Michigan Avenue and one of the city's biggest food hubs—Western Market, where farmers sold their goods on weekends. And there were a bunch of slaughterhouses where cows, pigs, sheep, and goats became meat for the masses. On Saturday mornings I would sometimes gather with neighborhood boys to watch the animals led from trucks to their deaths inside the building. I remember watching a guy with a sledgehammer smash cows on the forehead and slap a hook into its neck to drag it along the automated processing line.

I had free reign to run the neighborhood, although my sisters were kept close to home. I'd roam over to the public library at Warren Ave. and West Grand Blvd., kitty-corner from a funeral home that my sister would insist we go into to view dead people. Uncle Manny lived near there, and several cousins populated the neighborhood. We were a really big family, literally hundreds of Gabriels in the area between our house and Uncle Manny's. We had cousins who lived on our block, and other cousins lived in the little house at the back of their property.

We sometimes swam at the Kronk Recreation Center pool on McGraw Street, and went to the Globe Theater at Trumbull and Grand River on Saturdays. You could get in for a dime and buy a candy bar for a nickel. The Globe

didn't show first-run movies, but I saw my share of cowboy and gladiator films there. Sometimes we'd go the other way to the Kramer Theater on Michigan Avenue near what we now call Mexican Town.

Mexicans were pretty much all around. I never thought of them as different or foreign. They were just a part of the mosaic of my life. On Saturday nights a tamale cart would appear on the corner by the beer garden. It was a special evening when we could get some of these spicy treats wrapped in cornhusks. Freshly made tacos were regular parts of meals at church dinners. Years later I learned that Ralph Valdez, a local culture vulture who hosted the Radio Free Detroit show on WDET-FM, lived just one block over from me when I was a kid. The Valdez family went to the same church that we did, but it wasn't until decades later that we realized we grew up as neighbors.

The first school I went to was Chaney Elementary because my birthday was in February and I could start there for second semester, but in the fall I was enrolled at St. Leo. St. Leo wasn't the Catholic school closest to our home. That was St. Casimir, but we couldn't go there because it was a Polish institution, where mass was said in Polish and classes at the school were taught in the language.

That didn't seem strange to me either. While I was aware of white people, I didn't see them as a unified group. There were Germans, Polish, Irish, Italians, and some folks who came from the rural South that were known as hillbillies. All kinds of languages could still be heard around town. They were all distinct groups that tended to stick to themselves socially and culturally.

Almost all the men worked in some aspect of the auto industry—Ford, Chrysler, General Motors, or one of the suppliers, such as McGraw Glass or Kelsey Hayes Wheels, the site of one of the UAW's earliest sit-down strikes and organizing victories in 1936. When I met someone who didn't work for an auto company I viewed him as a strange bird indeed.

School was a half-hour walk from home. Dismissal was at 3:00 P.M. and we had to be home by 3:30 P.M. I found a way to beat the clock. There was a train overpass at Grand River near Warren, just a block from school, and a freight train passed about 3:25 P.M. I could stay around school after classes were out to play with my friends, jump on the 3:25 freight, jump off at Humboldt, and run a couple of blocks to make it home just in time.

Looking back I guess I had an adventuresome streak. One time I had gone downtown with my sisters. We were standing on Michigan Ave. waiting for the bus home. I had to pee and went into an alley to relieve myself. When I came back out, I saw the bus pulling away and thought my sisters had left me. I knew I was on Michigan Avenue, and I knew that Western Market was on Michigan just down the street from our house. It would be easy to find my way, so I started walking, secure in the knowledge that I would get home. Landmarks such as the United Shirt Distributors and Briggs Stadium—later Tiger Stadium—assured me I wasn't lost. In the meantime my sisters had not abandoned me. They had gone looking for me, but we somehow missed each other. They thought someone had grabbed me in the alley. When I finally strolled up to the house it was to an uproar. The police had been notified and they were looking for me. I didn't see what the big deal was. I had openly walked along the biggest street I knew of in broad daylight.

Catching fish in the Detroit River was a big supplement to our diet. During fishing season it wasn't unusual for Daddy to come home from work, grab a few kids, and head over to the river to go fishing. On weekends we would leave as the sun rose and head to Grosse Isle to fish in Lake Erie behind the Naval Air Station, where the water was never deeper than five or

six feet. We usually caught a lot of fish; perch, bass, bluegills, and crappies were the main fish we caught, although there were occasional catfish and carp. Generally there was enough to share with neighbors. Sometimes we would cross the Ambassador Bridge into Canada to go fish at Leamington Pier, especially in the spring during the smelt runs. Most times we'd get home and clean the fish on the back porch right away. Mama would dip them in cornmeal and fry them up. It's hard to beat fresh fried fish that had been swimming around just a few hours ago.

We lived within walking distance of Briggs Stadium, where the Detroit Tigers and Lions played, and to the nearby Michigan Central Depot train station. Sometimes in the early evening on Saturdays, Mama would walk us kids over to the massive eighteen-story edifice, where we would have soft-serve ice cream—back when it was a new and special treat—and watch passengers coming and going.

Other times friends and I would go to Briggs Stadium when games were scheduled. Sometimes folks with extra tickets would give them to us. Other times the ushers would let us in after a few innings of baseball or a quarter of football—something I doubt ever happens these days. Daddy would sometimes get tickets for Firemen's or Policemen's Field Day, and we'd go watch the clowns and acrobats put on a show in the stadium. One time a performer fell from a high wire and was killed right before our eyes. After he was carried from the field on a stretcher, the show went on. If we didn't get tickets for a field day, we could still watch the fireworks shows that always finished off the events; they were visible from our upstairs window.

Right before I turned twelve, the family moved over to the neighborhood just west of the University of Detroit. I always think of that move as the one that saved me from the streets.

I was just getting to where I was noticing some of the more detrimental aspects of street life. My older brother had hung out and got into trouble on those streets; I wanted to be like him. Then suddenly we were in a new neighborhood where I didn't know anybody and didn't know where to get in trouble. I then went to Gesu elementary school, switching from a place where my family was well known—all my old teachers had taught my older siblings—to a place where nobody knew me, or my family. My grades dropped from pretty much A's and B's to straight C's.

We were the second black family on our block in a formerly Jewish neighborhood where mezuzahs hung on the doorframes in many houses. There were more brick houses in the neighborhood than wood frame, and north of us in the University District there were huge three-story homes that held huge sixteen-member families with ease. We lived two blocks from the University of Detroit. There was no fence around the college then, and folks from the neighborhood were free to hang out on campus. I'd ride my bicycle around there and hang out at the fountain in the middle of campus. I'd been there a few times earlier for basketball games at Calihan Hall, and the football stadium (now a parking lot) was the home field for the Gesu football team.

I was a Boy Scout, and on Saturdays my friends and I would ride bikes over to Palmer Park for cookouts and to cruise around in the woods. During the winter, we would ice skate and play hockey on the big pond, then get some hot chocolate at the concession building. There was an offshoot of the pond that never froze over, and the ducks and geese would winter there.

I missed the 1967 uprising, or riot, depending on your perspective. I was away at Boy Scout camp. Actually I was a counselor that summer at the camp near Lapeer, working in the nature center, swimming and fishing on a daily

basis. I lived in a tent with a guy from Hillsdale County—my first heavy exposure to a nonurban someone. When the violence struck, as far as I could tell from radio reports the entire city from Eight Mile Road to the Detroit River had been leveled. It took a couple of days for me to get to phone the family and find out if they were okay. Two weeks later I got to Detroit expecting to see devastation everywhere, but my neighborhood looked the way it always had. The only casualty was a paint and hardware store on Livernois, near Seven Mile Road, that had been torched. It was never rebuilt, and now a strip mall sits on the site. I never went downtown to view the devastation near the epicenter of the violence at 12th and Clairmont Streets. My parents kept me close to home in the short period between getting back from camp and the beginning of fall high-school football.

## HEADED TO THE CASS CORRIDOR

It wasn't until I left Detroit to go to Michigan State University that I really began to go downtown and discover Detroit for myself. Some friends with whom I worked my summer job at the Detroit Zoological Park were living in the Woodbridge neighborhood near Wayne State University (WSU), and I visited around there when I was in town. Over time I met more people and started becoming familiar with the Cass Corridor and surrounding neighborhoods. That's when I first learned about gentrification. The first unsure steps of it were beginning to pop up. Young suburbanites who had come into the city to attend WSU were buying big brick houses for a song and rehabbing them with the expectation that the neighborhood would improve. A lot of folks gave up on that plan. It's been some forty years, and it's only recently that those investments are bearing fruit with the ascendance of nearby Midtown. The folks who

held out for a few decades and didn't get chased away by fear or violence, or the need to send their kids to better schools, are beginning to see some of their neighborhood rise up.

While I was in college, my father left Ford after twenty-one years because he had contracted rhinitis from the fumes in the paint shop at the Rouge plant. He contacted Ken Cockrel Sr., the crusading lawyer who had made his name on high-profile police brutality cases, and sued Ford's for his medical retirement. Cockrel told Daddy that he needed to be able to hold out for three years before the case was settled. Daddy went back to playing music full-time (he had never totally stopped) and doing fix-up work on houses while Ford managed to get one postponement after another on the case. I ended up coming home from college for several months to work and help support the family. I managed to stay in school by taking independent studies classes, allowed because I was in the honors college.

While the case was pending, Daddy couldn't pay the mortgage on the house. He talked to his banker and made an agreement with him that he would pay the interest on the loan but not the premium until he got his cash flow going again. I think about that today with the mortgage crisis, and how I hear about people who can't even figure out who actually owns the mortgage that they could talk to about their mortgage, let alone work out an agreement with them to lower their payments.

I graduated from MSU in 1975 and headed to the Cass Corridor, taking a job as a resident caretaker in a collective with friends at the First Unitarian Universalist Church. It was right behind the old Vernor's bottling facility on Woodward. Civil rights activist Viola Liuzzo attended services there in the 1960s. Alice Cooper had rehearsed the *Killer* album in the church basement a couple of years before I arrived. Rock bands seemed to be rehearsing in

every nook and cranny of the neighborhood. That's where my friends lived.

It wasn't what you would expect a college graduate to do, but I wasn't very interested in pursuing a career. I wanted to pursue art, and there was plenty of it around there. WSU was nearby, with its art galleries and music series, as well as the Main Branch Public Library. The Detroit Institute of Arts is across the street from the library. In those days if I saw a film it was either at the Detroit Film Theater at the DIA or at Cass City Cinema in the Unitarian Church. Foreign, art, and experimental films were the mainstays at these venues. I may have seen every Francois Truffaut movie made, up until then, at one of those two spots. The Jazz Workshop where Belgrave, Wendell Harrison, and pianist Harold McKinney taught was nearby, as well as the Strata Concert Gallery. The Artist's Workshop, where writers like John Sinclair and George Tysh, musicians Ron English and Bud Spangler, photographer Leni Sinclair, and numerous others had honed their skills, was just down the street. I was a poet and musician, and this was my land. It seemed like everyone was an artist or musician or writer or dancer. There was inspiration in the very air we breathed.

I also worked part-time at the Detroit Child Care Center at the Detroit Free School, housed in a building off Woodward and the I-94 freeway where Concept East, a theater founded by Woodie King Jr., had once staged its dramas. I didn't believe in any particular leftist philosophy, but hung out with leftists because I was at least sympathetic to their efforts.

Poetry seemed to pour out of me, and I read at various series at neighborhood cafés and bars. I was trying to mix words and music and sometimes had my musical friends accompany me. I wrote a novel that was never published about a traveling circus that gets stranded in Detroit. It was titled *City Rat*. One of my favorite things to do was taking long walks of up to five or six miles around the Cass Corridor, Wayne State University, the Cultural Center, and the New Center at two or three o'clock in the morning. Cruising around the darkened buildings—Old Main, General Motors, Detroit Historical Museum, DIA—was like walking in canyons between steep cliffs. Sometimes I would encounter other pedestrians who crossed the street to avoid me.

After a couple of years I went to graduate school at Pennsylvania State University. I'd always intended to go to graduate school, and a couple of years working convinced me that was a good idea. When I was finishing up in 1979 I stated my intention to return to Detroit to some colleagues. They couldn't believe it. You're out, why would you go back? they asked. My advisor tried to get me to stay there and pursue a PhD, but to me returning home seemed the natural thing to do. Go back where I came from. Go where my family and friends were, where I knew how to get around and where to find the cool stuff. I came back and returned to the caretakers collective at the Unitarian Church. I was a janitor with a master's degree, but I was writing and playing music—for me, things couldn't have been better.

Then I was like so many of the young people who have been streaming into the city in recent years. Come what may, I planned to make my stand in Detroit despite what possibly wiser heads had to say. It was my turf.

## THE CITY ON ITS KNEES

The early 1980s was a time of high unemployment in the city. People were leaving in droves. Newspapers from other cities were sold on Detroit corners because people were searching the want ads for jobs elsewhere. Oil was big in the Southwest, and Detroiters were headed there. Company after company that

had been important to the city closed or moved away. In 1980, Chrysler, reeling from foreign competition, closed its Dodge Main plant. The 67-acre facility was mostly in Hamtramck, a small city totally surrounded by Detroit. The shuttered plant represented another 3,000 local workers on the unemployment rolls. About the same time, Uniroyal closed its plant on the east side riverfront to idle another 1,700 workers.

Coleman Young had been mayor since 1974, presiding over a crumbling city. Desperate to create more jobs, Young made a deal with General Motors to build a new assembly plant on the Dodge Main site and in the Poletown neighborhood in Detroit just south of there. It was a tempting scenario. GM dangled the retention of 6,000 automotive jobs, 4,000 temporary construction jobs, and another possible 20,000 jobs created by the multiplier effect of the plant in the community. That was well and good, but the city would have to use an eminent domain policy to relocate 3,500 people to clear the nearly five hundred acres the plant required with its suburban "green field" design—built as much for security as production.

At first, a majority of Poletown residents accepted the above-market-value offers for their homes. After all, GM, the city of Detroit, the federal government, the UAW, and the Archdiocese of Detroit supported the development. However, a determined opposition emerged, supported by national consumer advocate Ralph Nader, and the ensuing battle over eminent domain and relocation would take place on the streets and in the courts. Some of the street protesters were people I knew who worked at the *Fifth Estate*, an anarchist political newspaper, and were involved with the Layabouts, a politically oriented rock band. My father stood solidly with the establishment, claiming that the plant was necessary for the jobs. His New Orleans–style marching band led

a parade Young put on in support of the GM plant. The state Supreme Court ruled in favor of the development in 1981.

I knew that kind of stuff was going on, but didn't pay much attention to it. I was busy writing poetry and short fiction, publishing some of it in small literary magazines and chapbooks. I made the choice that I would pursue writing rather than music. I knew too many musicians who were better than I was ever going to be, and they were struggling. I at least knew a couple of folks who were making a decent living working at newspapers.

Right around then, a terrible "Murder City" tragedy took place. A man waiting at a bus stop was killed. Then the killers took his keys, went to his apartment, and killed his wife and baby. It was one of those things that could still shock a city that seemed used to violence of every sort. The parents of one of the victims were Unitarians and donated the couple's furniture to the church. Another caretaker and I spent an afternoon loading their stuff onto a truck and transporting it to the church. The bloody blankets were still on the bed, and baby bottles filled with formula were neatly lined up in the refrigerator door. There was a layer of fingerprint powder on every surface in the place.

At the time, I was trying to figure out how to make more money as a writer, and a couple of weeks later I realized that I had a story from the murder that no one else had. I typed up my observations on the experience and sent it to the *Detroit Free Press*. My story, "Dismantling Lives," became the cover story for the Sunday magazine. I had broken into the mainstream as a writer.

And then there was Hudson's Department Store, a twenty-five-story building on an entire city block that had been the centerpiece of Detroit's downtown. It had hung the world's largest American flag on its walls for years. The store sponsored the International Freedom Festival fireworks and the Detroit Thanksgiving

Day Parade, which was two years older than the iconic Macy's parade in New York. When Hudson's closed its doors in downtown Detroit in 1983, it was a huge blow to the city. It may not have been that bad as a practical matter for the city—downtown was already pretty well deserted—but the image of the downtown icon closing was crushing. For generations of Detroiters and former Detroiters, there was no longer a compelling reason to go downtown. The malls that ringed the city had won the retail war, and no one seemed to know what downtown was for. The Renaissance Center, a hotel and office building opened in 1977 with a ground floor that was defensive rather than inviting, had not made much difference to everyday Detroiters.

I mostly didn't notice the decay as it crept through the city. And when I did sort of notice it, I sort of celebrated it as part of the rough urban scene that I was a part of. The grit seemed just another layer of my tough skin as I prowled the urban jungle. Like many Detroiters, I had an attitude that if folks didn't want to be in Detroit, they could just go their way; as far as shopping was concerned, if I couldn't get it in Detroit then I didn't need it.

I had made a few trips to Third World countries for vacations and seen real poverty—people living in dirt-floor shacks whose only clothes were what they were wearing; people whose best chance of getting some money that day was to follow me around in hope that I might give them something. So what was happening in Detroit didn't seem so bad. But eventually even I began to be concerned about the empty and falling-down houses I saw when I went to visit my parents in a formerly solid middle-class neighborhood. Daddy used to brag that the area would never go down because it was so close to the university. Students used to rent flats on our street. But as things got tougher in town, like so many others, U of D

seemed to draw back in on itself. A high metal fence went up around its boundaries. Security guards were placed around entry points. Students drew back too, staying in newly built residential buildings on campus. Businesses along Livernois Ave. that used to draw student business shut down.

So many other still-viable enterprises in the city had followed the same defensive posture—hunker down in a secure position; throw up inch-thick bulletproof plastic barriers between yourself and the community that spent their money in your establishment; put guards in the parking lots; and never step off the beaten path for fear of violence.

Detroit became a national joke where it had once been the model of industrial production. Mayor Young, always known for his salty language, greeted a group of journalists via closed circuit television with "Aloha mother-fuckers." The line was raunchy and raw, but it was totally appropriate for Young, who had declared cursing an "art form." But the line was just more evidence to others that Detroit was a lost zone with a lunatic for a mayor. Things got more bizarre; television news anchor Bill Bonds, who had a stormy relationship with the mayor, challenged him to a fistfight while on the air.

It was typical as things fell apart around the city. Where you once could practically set your clock to the bus schedule, people began having to wait hours for buses. And in the last couple of years, as Detroit faced financial deficits, the city cut back even more on bus service. It's nearly impossible to hail a cruising cab unless you're downtown.

In 1985 I got a job at the *Metro Times* newspaper as the listings editor, compiling the "What's Happening" section. Just from listing events, I learned about areas and places in the city that I had previously had no idea about. At the time, Rivertown area seemed a burgeoning entertainment district, with restaurants and

dance clubs popping up in old industrial warehouses. I would burst with pride on a weekend night when I was cruising through the area and saw someone standing under a streetlight looking at the *Metro Times*. I knew they were trying to figure out what to do next, and I had put together their guide.

Life was changing for me. My girlfriend and I bought one of the small, cheap wood-frame houses in the Brightmoor neighborhood on the west side for $3,500. We slept on the living room floor for six months until I turned the unfinished attic into the master bedroom. The block we lived on was a dead-end at a park, which was pretty cozy. The guy next door pretty much stayed drunk and played cards with his friend on a picnic table in the driveway all day. His wife worked at a nursing home. His teenage kids had jobs too. Once they hit fourteen they had to contribute to funding the household. Over time I found out that if I left anything of value on the front porch, the neighbor was going to take it.

The drunken guy was useful. As the houses across the street from us went empty, drug dealers would take them over. Because of the dead-end, we would have traffic jams on our street every morning, as suburbanites headed to work downtown stopped in to get their fix for the day. My neighbor didn't like that and would burn down the drug houses as their clientele grew. So they went, one after the other, until there were no houses on the first four lots off the park.

Burned houses weren't a big deal around there. One day I was sitting on my front porch looking across the now empty lots at the back of a row of houses on the next street. There was a new pickup truck parked in one of the yards. Two guys came out of the house, jumped in the truck, and drove off. A few minutes later I saw smoke and flames burst out of the back windows. I called the fire department. After the

fire fighters put out the blaze, I tried to tell them about the guys who had set the fire. They weren't interested in pursuing the culprits.

My girlfriend—we later married—was a gardener. We had vegetables in the yard and flowers in the empty lot next door. I would stand on my porch looking at the field across the street and think that I should start a farm over there. I wasn't hooked up with anyone in the urban agriculture scene in the early 1990s, but looking at all that land, it just seemed to make sense to me. It obviously made sense to a lot of other people, because that is when big-time gardening really began to take root in the city.

By then I had become managing editor at the *Metro Times*, and in 1991 moved to the *Free Press* as an assistant entertainment editor. Still, I did more writing than anything else. I wrote big stories about the history of black Detroit, an exposé on the Motown Museum's shoddy facility after a high school kid stole Michael Jackson's glove from an unsecured case, and I covered the history and sale of WGPR, the first black-owned television station in the country, when it was sold to CBS. A lot of what I covered added up to the fact that the former grandeur of Detroit was exactly that: former.

I got a big lesson in that when the Detroit newspaper unions went on strike in 1995, it was one week after we had moved into a new house that was considerably more expensive than our first one. I had seen my father go on strike in the past, and there was always a fairly quick resolution. But everything was changing about the newspaper business; the newspapers had entered into a joint operating agreement a few years earlier, and it seemed they were out to break the union. The Freep had actually built barracks for security guards on the second floor of its building while workers put out the papers on upper floors before the strike. Management hemmed and hawed about negotiating while running a blistering public

relations campaign against the unions. On one occasion, management burned a semi truck at their Sterling Heights printing plant and implied that striking workers had set the blaze. News footage of the flames in the night sky was on all the television stations. Yet months later, after the Macomb County Prosecutors investigated the incident, it was found that the Detroit Newspaper Agency had burned its own truck. That wasn't headline news.

When the Hudson's building was demolished in 1998, it was headline news. By then I was editor of the *Metro Times*. The place had been empty since 1983, but taking the iconic building down was a final blow to whatever spirit of Detroit's old downtown still lived. Another blow to the city came in 1999 when the state legislature lifted the residency requirement for city workers. Police and firemen left the city in droves. Today 53 percent of the Detroit police force lives outside the city. Many city employees, pillars of Detroit's middle class, began shifting to the suburbs.

Still, when Hudson's came down it seemed the city could see a new vision. Peter Karmanos helped build Campus Martius and moved his CompuServe Corporation into it. Mike Illitch, founder of Little Caesars Pizza and owner of the Tigers and Red Wings sports franchises, had stuck by the city and restored the magnificent Fox Theater. He was talking about building a new hockey arena and creating an entertainment district near the Fox. Even as people were still fleeing town, there was a new class of young people moving into town, entrepreneurs who saw opportunity in the low startup costs for business in the city, and farmers, some of whom squatted in abandoned houses and tilled open land in their neighborhoods. Either way, they saw opportunity in the one thing Detroit is rich with—space. Rents were cheap and so was land. But there was still plenty more that could go wrong.

I voted for Kwame Kilpatrick in 2001. He was a new face and I didn't like his opponent Gil Hill, the city council president who I'd been told was taking bribes. True or not, I felt like the city needed new blood. Apparently you have to be careful what you ask for.

The Kilpatrick administration was scandal-plagued from the start. Rumors of a wild party with strippers (one of whom was supposedly assaulted and severely injured by the mayor's wife and was, in fact, later murdered in an unsolved case) never went away, although state attorney general Mike Cox declared it an "urban legend." Kilpatrick was eventually found guilty of perjury for denying an affair with his chief of staff, Christine Beatty, and he was later found guilty of multiple federal charges of racketeering and extortion. So much for voting against the guy I thought was on the take.

In 2003 the city entered into a federal consent decree after a civil rights lawsuit was brought against the police department. The lawsuit alleged that Detroit police subjected citizens to "excessive force, false arrests, illegal detentions and unconstitutional conditions of confinement." People were mysteriously injured and died while in jail. The department was to be overhauled under the supervision of a federal judge.

Five years later, the department was only in 36 percent compliance with the benchmarks set by the consent decree. Furthermore, it was revealed that Mayor Kwame Kilpatrick had possibly inappropriate personal meetings with Sheryl Robinson Wood, the federally appointed monitor, who resigned her post when the information became public. Detroit has had seven chiefs of police since 2003—four of them left office under the cloud of scandal.

One evening I went to a yard party at the mayor's residence. Kilpatrick spoke

inspirationally about a new arts initiative that the city was making. The next day Kilpatrick was arrested for assaulting a county sheriff. It was strange to me that one day he could sound so good and the next day be so bad. It seemed like there were two different people inhabiting the same body.

Through all of this I only rued my choice to stay in Detroit for a short time. A few years back, a friend of mine was moving to Chicago. At her bon voyage party I became jealous, thinking I had missed my chance to get out and I was too old to make a move now. I looked around and saw things without the rose-colored glasses of family and friends. Both my parents and the one sibling who had stayed here had passed away. Mostly I was concerned that my daughter had to grow up in such a negative atmosphere. I wrote this blues lyric in response:

> *The devil came to Detroit*
> *Tore everybody down*
> *The devil came to Detroit*
> *Tore everybody down*
> *If you ain't seen chaos and destruction*
> *Just take a look around*

**A VISIONARY ENVIRONMENT**

As bad as things are in Detroit, there is a counternarrative about what's happening that doesn't focus on the pornography of ruin and destruction. Political activist and philosopher Grace Boggs, who turned ninety-eight in 2013, sees global forces at work in Detroit's transformation.

"I think the sense you have in Detroit is that it's the end of something and the beginning of something new. It's very rare that someone lives at that time, at that place, where something's disappearing, vanishing into the past, and something new is emerging. That's very inspiring, to be at that particular time."

I was aware of the Boggses as early as the 1970s due to their involvement in the Dodge Revolutionary Union Movement. I had friends involved there. But from a distance I felt like they were some kind of political cult. Since then I have learned much more and have become friendly to the Boggs way of thinking, although James passed away in 1993. The way Boggs and the wide circle of community activists who work with her see it, the world economy is going through a postindustrial change that is akin to the changes brought on when humans changed from a hunter-gatherer society to an agrarian society, and again from the Agrarian Age to the Industrial Age. Those changes resulted in vastly different social organization. If that is happening now, then the changes in Detroit, which was at the forefront of the Industrial Age, foretell what will happen elsewhere. As the Industrial Age ends, we are falling faster and harder than other places. At the same time, their thinking goes, Detroit will be among the first to emerge onto the other side. The question is what is on the other side of the wormhole.

The goal of the James and Grace Lee Boggs Center to Nurture Community Leadership is to imagine what that should be, and to work toward it with whatever resources are available. It has had a series of workshops on creating a new vision for the future: re-imagining education, re-imagining work, re-imagining community—everything that impacts our lives—with a focus on doing what you can with what you have. Most efforts over the past fifty years have been to somehow patch up the system, to fix it. But there is a growing realization that we need a new social order to meet technological advances and community needs.

There are numerous community enterprises that have a connection with the Boggs Center.

The Avalon bakery is one of them. The enormous urban agriculture movement is connected to it. The Detroit Coalition Against Police Brutality, which had a hand in the lawsuit that brought the police consent decree, is another, as are Detroit Summer, the Allied Media Project, Yusef Shakur's Urban Network bookstore, and the Hope District. Boggs has connections to community projects and organizations across the city; it's a vast network growing up from under.

## PICKING UP THE PIECES DOWNTOWN

There are plenty of good things going on around town. Detroit is, after all, still one of the twenty most populous cities in the United States. Ernest Zachary, founder of Midtown-based developer Zachary & Associates, reminds us of that in recalling his discussion with a worker from the Seva restaurant inside the nearby N'Namdi Center for Contemporary Art: "I said, 'Boy you had a big crowd today.' And he says, 'Yea, you know what? We have 700,000 people still living in this city.' And he says, 'And guess what? We get married; we buy cars; we go out and eat in restaurants. We're just like everybody else. And there are 700,000 still here and we still function.' And that restaurant, they opened it in January; it was an immediate success. They have another one in Ann Arbor, but this does better than the one in Ann Arbor. So if you can do it, if you can pull it together and create something, people are going to come."

More recent estimates say that the population has dropped under 700,000, but Detroit is still by far the biggest city in Michigan. Recent government and corporate actions show that they aren't giving up on this city. Zachary and his team are one example of those working to creatively connect Detroit's past with its future. The development group is

restoring an area on the east side of Woodward in Midtown. The building at 71 Garfield St. was rehabbed as a green structure. The roof supports 1,800 square feet of photovoltaic cells generating electricity for the building. It has a solar water-heating system, and heating and cooling is provided through a 270-foot-deep underground geothermal system. The building utilizes natural light, LED lights, and light sensors to conserve electricity. A water collection system feeds a 3,000-gallon cistern that irrigates a green walkway alongside of the building. Some doors and flooring are recycled materials from Detroit's Architectural Salvage Warehouse. It seems that nearly every green practice possible was incorporated into the building, with retail space on the first floor and residential units on the upper floors—all this in a building that could well have seen the wrecking ball.

For a long time I disliked the development going on in what had formerly been my stomping grounds. I loved the familiar grit and grime and was put off by the shiny new vision. Then one day I realized that everything changes. The world my parents grew up in is vastly different than the one I know. It will be the same for my daughter. I had moved on from the Cass Corridor and it wasn't mine anymore. There are plenty of people who live and work there who have a hand in what it's becoming for better or for worse. There are issues and contradictions between the old and the new. For instance, there is a clash between the poor people who have been living there for decades and the upscale newbies repopulating the area. The bottom line is that the one thing you can count on is that things will change. None of the businesses in the Willis Village that I love so much now were there when I lived there.

Midtown has become a destination neighborhood for those who want to live in Detroit. A Whole Foods store opened there in June 2013. It may have not been that big a deal

other places, but in a city that did not have a national-chain grocery store it signaled a change of fortune. Whole Foods is known for figuring out just when a neighborhood is ready to take off, and locating there to help propel the synergy of the neighborhood over the top. It also has some old-school benefits—two-thirds of the 97 opening-day employees were Detroiters. That's nothing like the 100,000 workers who once labored at the Ford Rouge Plant, but it is the proliferation of smaller employers spread throughout the city that shows the promise of Detroit's future.

And there is overflow from Midtown spilling over into my neighborhood on the north side of town. A couple moved in last year from Toronto. They told me that they were at first interested in Midtown but then started looking further afield. Another family nearby moved from the area, and I met a prospective buyer recently that was interested in moving to my neighborhood from Midtown. Apparently an attractive downtown feeds the neighborhoods.

One of the more ambitious new investments, however, has been made by Dan Gilbert, founder of Quicken Loans and owner of the Cleveland Cavaliers. Gilbert moved the Quicken headquarters to downtown Detroit in 2010. Since then, his Rock Ventures group has purchased some two dozen downtown buildings (and counting), plus several parking garages. Now Gilbert has embarked on a quest to build up street-level retail and so-called pop-up businesses. Not to mention his backing of the Woodward light rail line. If Detroit doesn't respond to this injection of cash, his may be the biggest folly. But the rewards of a revitalized Detroit for Gilbert will be equal to the risk.

Still, Detroit needs more than downtown and Midtown in order to thrive. We need invigorating and walkable neighborhoods. They have more direct impact on the quality of family life than the central districts, but neighborhood development has never gotten near as much attention as downtown. The prevailing wisdom is that vibrant cities need vibrant downtowns as an anchor to the region. Attempt after attempt at revitalizing Detroit had little enough impact downtown, and efforts just never seemed to get to the residential neighborhoods.

Agriculture is the thread that runs through most neighborhood initiatives. While the idea is taking off around the world, nowhere else in the United States has it taken off like it has in Detroit. According to the Greening of Detroit's Garden Resource Center, with more than 1,200 community gardens Detroit has more per capita, more per square mile, and more total community gardens than any other city in the nation. About 24 of the city's vast 149 square miles are open for cultivation.

Detroit was founded as an agricultural city with the French ribbon farms streaming up from the riverfront. During the recession of the 1890s, Mayor Hazen Pingree leased public land, including the city hall lawn, for growing food. During the world wars, victory gardens were patriotic, and during the Great Depression a survival strategy. In the 1970s when urban flight left the city spotted with empty lots, Mayor Coleman Young started the Farm-A-Lot program—the city supplied seeds and some technical assistance to residents who wanted to garden vacant lots.

The recently developed Detroit Future Cities plan calls for greenways, creating surface lakes with streams that have been covered up, and urban farming as a use for open spaces. A lot of healing can go on with this newfound respect for the land. Gardeners are restoring land that has been polluted over the past century; they're feeding themselves and their neighbors, and they're finding something in common with people outside of the area where agriculture has been a big part of the economy. Planting and

growing things teaches you about nutrition, it teaches patience, and it enhances caring. And it is a powerful community-organizing tool. Through community gardening you meet and cooperate with neighbors instead of fearing them. As much as the corporate forces are molding a new downtown, agriculture is transforming the neighborhoods. Every year a little more of my front and back yards are turned over to growing food. It's truly gratifying to be able to just wander into the yard and pick something for dinner.

Growing food in the city is no pipe dream. MSU's Kathryn Colasanti has determined that using intensive growing methods, nearly 76 percent of vegetables and 42 percent of fruits consumed in the city could be supplied from as little as 2,086 acres of land—about one-sixth of what's available. Farmer's markets are popping up across the city.

As Rev. David Bullock says, "It begins with food production and hoop houses and chickens, but ultimately it turns into an eating and living lifestyle."

**BACK TO THE CORNER**

A few months ago, I walked into the Spiral Collective and my heart sank. Janet and her books were gone. I feared that another cultural community business had bit the dust. However Sharon Pryor, who runs Tulani Rose, told me that the Source had moved to the Auburn building, a new development across the street. The Source was in a new space in a new building. Back in the Spiral Collective building, the Del Pryor Gallery and Tulani Rose expanded into the extra space.

"It's all good," Pryor said.

Across the street in the Auburn Building, which stretches for an entire block, a whole new kind of retail inhabits the street-level spaces. It's more upscale than I would ever have imagined back in the 1970s. There are two restaurants bookending the development. In between the eateries, the Butcher's Daughter contemporary art gallery has relocated there from Ferndale. There's Hugh, a bachelor-pad shop with furnishings and implements one imagines a modern Hugh Hefner might use. Next door, a design store named Nora has a decidedly more feminine edge. These places seem more like something you would find in Birmingham rather than the Cass Corridor. The shops seem attuned to folks buying up lofts in the area that go for as much as $600,000. And they bring a line of products hard to find downtown now that people there are concerned with buying such items as sheets, knives, and glassware to furnish their new living spaces.

The area is bursting with new enterprises. So much so that when I do my Christmas shopping, I head to Midtown instead of out to the malls. The Willis Village is still there, but things are changing fast. Avalon is expanding and moving to another space a block over on Canfield, next to Traffic Jam, a venerable eatery that has held on for decades. Whatever happens, the space that Avalon moved from won't stay empty long. Not in an area that has changed profoundly, an area where the descriptions "upscale" and "gentrified" are starting to rest easily. George N'Namdi, whose art center complex is a few blocks away, puts it all in perspective: "If you go ten years back I'd say most of this wasn't even here, and I think if you go ten years from now it's going to be equally as different."

Equally different—that's a wide-open assessment, one that a new generation of Detroiters endeavors to help define. I have no regret that I stayed in Detroit. It is indeed home. Here we have dreams, and it's no Rust Belt scene. ■